History of Western Music

HARPERCOLLINS COLLEGE OUTLINE

History of Western Music

5th Edition

Hugh M. Miller
College of William and Mary

Dale Cockrell
College of William and Mary

▦ HarperPerennial
A Division of HarperCollins*Publishers*

An American BookWorks Corporation Production

Project Manager: Mary Mooney
Editor: Edgar Williams, Jr., Ph.D.

Library of Congress Cataloging-in-Publication Data

Cockrell, Dale
 History of Western music / Dale Cockrell, Hugh M. Miller.— 5th ed.
 p. cm.
 Rev. ed. of: History of music / by Hugh M. Miller, 4th ed. 1973
 Includes bibliographical references and index.
 ISBN 0-06-467107-0 (pbk.) :
 1. Music—History and criticism. I. Miller, Hugh Milton, 1908–
 II. Miller, Hugh Milton, 1908– History of music III. Title.
ML160.C67 1991
780' .9—dc20 90-56005

91 92 93 94 95 ABW/RRD 10 9 8 7 6 5 4 3 2 1

Contents

Preface

Prof. Hugh Miller's *History of Music* was first published in 1947. It quickly became an important text of reference for many students of music history. His work eventually underwent four minor revisions, the last in 1972. This is a thorough revision of his book, incorporating new scholarship on music before the twentieth century and an updated section on twentieth-century art music, and including for the first time information on vernacular music.

One of the more obvious changes is the book's new title: *History of Western Music*. It is much less the case today than in 1947 that a title with the unmodified word "Music" is implicitly about the music of the West (i.e., Europe and regions where European culture was transplanted). To many musicians, even those in the West, the word no longer carries any connotation of place, time, or function. Given this major shift in perspective, "Western" was added before "Music" so that the title might reflect more accurately the book's content.

This revision acknowledges the tremendous growth in scholarly interest in vernacular music. A section of the book is accordingly devoted to popular music, jazz, and rock. The term "art music" is uniformly used to distinguish "classical music" (as Professor Miller called it) from vernacular music. This expression, which has recently gained wide acceptance, has the advantage of preventing confusion between "classical" music and music of the "classical" period, and is a more accurate denominator of the music's functions and the composer's intentions as well.

Histories of music frequently include a quantity of factual material that is of purely antiquarian interest. This one has minimized or eliminated altogether this kind of information. The emphasis is placed on organization and presentation of essential historical information that bears directly upon the actual music of any given period or style, or upon the development of musical ideas. The book deals primarily with characteristics of form and style as they apply to music of broad and specific periods and types, to nationalities or schools, and to the most important composers and performers. It is, then, intended to be a substantive guide to the intelligent study of music by the amateur.

History of Western Music is more than a mere review outline. It is intended to be a functional work that can be used as the basic text in an

introductory college music history course. This does not preclude collateral reading in the many excellent survey texts of music history or more specialized readings. Indeed, the bibliography to this work directs the student to some of the more useful of these.

The acquisition of historical information about music is of little value unless that information is vivified by the music itself. In keeping with this, most chapters close with a list of recommended scores and recordings. Today's student is fortunate that there are excellent anthologies of scores with equally fine accompanying recordings. I have relied extensively on two of these and suggest that the serious student have at least one of them at hand for ready and frequent use. They are: Claude Palisca, ed., *Norton Anthology of Western Music*, 2d ed., 2 vols. (New York: W. W. Norton, 1988); and Roger Kamien, ed., *The Norton Scores: An Anthology for Listening*, 5th ed., 2 vols. (New York: W. W. Norton, 1990). To refer to the former I have used the acronym "NAWM" throughout, followed by the number of the example. To refer to the latter, "NS" is used, followed by roman numeral "I" or "II" to indicate volume number; again, the arabic number is a selection and not page referent. In the earlier chapters one might also find reference to "HAM," an acronym of the venerable *Historical Anthology of Music*, 2 vols. (Cambridge: Harvard University Press, 1950), edited by Archibald T. Davison and Willi Apel. Selection numbers follow the acronym. Recordings of uneven quality have been made to accompany this anthology and are available in most music libraries.

I wish to express my deep gratitude to two of my colleagues at the College of William and Mary. Katherine Preston first suggested I undertake this project and has maintained an active interest in its content and progress throughout. Edgar Williams read the entire manuscript with a ready green pen in hand; his numerous suggestions and comments big and small were invaluable and contributed directly to a manifestly better and more accurate book. Dan Gutwein and William DeFotis, also colleagues at William and Mary, offered me their expertise on contemporary music, as did Prof. Fred Maus (University of Virginia) and Prof. William Brooks (University of Illinois).

Dale Cockrell

History of Western Music

1

Introduction

The study of music history requires a preliminary understanding of some basic concepts and approaches.

INTERDEPENDENCE OF MUSIC

Music, like other arts, is not autonomous. It is always one aspect of the cultural life of a society. Often the relationship with other cultural aspects is obvious. For example, music has always been closely associated with the literary arts, and must be appreciated in that context. But it is also important to study music in the context of seemingly more distant developments, such as those of social, economic, political, cultural, and philosophical. In this book, each of the eight parts is prefaced with a "Timeline" containing musical, cultural, and historical dates and events of significance. Further, each section detailing the chronology of art music contains a summary of important historical developments.

MUSIC LITERATURE

The study of music history is necessarily based on the study of music literature. Factual information is, of course, essential to understanding history in any field, but unless musical facts are applied directly to the actual

sounds of music they are of negligible value to the understanding of music history. Thus, one must hear representative music of any era or style to understand that development musically. It is a great advantage to the modern student that there is a wealth of music authentically recorded and available for study. Each appropriate chapter here contains a list of suggested recordings.

The study of music literature also includes musical scores. Modern editions and anthologies of music enable the student to see in detail aspects of musical construction. Whenever possible, it is best to combine the visual perception with the auditory, to "see" the music while hearing it. Accordingly, most chapters here refer the student to scores for "visual" listening.

KINDS OF HISTORICAL INFORMATION

An adequate study of music history involves a coordinated knowledge of several areas.

Forms

The term *form* refers to the structural principles governing musical composition. A given form is determined by a combination of these principles. An important way of understanding the history of Western music is as a chronicle of ever–changing forms. Forms are often discrete enough that they define types of music, or *genres*.

Style

Musical *style* is present when the vocabulary of music—which involves melody, rhythm, harmony, texture, dynamics, form, performance practice, and other elements—forms some state of commonality. Implicit in this term, though, is an opposition to other stylistic commonalities. This recognition allows us to speak of certain stylistic periods of music history, in which several styles might prevail. It helps us speak of composers who have an individual style, in which a body of music is recognizably related to, but different from other composers. Eras, countries, schools, and individual composers have their own stylistic characteristics. Thus, one can speak of Renaissance style, French style, Venetian style, Beethoven's style, minimalism, or jazz.

Medium

In music, the term *medium* means the agent of performance. In general, media are vocal, instrumental, or both; they are subdivided into various solo or ensemble combinations. The kinds of media employed in any given period or style constitute one indication of the kinds of musical sounds encountered.

**Broad
Categories**

Music history can be approached from the standpoint of broad categories of music literature such as religious music, secular music, dramatic music, symphonic music, and so on.

**Geographical
Areas**

Music often develops differently in different regions, such as countries or cities. Music of a particular region, if there is also a stylistic consistency, is usually referred to as belonging to a *school*. Hence, we have such expressions as the Flemish school, the Italian school, or the Venetian school.

Composers

To know the history of art music is to be familiar with the important composers and their contributions to music literature and stylistic developments. Sometimes a composer represents the culmination of a period (Johann Sebastian Bach in the Baroque Period); sometimes a composer represents revolutionary innovations (Igor Stravinsky and Arnold Schoenberg in the twentieth century). Among vernacular musics (e.g., popular music, jazz, and rock) the composer is often less important. In fact, in some cases, performers are far more significant to understanding the style.

**Documents and
Manuscripts**

Valuable contributions to Western music history have been made by theorists, critics, and historians who have explained the musical practices of their own times. Such documents, many of which have been translated and published in modern editions, often afford insights.

Our present knowledge of earlier periods in the history of art music stems largely from manuscripts in musical notation preserved in libraries and in museums throughout the world. The well–informed student of Western music history should know about them.

Notation

Since Antiquity, music has been written down according to various systems of symbols called *notation*. How such systems developed is an important facet of historical knowledge (though such knowledge contributes little to the student's perception of musical sound). Perhaps more importantly, notation is an important clue to the thinking and the expression in music of any time or place.

**Chronological
Organization**

The study of the history of Western art music has traditionally involved establishing the chronological development of thought and practice from its earliest known beginnings to its present forms. This has led to the conventional divisions into historical eras, or periods of time. These divisions, which generally conform to similar eras in general history and the history of other arts, are referred to, respectively, as the pre–Christian Period (Antiquity), the Middle Ages, the Renaissance, the Baroque Period, the Classical Period, the Romantic Period, and the Twentieth Century. Some periods are subdivided into early, middle, and late, and subdivisions of major periods

sometimes carry special names, such as the Ars Antiqua and the Ars Nova of the Middle Ages.

Vernacular musics are also conventionally treated chronologically. The notion of periodization is somewhat less rigid than in the study of art music, though, and some historians of these styles avoid it altogether.

Although period divisions are used for convenience in the historical organization of events and developments, it must be kept in mind that change from one period to the next does not take place suddenly. Evidence of change is invariably manifested before the beginning year of an era, and, conversely, the characteristics of an era continue long after it has ended. For example, evidence of Baroque practices can be found at least two decades before the year 1600, when the period is said to have begun, and Renaissance techniques continued to be employed well beyond that year. Furthermore, no period or style is static in itself; change is dynamic and takes place continuously within periods and styles.

PART ONE

ANTIQUITY

PART ONE

ANTIQUITY

2

Antiquity

586 B.C.	Sacadas plays aulos at Pythian Games
ca. 500 B.C.	Pythagoras determines ratios of musical intervals
ca. 380 B.C.	Plato discourses on music in the *Republic*
ca. 370 B.C.	The books of the *Old Testament* reach their present form
ca. 330 B.C.	Aristotle's *Politics* discusses music education
ca. 320 B.C.	Aristoxenus finishes the *Harmonics* (oldest extant Greek musical treatise)
ca. 130 B.C.	Composition of the two "Delphic Hymns"
ca. 30 A.D.	Jesus crucified
first century A.D.	"Epitaph of Seikolos" composed
second century A.D.	"Hymn to Nemesis," "Hymn to the Sun," and "Hymn to the Muse Calliope" composed by Mesomedes of Crete
ca. 200 A.D.	Athenaeus's *Sophists at Dinner* includes dialogue on music
fourth century A.D.	Aristides Quintilianus, the last theorist of Greek music

We do not know precisely how or when music began. Perhaps in prehistoric times man used primitive forms of drums and trumpets for signaling. He may have found these sounds pleasing to the ear and began to use them to create music. Another theory is that music developed from the natural urge to accompany human movement with rhythmic sounds, which gradually became musical creations. Song may have also evolved from the spontaneous vocal expression of anger, fear, anguish, and joy.

Relatively little is known about the music of Antiquity (from prehistoric times to about 200 A.D.). We know that music existed in many ancient civilizations, and there is substantial evidence on musical life in ancient Egypt and China. It is likely that some of the musical traditions of Antiquity influenced European musical heritage in important ways. The one about

which we know the most and that has most directly influenced the theoretical basis of Western music is that of Ancient Greece.

MUSICAL CHARACTERISTICS

Our knowledge of the music of Antiquity is seriously limited by the ephemeral nature of the musical medium, unlike ancient pictorial art, architecture, or literature. Notation is a method for preserving information about sound, but it was not fully developed in Antiquity. The few bits of extant music notated before the birth of Christ are mostly indecipherable.

We have gathered information about ancient music in four ways. (1) Pictorial representations of musical activity, especially those of people playing instruments, tell us something about the music of Antiquity. These images certainly confirm the existence of music making. (2) Several important writers have recorded their ideas about music and noted the rules of its construction. Literary sources constitute our best information about ancient music. (3) A considerable number of instruments have been excavated from the sites of ancient culture. Analysis of them yields conclusions about scales, modes, and social function. (4) *Ethnomusicology*, the study of non–Western systems of music, provides some insight into ancient practices. For example, by studying mature folk cultures (Indian, Middle Eastern, Persian, etc.) that were directly influenced by the ancient Greeks, scholars have been able to draw conclusions about the music of Antiquity.

Though we possess no definite knowledge of how the music actually sounded, we can make certain generalizations about the practice of music in ancient times.

Dependency

It is unlikely that ancient music was an independent art created solely for the pleasure of casual listening. Rather, it seems to have been an adjunct to other activities, such as dancing and ritual.

Monophony

It is generally believed that the music of Antiquity, like that of many aboriginal cultures today, was *monophonic*. That is, it was comprised of a single melodic line without accompaniment or harmonic support.

Improvisation

Probably all ancient musical cultures encouraged the musician to improvise. Skill in performance was to some degree a function of the musician's ability to alter, vary, and ornament a melody. This helps explain why so little music was notated.

Powers of Music Ancient man seems generally to have believed that music had mystic and magical powers capable of affecting his life, character, and well–being. References to this aspect of music are found in abundance in the literature of the ancients.

MUSIC OF ANCIENT CULTURES

Greek The music of Antiquity about which we know most and that has most profoundly influenced European musical concepts, theories, and aesthetics is that of Greece. The word "music" itself comes from Greece, as do many other musical terms, such as *tetrachord*, *lyric*, *rhythm*, *polyphony*, and *hymn*. Present knowledge of Greek music is based on a wealth of extant literature and pictorial evidence, although little music is preserved in notation.

Characteristics

Greek music was largely monophonic. If the melody was sung or played by two performers, most likely the accompanying line sounded simultaneously as an elaborated version of the primary melody. This texture is called *heterophony*. Most music was improvised and heavily ornamented. The performer's ability to embellish a melody was a critical aspect of skill. Greek music was inseparable from poetry and drama and was important in mythology and in ceremonial rites.

Cults

Two cults dominated musical concepts: (1) the *cult of Apollo*, which used the *kithara* (a plucked string instrument), was characterized by clarity and simplicity of form and restraint of emotional expression; and (2) the *cult of Dionysus*, which used the *aulos* (a double–pipe reed instrument), was characterized by subjectivity and emotional expression. These two concepts have played varying roles in the subsequent development of Western music.

Doctrine of Ethos

Aristotle and Plato, among others, articulated a doctrine of ethos, in which music was stated to have a direct and profound influence on character. They believed music could imitate two general states of being (peacefulness; excitement and enthusiasm) and inculcate them in the listener. Factors that determined a particular musical ethos were its rhythm, mode, and the instrument employed.

Theory

Greek theory was based largely on the acoustical mathematics of Pythagorean ratios. Music was organized by *modes*, with names like Dorian, Phrygian, Lydian, and so on, each one of which produced different mental states. The modes were based on *tetrachords* (groups of four notes spanning the interval of a perfect fourth) that could be arranged in *conjunct order* (the highest note of the lower of two tetrachords being the lowest note of the tetrachord immediately above) or *disjunct order* (the highest note of the lower of two tetrachords being adjacent to the lowest note of the tetrachord immediately above). There were three *genera* of tetrachords: (1) the *diatonic* (e.g., the notes B, C, D, and E), (2) the *chromatic* (e.g., the notes B, C, C#, and E), and (3) the *enharmonic* (e.g., the notes B, B#, C, and E). (The modern system of notation does not easily allow for intervals smaller than a half–step. The first three tones of all these tetrachords were most likely such microintervals.) Eventually a two–octave scale made up of conjunct and disjunct tetrachords evolved, called the *Greater Perfect System*.

Another important aspect of Greek theory was the systematic application of poetic meters. *Rhythmic modes* were developed as a result of this (see Example 7.1).

Notation

The Greeks were among the first to develop systems of notation. There were two kinds: an instrumental notation, its symbols from Phoenician letters, and a vocal notation, with symbols derived from the Ionic alphabet and placed above the words of the text.

Instruments

The principal instruments used were the *lyre* and *kithara* (both small harps), *aulos*, *syrinx* (panpipes), *krotola* (a castanetlike instrument), *tympanon* (a frame drum from which the word timpani comes), and *hydraulus* (water organ).

Extant Music

There are six melodies and about the same number of fragments left to us. The more–or–less complete melodies are two "Delphic Hymns to Apollo" (ca. 130 b.c.), two short "Hymns to the Muse," a "Hymn to Nemesis," and the "Epitaph of Seikilos" from the first century a.d. Obviously, these constitute a wholly inadequate basis upon which to judge ancient Greek music.

Writers

About twenty treatises, most of them fragmentary, provide knowledge about ancient Greek music. Some of the more important are the writings of Terpander (ca. 675 b.c.), Pythagoras (ca. 500 b.c.), Timotheus (ca. 450 b.c.),

Aristoxenos (*Harmonics*, ca. 330 b.c.), Aristotle and Plato (fourth century b.c.), and Ptolemy (second century a.d.).

Roman

After Greece became a Roman province in 146 b.c., Roman music imitated the Greek. Apparently musical life flourished, for there are many reports of large choral and orchestral performances from the first two decades of the Christian Era. Brass instruments were developed and used mainly for military purposes. No Roman music has been preserved in notation, however, and apparently the Romans contributed little to the development of music in theory or practice. Much Roman music was grounded in social occasions abhorrent to the early Catholic Church, and our lack of knowledge about this music may result from the Church's attempt to eradicate Roman rituals and accompanying music.

Hebrew

Although no pictorial material is preserved from ancient Hebrew culture, there is ample literary reference in the Old Testament to music, singing, dancing, and many kinds of instruments. Hebrew music was primarily religious, and in the form of psalms sung in unison *responsorially* (a solo singer answering choral groups) or *antiphonally* (two alternating choral groups). Various flutes, string instruments (psalteries), and percussion instruments were employed. Aspects of the music of the Catholic Church were borrowed from Hebrew music.

Scores and Recordings

Greek
 "Epitaph of Seikilos": NAWM 2
 "First Delphic Hymn": HAM 7a
Hebrew
 HAM 6

PART TWO

THE MIDDLE AGES

(800–1400)

3

Introduction to the Middle Ages

The period from the ninth to roughly the early fifteenth century is referred to as the Middle Ages (sometimes, the Medieval Period). With the crowning of Charlemagne in 800 by the Pope, much of Western Europe was consolidated politically and religiously. It became possible also to speak of a common society and culture. Liturgical music of the Roman Catholic Church, Gregorian chant, was the first common Western European body of music, although regional traditions were still important. A theory of its usage was written during this time. Additions were made to the body of chant. Methods for its embellishment were developed. This impulse led eventually to the revolutionary rise and growth of polyphony, the most important development in Western music. As part of this development, the act of composition replaced improvisation, the norm during earlier periods. With this came a need for notation, a system of preserving sounds. Individuals began laying claim to their musical work, and we have the first names of composers in Western music history. By the end of the period composers had learned to construct large-scale, complex musical works of sophisticated forms, melodies, and rhythms.

The feudal system, which developed during the Middle Ages, provided a cultural balance to the hegemony of the Catholic Church. Feudal courts fostered developments in secular music, which celebrates earthly pleasures. The creation of a courtly poetic tradition flourished, as did music to accompany it. Instrumental music and stylized dances also came to be important. As was probably also true of religious music, folk music (i.e., music that exists only in a non-notated, oral tradition) was influential. The fourteenth century applied techniques learned in the composition of sacred music to the writing of nonreligious music. Secular music's inherent immediacy fueled the development of an extraordinarily vibrant polyphonic tradition, the Ars Nova, or New Art.

HISTORICAL CONTEXT

The period immediately before the turn of the millenium (sometimes called the Dark Ages) saw the groundwork laid for the building of modern–day Europe. That work began in 800 when Charlemagne was crowned Emperor of the Holy Roman Empire, thus consolidating much of Europe under one rule. By the eleventh century, the power of the Empire had dissipated to the point that there was a final schism in 1054 between Eastern and Western Churches. Nevertheless, there was prosperity in western Europe, an increase in population, and the beginning of modern cities. The Norman Conquest of England in 1066 brought the English into Europe. Intellectual vitality is manifest in the beginnings of the university and scholastic philosophy, the first translations of Arabic and Greek literature, and the rise of Romanesque architecture.

The twelfth and thirteenth centuries were the time of the Crusades, the building of the Gothic cathedrals, chivalric poetry and song, and the economic, political, and social system known as feudalism. Some important persons were St. Francis of Assisi, Roger Bacon, St. Thomas Aquinas, Frederick II of the Holy Roman Empire, and Louis IX, King of France from 1226 to 1270.

The decline of feudal aristocracy and the rise of urban middle classes began in the fourteenth century. It was also the time of the initial separation of church and state, and between religion and science. Political dissension in the Church resulted in two, sometimes three, claimants to the papacy. It was the century of the Great Plague (1348–1350), and the beginning of the Hundred Years' War (1337–1453). As a result, the population of Europe was significantly smaller at the end of the century than at the beginning. Giotto, a Florentine painter, was the most famous artist of the period, partly resulting from personalization of his subject and the development of perspective. Significant literary activity reflected the thought and spirit of the period in the works of Petrarch, Dante, Boccaccio, and Chaucer, who with others developed the novel and vernacular epics. Above all was a pervading sense of humanism, after centuries of domination by the Church.

4

Gregorian Chant

Gregorian chant, variously referred to as plainsong or plainchant, was the principal religious music of the Roman Catholic Church for approximately its first thousand years. It constitutes the largest and oldest single body of Christian music. Gregorian chant is important because it was the source of religious polyphony in the Middle Ages and Renaissance.

HISTORY

Early Christian chant was borrowed from three especially important areas. (1) Byzantium (later Constantinople, now Istanbul) contributed a wealth of *hymns* (songs of praise not taken from biblical scripture). (2) Syria, a part of the Roman Empire near Palestine, and the scene of significant religious activity, developed antiphonal and responsorial singing. (3) Palestine was probably the most direct influence on early Christian chant through its extensive body of Hebrew chant.

Branches of Chant

During the first millennium of Christianity chant developed into five discrete styles. (1) Byzantine chant, which continued to influence all plainsong, ultimately became the chant of the Greek Orthodox Church. (2) Ambrosian chant, named for Ambrose, a fourth–century bishop of Milan, is noted for its hymns and antiphonal singing. (3) Gallican chant was used by the Franks until the time of Charlemagne in the eighth century. (4) Mozarabic chant, which was used in Spain, was influenced by the Moors who invaded the Iberian Peninsula in the eighth century. (5) Gregorian chant, a term often used for all chant types, is named for Gregory the Great, a sixth–century pope who was largely responsible for organizing existing

chant into a unified body. Ultimately, Gregorian chant came to dominate all Western plainsong as Rome became the center of Western Christianity.

MUSICAL CHARACTERISTICS

Gregorian chant (1) is monophonic; (2) is *modal* (based on the church modes); (3) was normally sung *a cappella* (without instrumental accompaniment); (4) is *nonmetric* (does not employ time signatures or bar lines); (5) uses free and flexible prose rhythms; (6) is melodically *conjunct* (stepwise progression with few skips); (7) has a limited *range* (from the highest to the lowest notes of the melody); (8) was sung in Latin (now often in translation); (9) and was written in a special *neumatic notation*. (See Example 14.3 for an example of Gregorian chant.)

The Church Modes

Plainchant theory evolved during the early Middle Ages partly as a result of the attention then being given to the writings of the ancient Greeks. This theoretical system, like Greek music, is based on a system of modes. The eight church modes are divided into two classes: *authentic* and *plagal* modes.

Authentic Modes

The *authentic modes* have an *ambitus* (melodic range) from the *final* (the final tone of a plainsong melody) to about an octave above it. The four authentic modes have Greek names: *Dorian*, with a final D; *Phrygian*, with a final E; *Lydian*, with a final F; and *Mixolydian*, with a final G.

Plagal Modes

The *plagal modes* have the same ambitus as the authentic modes, but they range from approximately a fourth below to a fifth above the final. The four plagal modes have the same finals as the corresponding authentic modes and contain the prefix "hypo": *Hypodorian*, with a final D; *Hypophrygian*, with a final E; *Hypolydian*, with a final F; and *Hypomixolydian*, with a final G.

Mode Number

The eight church modes are conventionally numbered so that the authentic modes are the odd–numbered modes and the plagal modes are the even–numbered modes: (1) Dorian, (2) Hypodorian, (3) Phrygian, (4) Hypophrygian, (5) Lydian, (6) Hypolydian, (7) Mixolydian, and (8) Hypomixolydian.

Other Modes

Four additional modes are occasionally found in Gregorian chant. These are the *Aeolian* and *Hypoaeolian* modes, with a final A (the same as the natural minor mode), and the *Ionian* and *Hypoionian* modes, with a final C (the same as the major mode). Although not recognized by the Church until the sixteenth century, these four modes existed as a result of *musica ficta* (accidentals, or altered notes). For example, the use of the note B ♭ in the first and second modes would produce the natural d minor mode, and the same note used in the fifth and sixth modes would produce the F Major mode.

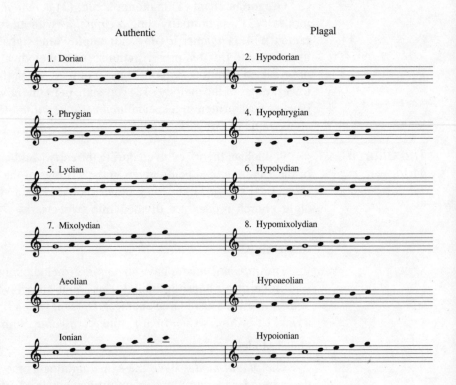

Example 4.1. The Church Modes

Mixed Modes

It is not unusual to find the plagal and authentic forms of a mode used in the same chant. This allows a useful range from several notes below the final to an octave or more above it.

FUNCTIONS AND TYPES OF CHANT

Gregorian chant's primary responsibility is to enhance the meaning of the church liturgy. *Text setting*, the relationship between the chant melody and the text, is divided into four categories: (1) *syllabic*, in which one note of the melody is set to one syllable of the text—typical of hymns and sequences; (2) *neumatic*, in which a few notes of melody are set to one syllable of text—the most common style; (3) *melismatic*, where many melodic notes are set to one syllable of text—used commonly in settings of the Alleluia; and (4) *psalmodic*, in which there are numerous syllables on one repeated note—used in settings of the Psalms. It should be noted that a chant may shift from one style of text setting to another, but usually one style predominates.

The Roman Catholic Liturgy

Because of its close association with developments in Western music, the basic organization of the Catholic liturgy should be understood. It consists of two main divisions: the *Divine Offices* and the *Mass*.

The Divine Offices

The eight services celebrated at certain times of the day are called *Divine Offices*, or *Canonical Hours*. They are Matins, Lauds, Prime, Terce, Sext, Nones, Vespers, and Compline. The most important Offices employing music are Matins, Lauds, and Vespers.

The Mass

The Roman Mass is divided into two main parts: the *Proper* of the Mass and the *Ordinary* of the Mass. The Proper contains the variable portions of the mass, which are liturgical texts unique to the feasts of the church year being celebrated. The Proper includes six sections that use music. These are the *Introit, Gradual, Alleluia, Tract, Offertory*, and *Communion*. The Ordinary, which contains the five invariable portions of the mass, includes the *Kyrie, Gloria, Credo, Sanctus*, and *Agnus Dei*. Musical compositions entitled "Mass" are usually settings of the Ordinary because these liturgical texts can be sung at any mass throughout the church year. Such works include Palestrina's *Missa Brevis* and J. S. Bach's *Mass in B Minor*.

Requiem Mass

The *Requiem Mass* (also called *Missa pro Defunctis* [Mass for the Dead]) is a special funeral mass that includes sections from the Ordinary (Kyrie, Sanctus, Agnus Dei) and the Proper (Introit, Offertory, and Communion).

Tropes and Sequences

From the ninth to the twelfth centuries two new forms of liturgical chant were created: *tropes* and *sequences*.

Trope

A *trope* is a phrase of text inserted syllabically into the melodic line of a chant. The text was either fitted to preexistent notes in a melismatic passage, or else a new melody was composed to the interpolated text. Example 4.2 illustrates the form of a trope. The words "Christe eleison" ("Christ have mercy upon us") are the original words of the plainsong. The words (presented here in italics) "*Dei forma virtus patrisque sophia*" ("form, strength, and wisdom of God the Father") is the inserted trope, set syllabically to the originally melismatic passage of the chant. Note also that this characteristic example of a notated chant is monophonic, modal (Dorian), sung *a cappella* (without instrumental accompaniment), nonmetric, and that it exhibits free rhythm, a narrow ambitus (a perfect fifth), conjunct progression, and is in Latin.

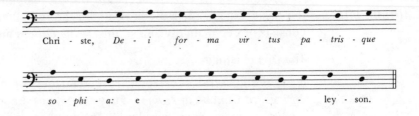

Example 4.2. The Form of a Trope

The most famous composer of tropes was Tuotilo (d. 915), a monk who resided at the Swiss Abbey of St. Gall.

Sequence

A special kind of trope called a *sequence* was created by adding texts syllabically to joyous, melismatic passages associated with the Alleluia. The sequence had an indefinite number of sections beginning with a single line of text and melody, then a series of pairs of text lines with the same melody, and concluded with a single line of text and melody. Thus, the sequence form can be represented by the formula *a bb cc dd . . . n*. Sequences were later separated from the Alleluia, and became autonomous sections of the liturgy. Probably the most famous example of this is the thirteenth–century sequence, the *Dies Irae*, which is one of the sections of the Proper of the Requiem Mass.

Notker Balbulus (ca. 840–912), a contemporary of Tuotilo at St. Gall, is the earliest known composer of sequences. Other composers were Adam of St. Victor (twelfth century), St. Thomas Aquinas (1225–1274), and Jacopo da Todi (thirteenth century).

**Scores and
Recordings**

Mass for Septuagesimi Sunday: NAWM 3
Office of Second Vespers, Nativity of Our Lord: NAWM 4
Gradual: NSI 1
Trope: NAWM 6
Sequence: NAWM 5

5

Secular Song

Secular song undoubtedly played an important role in medieval society, but relatively little of it has been preserved. Extant historical evidence suggests secular song and poetic creativity flourished mainly in France and Germany during the Middle Ages.

MUSICAL CHARACTERISTICS

Secular song was stylistically more diversified than Gregorian chant, and it had several distinguishing traits. (1) Like chant, it was notated monophonically. Although pictorial evidence suggests that secular songs may have been performed with some kind of improvised instrumental accompaniment, the manuscripts contain only single–line notation. (2) Unlike chant, it was metrical and mostly in triple meter. (3) It had stronger and more regular rhythms and employed recurrent short rhythmic patterns. (4) It had clear phrase and sectional structures with repeated sections and refrains. (5) Secular song generally employed the traditional church modes, but it also used extensively the major (Ionian) and minor (Aeolian) modes. (6) It was generally syllabic. (7) It was mostly in vernacular languages, unlike the Latin of Gregorian chant. (8) Secular songs dealt with a wider range of subjects than plainsong.

Performers Minstrels of a low social order were called *jongleurs* in France, *Gaukler* in Germany, and *gleemen* in England. They roamed Europe in the Middle Ages, entertaining the feudal courts with juggling, card tricks, trained animals, and songs composed by others. Although neither poets nor composers,

they were important musically because they kept alive and disseminated the large body of secular song literature.

FRENCH SECULAR SONG

The largest body of medieval secular song came from two classes of French poet–composers: *troubadours* and *trouvères*, both terms meaning "finders." They were educated and cultured noblemen, mostly residents in the feudal courts.

Poetic Types

Troubadour and trouvère poetry is classified according to the following subject categories: (1) *canso*, a love poem; (2) *sirventes*, a satirical poem; (3) *planh*, a plaint or lament on the death of an eminent person; (4) *pastourelle*, a song, often in dialogue form, between a knight and shepherdess; (5) *chanson de toile*, a spinning song; (6) *enueg*, a satirical poem; (7) *aube*, the song of a friend watching over lovers until dawn; (8) *tenso* or *jeu–parti*, a poem in dialogue; and (9) *chanson de geste*, an epic chronicle, the most famous of which is the eleventh–century *Chanson de Roland*.

Genres and Forms

The lines of distinction among the numerous song forms are less clearly defined than those among the poetic types, and there is considerable diversity of structure within each type. Recurrent sections of text and melody, called *refrains*, were common to several forms. One of these, which carried over into later polyphonic music, was the *virelai*, constructed according to this formula:

```
phrase    1  2  3  4  5
text      a  b  c  d  a
melody    A  b  b  a  A
```
(Capital letters indicate the refrain.)

Another popular form was the *rondeau*, with the following sectional plan:

```
phrase    1  2  3  4  5  6  7  8
text      a  b  c  a  d  e  a  b
melody    A  B  a  A  a  b  A  B
```

The *ballade* employed several different structures but was similar to the virelai and rondeau in the use of refrains.

Troubadours

The troubadours flourished in Provence in southern France from the end of the eleventh to the end of the thirteenth centuries. Approximately 2,600

poems and some 260 melodies have been preserved. Some important troubadours were Marcabru of Gascony (ca. 1100–ca. 1150), Bernart de Ventadorn (ca. 1130–ca. 1200), Giraut de Bornelh (ca. 1140–ca. 1200), Guiraut Riquier (ca. 1230–ca. 1300), and Bertran de Born (ca. 1145–ca. 1215).

Trouvères

The trouvères flourished in northern France slightly later than the troubadours. Of their poems, 2,130 are extant, and 1,420 of them have been preserved with melodies. Some important trouvères were Conon de Béthune (ca. 1160–1220), Blondel de Nesle (fl. 1180–1200), King Thibaut IV of Navarre (1201–1253), and Adam de la Halle (ca. 1245–ca. 1288 or ca. 1306), the last and most famous trouvère, who wrote a medieval play with music entitled *Jeu de Robin et de Marion*.

GERMAN SECULAR SONG

French troubadour and trouvère songs were the models for German poet–composers, *minnesingers* and *meistersingers*, from the twelfth to the sixteenth centuries.

Minnesingers

The minnesingers ("love singers"), who flourished from the twelfth to the fourteenth centuries, produced a literature of German poetry and song (*Minnelied*) dealing with a variety of subjects, including those of a quasi–religious nature. Minnelieder were usually in duple meter. The most typical form was a structure in three melodic sections, *AAB* (called *bar form*), in which a melodic phrase (*Stollen*) was sung, then repeated with a different line of text, and this was followed by a different melodic phrase (*Abgesang*). The principal minnesingers were Walther von der Vogelweide (ca. 1170–ca. 1230), Neidhart von Reuental (ca. 1180–ca. 1237), Heinrich von Meissen (nicknamed "Frauenlob"; ca. 1250–1318), Wizlav von Rügen (ca. 1265–1325), and Heinrich von Morungen (d. 1222).

Meistersingers

The successors to the minnesingers were the meistersingers (master singers), who flourished in the fifteenth and sixteenth centuries and who were members of middle–class guilds rather than the aristocracy. Their music, called *Meistergesang*, was created according to strict rules. Bar form was the standard structure. Among the principal meistersingers were Konrad Nachtigall (ca. 1410–ca. 1484), Adam Puschmann (1532–1600), and Hans Sachs (1494–1576), the most famous of all, who was immortalized in Richard Wagner's *Die Meistersinger von Nürnberg* (1862–1867).

OTHER COUNTRIES

The development of secular song was negligible outside France and Germany. In England, the Anglo–Saxon classes of *scops* (resident minstrels) and *gleemen* (traveling minstrels) produced a limited song literature, little of which has been preserved. In Italy the nonliturgical religious *lauda*, a song of praise to the Virgin, was composed in the Italian *ballata* form, which corresponds to the French *virelai* (*AbbaA*). In Spain a similar form, the *cantiga*, also extolled the Virgin and employed the same sectional structure, which in Spain was called *villancico*.

LATIN SECULAR SONGS

A sizable literature of Latin songs, called *conductus*, was created from the tenth to the early thirteenth centuries by vagrant students and minor clerics called *goliards*. Conductus dealt with a variety of subjects: love, drinking, political satire, ribald themes, and humorous paraphrases of Gregorian chant. A famous conductus is *The Song of the Sibyl* from the early Middle Ages.

Scores and Recordings

Troubadour song: NAWM 7

Trouvère song: NAWM 9; NSI 4

Minnelied: NAWM 10

Meistergesang (by Hans Sachs): NAWM 11

Lauda: HAM 21

Cantiga: HAM 22

English song: HAM 23

6

Early Polyphony

Probably the greatest single development in the entire history of Western music was the advent of polyphony toward the end of the first millennium of the Christian Era. It is not known when part singing began. A prototype was surely the practice of heterophony, common to many ancient and folk cultures. It is generally believed that different parts singing the same melody in octaves, in thirds (called gymel *or* cantus gemellus *["twin song"]), and perhaps in other intervals (most likely fourths and fifths) was practiced in secular song before it was known in church music. The earliest reference to part singing is from the eighth century. The known developments in polyphony from the ninth through the thirteenth centuries took place in church music and were based on Gregorian chant.*

ORGANUM

The term *organum* (plural *organa*) is used in various stages of polyphony from its beginning to about the middle of the thirteenth century.

Parallel Organum

The earliest form of polyphony, first clearly described in the late ninth century, consisted of two voices moving in parallel motion. A Gregorian chant melody, called *vox principalis*, was doubled a fourth below by a second voice, called *vox organalis*. Either or both voices could also be doubled at the octave to create three–or four–part music.

At about the same time, a slightly different form of two–part organum was described. In this the voices begin on a unison, then, while the vox organalis remained at a stationary pitch level, the vox principalis moved upward until the interval of a fourth was reached, after which the parts

proceeded in parallel motion. At a cadence they converged again toward the unison.

Rex coe - li Do - mi - ne ma - ris un - di - so - ni

Example 6.1. Parallel Organum

This practice suggested the possibility of melodic independence in part writing and led to the next stage in development.

Free Organum

In the eleventh century, strict parallel organum was replaced by free organum in which oblique and contrary motion between the voices was added to parallel motion, giving the two parts melodic independence. The intervals were predominantly fourths, fifths, and octaves. The organal voice was added above the tenor. During this time, the chant came to be called the *tenor* (Latin, *tenere*, to hold). The two parts, moving in note–against–note style, still lacked rhythmic independence.

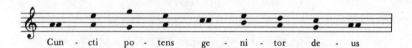

Cun - cti po - tens ge - ni - tor de - us

Example 6.2. Free Organum

The Latin expression describing this music, *punctus contra punctum* (note against note), was the origin of the term *counterpoint*.

Melismatic Organum

In the early twelfth century a new type emerged. It is referred to variously as melismatic organum, *florid organum*, *St. Martial organum*, or *organum purum*. A plainsong was assigned to one voice (the tenor) in long sustained notes, to which was added a higher voice in faster–moving note values.

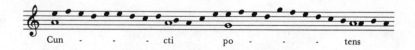

Cun - - - cti po - - - tens

Example 6.3. Melismatic Organum

At this stage, polyphonic music thus achieved both melodic and rhythmic independence.

SOURCES

Theoretical Writings

Among a number of treatises dealing with practices of organum, the most important are (1) an early reference to part singing by Bishop Aldhelm (ca. 640–709); (2) an anonymous treatise entitled *Musica Enchiriadis* (ca. 900) and (3) a commentary on it entitled *Scholia Enchiriadis*, which together constitute the first clear description of organum; (4) *Enchiridion Musices* by Odo de Cluny (ca. 878–942), a theoretical treatise in the first half of the tenth century; (5) the most important writings of Guido d'Arezzo (ca. 991–ca. 1033) in the first half of the eleventh century; and (6) the writings of the so–called John Cotton (eleventh to twelfth century), who describes the contrapuntal techniques attained by the early twelfth century.

Manuscripts

The most important manuscripts are the *Winchester Troper* (eleventh century), which contains tropes in organum, and the manuscripts of *St. Martial* (Limoges, France) and *Santiago di Compostela* (northwestern Spain), which contain melismatic organa of the early twelfth century.

Scores and Recordings

Parallel organum: NAWM 13

Free organum: NAWM 14; HAM 26

Melismatic organum: NSI 2; HAM 27

7

Ars Antiqua

The century and a half from approximately the middle of the twelfth to the end of the thirteenth centuries is commonly known as the Ars Antiqua (the Old Art), as it was referred to by musicians in the fourteenth century. It was an era of further significant developments in polyphony.

MUSICAL CHARACTERISTICS

The geographical center of music was Paris. The names of the first truly important composers became prominent. Polyphony continued to develop mainly under the auspices of the Church, but independent secular forms of polyphony appeared as well.

Polyphony

Polyphony involved mainly three parts (or "voices"), though two–part writing continued and four–part writing was introduced. All voices were generally in the same *register* (range) so crossing of parts was characteristic. *Imitation*, in which a part or parts copied another part's melody, was rare and incidental. A greater degree of rhythmic and melodic independence among parts was evident. *Cantus firmi* ("firm melodies," usually borrowed or derived from Gregorian chant), continued to be the principal basis of construction.

Meter

Triple division of notes, called *tempus perfectum*, dominated secular monophonic and polyphonic forms. This resulted in metric schemes equivalent to $\frac{3}{4}$, $\frac{6}{8}$, or $\frac{9}{8}$ time when transcribed into modern notation.

Rhythmic Modes

Rhythmic modes determined the rhythmic patterns of music. The medieval rhythmic modes consist of six patterns of long (−) and short (∪) units. According to theorists of the Middle Ages, these modes, labeled with Greek names, corresponded to patterns of three or six beats.

1. Trochaeus − ∪
2. Iambus ∪ −
3. Dactylus − ∪ ∪
4. Anapaest ∪ ∪ −
5. Spondeus — —
6. Tribrachys ∪ ∪ ∪

Example 7.1. The Rhythmic Modes

In actual practice only the first three modes were commonly used. There was some flexibility in the use of modes, for the patterns did not remain rigidly the same, and even the mode itself sometimes changed during the course of a melodic line.

Harmony

All harmonic intervals were employed. Fourths, fifths, and octaves still predominated, but dissonant intervals (seconds and sevenths) became prominent and were not restricted by rules of usage as they came to be in the Renaissance.

Instruments

Although instruments were certainly employed, they were not indicated in the notated music. It is probable that parts or passages without texts were played instrumentally and that instruments sometimes doubled vocal parts.

GENRES

New genres developed in the Ars Antiqua were *Notre Dame organum*, *polyphonic conductus*, *motet*, *hocket*, *rota*, and *rondellus*.

Notre Dame Organum

Organum, as developed in the Notre Dame School in Paris in the second half of the twelfth century, evolved from St. Martial (melismatic) organum. It consisted of sections in melismatic style with both parts sung by solo voices, alternating with sections of Gregorian chant sung by a choir. The

new feature of this organum was the appearance of sections in *discant style* in which the tenor was in shorter notes. Such a section was called a *clausula* (plural *clausulae*). Clausulae generally corresponded to the parts of Gregorian chant that were themselves melismatic. From the beginning of the thirteenth century, the melismatic sections of organa were gradually replaced by ones in discant style. Organa were composed in two–part textures (*organum duplum*), three–part textures (*organum triplum*), and four–part textures (*organum quadruplum*). Correspondingly, the second part was called the organum duplum, the third the organum triplum, and the fourth the organum quadruplum. Example 7.2 illustrates a fragment of organum duplum followed by the beginning of a clausula section on the syllable "Do" of "Domino."

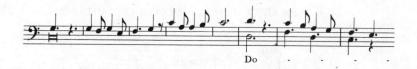

Example 7.2. Organum Duplum and Clausula

Polyphonic Conductus

Polyphonic conductus, not to be confused with the earlier monophonic conductus, flourished principally in the first half of the thirteenth century. Unlike organum, the parts moved together in similar rhythm, and the tenor part was composed rather than borrowed from Gregorian chant. Although sacred, the texts were nonliturgical and set mostly in syllabic style.

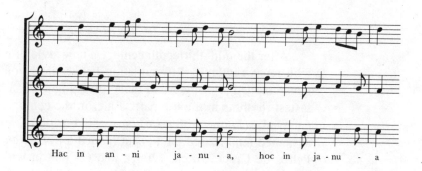

Example 7.3. Polyphonic Conductus

Polyphonic conducti were composed in two, three, and four parts. Conductus style was also employed in secular forms such as ballades and rondeaux.

Motet

During the second half of the thirteenth century, the motet became the principal polyphonic form, gradually replacing organum and conductus. It originated in the process of adding words—the French *mot* means "word"—to the duplum (upper) part of a clausula. This part was also called the *motetus*, a term that came to be applied to the entire composition. The thirteenth–century motet was constructed according to the following steps: (1) a Gregorian chant was selected for the tenor (lowest) part; (2) it was modified according to one of the rhythmic modes; and (3) above it were added two parts (motetus and triplum) in faster–moving notes. These parts carried different texts, religious or secular or both, in Latin or the vernacular. Since the tenor part carried no text other than the first word or words (called the *incipit*) of the chant melody, it was probably played on an instrument. As in other medieval polyphony, tempus perfectum was a typical feature, as were also the occasional clashes of dissonant intervals.

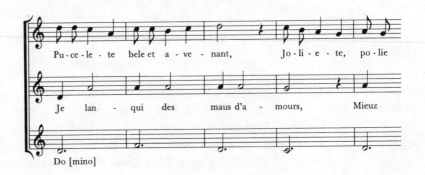

Example 7.4. Thirteenth–Century Motet Style

After the mid–thirteenth century a new style of motet came into being, with more rhythmic differentiation between all voices. The *Franconian motet*, named after theorist Franco of Cologne (fl. 1250–1280), placed the fastest rhythms in the top part. Later in the century, two new motet types emerged: (1) one with a fast, speechlike triplum, a slower duplum, and a sustained tenor based on a chant (called a *Petronian motet* after composer Petrus de Cruce [fl. ca. 1290]); and (2) one in which all parts moved at more–or–less the same speed, with a secular tenor melody.

Hocket

Hocket (also *hoquet* or *hoketus*, meaning "hiccup") was a device commonly found in late thirteenth– and fourteenth–century polyphony. A melodic line was frequently interrupted by rests that alternated between two voice parts.

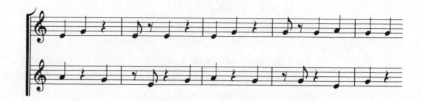

Example 7.5. Hocket

Although hocket appears in virtually all music of the Middle Ages, a composition that used the device extensively was called a hocket.

Rota

The rota is a *canon* or *round* in which two or more parts carry the same melody at different times—a form of imitation. Isolated examples of rota appear in the Ars Antiqua. The most famous rota is "Summer is icumen in," which probably dates from about 1250.

Rondellus

The rondellus (not the same as rondeau) was a secular form, usually in three parts, employing the principle of *exchange* (also, *Stimmtausch*) in which three different melodies (*a*, *b*, and *c*) were exchanged among the parts according to a rotational plan, such as the following:

triplum *a* *b* *c*
duplum *b* *c* *a*
tenor *c* *a* *b*

The parts begin together, rather than consecutively as in the rota.

COMPOSERS

Notre Dame composers Léonin (or Leoninus; ca. 1159–ca. 1201) and Pérotin (or Perotinus; ca. 1170–ca. 1236) composed organa, polyphonic conducti, and motets. Franco of Cologne, author of a late thirteenth–century treatise on notation, was also an important composer of motets. Petrus de Cruce (or Pierre de la Croix) composed motets in the late thirteenth century.

MANUSCRIPTS

Léonin's *Magnus Liber Organi* is a collection of two–part melismatic organa for the entire church year. The most important manuscript is the *Montpellier Codex*, which contains medieval compositions, mostly motets. Other manuscript collections are the *Bamberg Codex*, containing 108 three–part motets and *Las Huelgas Codex*, containing organa, conducti, and some 58 motets.

Scores and Recordings

Léonin, Organum duplum: NAWM 16b

Polyphonic conductus: NAWM 16c; NAWM 18

Clausula: NAWM 16d

Motet: NAWM 16e, 16f, 16g; NSI 3

Pérotin, Organum quadruplum: NAWM 17

Franconian motet: NAWM 20

Petronian motet: NAWM 19

8

The Fourteenth Century

Musical leadership in the fourteenth century was shared by France, where the period is commonly called the Ars Nova, and by Italy, where it is called the Trecento. Important characteristics were held in common. (1) Far more secular than sacred music was composed. (2) Tempus imperfectum (duple division of notes) was used more often than tempus perfectum. (3) The rhythmic modes were abandoned in favor of more complex and diversified rhythms. (4) Cantus firmus was used less often; more music was freshly composed without any borrowed material. (5) Melodic and rhythmic interest tended to center in the top voice. (6) Harmonic thirds and sixths appeared more frequently. (7) A melodic formula, commonly known as the Landini cadence, was often used. It consists of the scale–degree pattern 7–6–1 (and is sometimes called a 7–6–1 cadence). It appears in several different forms in fourteenth– and early fifteenth–century music.

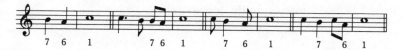

Example 8.1. Forms of the Landini Cadence

THE ARS NOVA

The Ars Nova in France was an evolutionary extension of the Ars Antiqua, unlike the Trecento in Italy. Still, forms and techniques were newly developed that characterized the Ars Nova.

Forms

The polyphonic motet continued to be written in France, but with important changes. Equally important were new polyphonic secular forms—ballade, rondeau, and virelai. These were collectively referred to as the *formes fixes*. Continuing the traditions of the trouvères, monophonic songs were also composed.

Isorhythmic Motet

The most important fourteenth–century form still based on the cantus firmus was the *isorhythmic* ("same rhythm") *motet*, which evolved from a melding of the thirteenth–century motet and certain compositional techniques imported from the Indian subcontinent. In a typical isorhythmic motet, (1) a chant (or part of a chant) is selected for the tenor; (2) the chant melody constitutes the *color*; (3) the color is repeated until the end of the piece; (4) the rhythmic pattern, called *talea*, is composed; (5) it is of much more extended length than the old rhythmic modes and of a length different from the color; (5) it, too, is repeated, but since its ending does not coincide with the ending of the color, a new relationship of talea and color results; (6) the upper parts are free to use the isorhythmic principle (but based on a newly composed cantus firmus), or not; (7) the isorhythmic motet continues the practice of using different texts in the upper parts and passages of hocket.

Ballade

The *ballade* consisted of several four–line stanzas, each with the same music. The first two lines were sung to the same music, the third to a new melody, and the fourth, the refrain, to yet another. The sectional formula is thus *aabC*, in which the uppercase letter refers to the music of the text refrain. Ballades were mostly three–part compositions with melodic and rhythmic interest in the top voice.

Rondeau

The polyphonic *rondeau*, not to be confused with the rondellus, derived from the monophonic trouvère form and followed the same formula (*ABaAabAB*). It could be in two, three, or four parts, but was most commonly in three parts, with a solo vocal line and two lower instrumental parts in slower–moving rhythms.

Virelai

The *virelai*, also called *chanson balladée* in the fourteenth century, was, like the rondeau, derived from the monophonic trouvère form, but with the sectional plan *AbbaA* for each stanza of the poem. Most chansons balladées were monophonic, but many polyphonic compositions were also written in this form.

Composers

The leading composer of the French Ars Nova was Guillaume de Machaut (ca. 1300–1377), who was also an eminent poet. His compositions

include all the French forms of the time, and, typically, he wrote more secular than sacred music. However, his longest and most celebrated composition is the *Messe de Notre Dame*, one of the first complete polyphonic settings of the Ordinary. In four–part texture, it employs the isorhythmic principle in all but the Gloria and Credo.

Philippe de Vitry (1291–1361), also a poet–composer, is known primarily for his treatise on notation, entitled *Ars Nova* (ca. 1325), from which the entire fourteenth–century musical practice in France took its name.

Compositions

In addition to the Machaut *Mass*, other important works of the period are (1) the *Roman de Fauvel*, a satirical poem that contains 130 interpolated compositions of various types including some isorhythmic motets; (2) the *Mass of Tournai* (ca. 1300), containing a complete setting of the Ordinary, but whose sections were probably composed at different times by different composers; (3) *Ars Novae Musicae*, a treatise by Jehan des Murs (ca. 1300–ca. 1350); and (4) another treatise, *Speculum Musicae* (*Mirror of Music*), by Jacques de Liège (ca. 1260–ca. 1330), which argued in favor of the "old art," against the Ars Nova.

THE TRECENTO

Italian polyphonic music came prominently into the picture for the first time. The principal distinguishing features were that (1) it did not usually employ cantus firmus technique; (2) it was rhythmically less complex than French music; (3) it employed simpler textures; and (4) it introduced a characteristic florid vocal style.

Forms

Three secular forms dominated the Italian Trecento: madrigal, caccia, and ballata.

Madrigal

The earliest Italian polyphonic form was the *madrigal*, usually in two vocal parts. Each stanza, in duple time, concluded with a *ritornello* section in triple meter. The texts were idyllic, pastoral, amatory, or satirical.

Caccia

The caccia ("chase" or "hunt"), which flourished from about 1345 to 1370, was the first musical form to exploit the principle of canon based on continuous imitation between two or more parts. Two upper parts were sung

in strict imitation at the unison and with a long time–interval between the first and second parts. The third and lowest part was freely composed in slow–moving notes and was probably played on an instrument. Caccias usually had a canonic ritornello section at the end. Texts typically described a hunt or some other outdoor activity.

Ballata

The *ballata* (not to be confused with the French ballade) originated as a dance song, and it developed somewhat later than the madrigal and caccia. Its sectional structure resembled the French virelai, with a refrain called *ripresa* sung at the beginning and end of each stanza (*AbbaA*).

Composers

The principal composer of the Trecento was Francesco Landini (or Landino, ca. 1325–1397). He was a blind organist in Florence who composed over 140 two– and three–part ballate, some ten madrigals, and one caccia. Other composers were Jacopo da Bologna (fl. 1340–1360), Gherardello da Firenze (ca. 1320–ca. 1362), and Giovanni da Cascia (also known as Johannes de Florentia; fl. 1340–1350). Johannes Ciconia (ca. 1335–1411) was French but settled in Italy, where he wrote some of the liveliest music of the period, combining features of both national styles.

Documents and Manuscripts

The *Pomerian* by Marchetto of Padua is an early fourteenth–century treatise that first established the acceptance of tempus imperfectum. The most important manuscript collection is the *Squarcialupi Codex*, which contains some 350 compositions, mostly two– and three–part pieces representing twelve fourteenth– and fifteenth–century composers.

Scores and Recordings

Ars Nova

Isorhythmic motet (de Vitry): NAWM 21

Isorhythmic motet (Machaut): NSI 5

Ballade (Machaut): NAWM 24

Machaut Mass (Agnus Dei): NAWM 25

Rondeau: NAWM 26

Virelai: HAM 46

Trecento

Ballata (Landini): NAWM 23

Madrigal (Jacopo da Bologna): NAWM 22

Caccia: HAM 52

9

Instruments and Dances

Pictorial and literary sources establish that instruments were widely used in the Middle Ages. However, little purely instrumental music has been preserved in notation and there are no composers of instrumental music known to us by name.

INSTRUMENTS OF THE MIDDLE AGES

There were many medieval instruments. Only the principal kinds are listed here.

Bowed Instruments

The most important bowed string instruments were *vielles*, the ancestors of the Renaissance viol family. The *rebec* was a pear–shaped instrument. The *tromba marina* of the later Middle Ages was a long, single–string instrument, or it had two strings tuned in unison.

Plucked Instruments

The most important instrument in this class was the *lute*, which had a pear–shaped body and an angled neck. The *psaltery*, an instrument of the zither family, had a flat sounding–board.

Wind Instruments

End–blown flutes were called *recorders*. The *shawm* was a double–reed instrument, an early ancestor of the oboe. Various types of horns and trumpets were also in common use.

Organs

A small portable organ was called a *portative organ*, or *organetto*. A medium–sized, nonportable organ was the *positive organ*, important because it was probably the first organ for which polyphonic music was composed.

In the fourteenth century, still larger organs (up to twenty–five hundred or more pipes) were built for churches in Europe. The earliest organ music preserved in notation is in the *Robertsbridge Codex* (ca. 1325).

*Other
Keyboard
Instruments*

Keyboard instruments of the harpsichord and clavichord types were not in general use until the fifteenth century.

*Percussion
Instruments*

Drums of various sizes and shapes were used mostly for dance music and military purposes. Kettledrums used in pairs were called *nakers*. The principal cylindrical drum was the *tabor*. Various kinds of cymbals and bells were also employed.

USES OF INSTRUMENTS

Whether a composition was to be performed wholly or partly by instruments was never indicated in a manuscript, nor were specific instruments named. Medieval practice can be described by the five ways in which instruments were probably used. (1) Textless parts in polyphonic music were likely intended to be played by instruments as, for example, in thirteenth–century motets and fourteenth–century caccias and ballate. (2) Instruments were used to double one or more vocal parts. (3) They may have been substituted for voices in one or more parts with texts. (4) Vocal polyphony was occasionally played entirely by instruments. (5) Music clearly intended for instrumental performance was mainly dance music and a few instrumental motets and conducti.

DANCE FORMS OF THE MIDDLE AGES

Almost all of the relatively few dances preserved are notated monophonically. Folk and court dance music was mostly improvised or played from memory. The *estampie* (also *estampida, istanpitta, stampita*) was the principal thirteenth–century dance form, usually in triple time, and with repeated

sections corresponding to repeated dance patterns. Other dances were the *danse royale* and the fourteenth–century Italian *saltarello*. A dance in three or four sections was called *ductia*. A concluding section of a dance piece, with change of meter, was variously called *rotta*, *rotte*, or *rota*—terms that were also used to designate a canonic form and an instrument.

Scores and Recordings

Estampie: NAWM, 12; HAM 40

Danse Royale: HAM 40a and 40b

Ductia: HAM 41a and 41b

Saltarello: NSI 6; HAM 59b

Organ estampie: HAM 58

PART THREE

THE RENAISSANCE

(1400–1600)

10

Introduction to the Renaissance

1417	Single papacy restored to Rome
1450	Gutenberg perfects printing from movable type
1453	End of Hundred Years' War
1475	Tinctoris's *Terminorum Musicae Diffinitorium*
1477	Demise of the duchies of Burgundy
1492	Columbus's voyage to the West Indies
1496	*Practica musice* by Franchinus Gaffurius
1497	Death of Ockeghem and Josquin's composition of "Déploration sur le trépas de Jean Ockeghem"
1501	Petrucci first prints polyphonic music (*Harmonice musices odhecaton A*)
1503	Josquin commands high salary as maestro di cappella at Ferrara
1508	*Intabulatura di lauto* by Joan Ambrosio
1511	Sebastian Virdung's *Musica getutscht und ausgezogen* (*A Summary of Music in Germany*)
1517	Martin Luther's Ninety–Five Theses nailed to the Wittenberg Cathedral door
1524	First publication of Lutheran chorales
1536	Luis de Milán: *Libro de musica de vihuela de mano intitulado El Maestro*
1539	Arcadelt's first book of madrigals published
1545–1563	Council of Trent
ca. 1549	First publication of Sternhold and Hopkins's *Psalter*
1558	Gioseffo Zarlino's *Le Istituzioni harmoniche* (*The Art of Counterpoint*)

After a century in which the supreme authority of the Church was undermined by political intrigue, petty jealousies, and cataclysmic disasters, the fifteenth century sought to build a stable world upon human achievement. The scholars and writers of the period spoke of a philosophy of humanism, which elevated the rank of the individual. They sought to learn more about the culture of ancient Greece, where reason and free inquiry, not just faith, had prevailed. They also pondered the emotional power of music manifested in Plato's doctrine of ethos, turned to their music, and believed it by comparison to be cold and unnecessarily intricate. Efforts to rekindle music's power over human emotions led to a period of sensuous, deeply felt music making. A paradox was implicit in this movement, though, for on the one hand the subject matter of this mostly vocal music was generally religious, while on the other it celebrated the human ability to create. The Renaissance was an era of two worlds—the sacred and the secular—that came to complement each other: the shining individual in a bright world created by God.

This creative paradox was evident even in the patronage system that supported musicians and music making. After the dissolution of papal authority in the fourteenth century, the courts filled the void and hired the musicians who were expected to provide music both for both religious edification and courtly entertainment. A result of courtly patronage was that the most sought-after composers, who were from the Franco–Flemish area, spread all over Europe and produced something like an international musical style. Only toward the end of the period was it possible to identify musics with distinct regional and national characteristics.

Franco–Flemish composers continued the development of large-scale vocal music structures, primarily the mass. This was achieved by balancing sections of imitative counterpoint and homophony within a cantus firmus framework. The technique of imitative counterpoint may be the single most important development of the period. The resulting texture, more than any other musical quality, characterizes the music of the Renaissance. Homophony, designed initially to contrast and complement imitative counterpoint, received its fullest development after the Renaissance. Early– and middle–Renaissance compositions are tightly knit, with no musical gesture out of

place. What might seem initially calm and quiet is in fact filled with details of great sensitivity. The music is flexible, but it has tremendous potential for quiet, intensive expression. Only toward the end of the period did music incorporate distortion and highly charged emotions.

Humanist regard for scientific inquiry led to momentous technological breakthroughs and improvements. Among them was the most important invention of the period—movable type—which directly affected the dissemination of music, its audience, and its creation. With the first polyphonic music publication in 1501, notated music was suddenly widely available to those of moderate wealth—generally the enterprising bourgeois classes of the new Europe. They wanted to buy music meaningful to them, on their own terms. Hence, music became more secular. New technologies also led to improvements in instrument making. As a result, for the first time in Western music, composers wrote idiomatic instrumental music, including works for keyboard instruments. Instrumental ensembles were formed. Most importantly, instrumental music implicitly questioned the basis for almost all music making of the previous several centuries: the relationship between word and sound. As such, its development is one of the most powerful portents of the vast changes that lay ahead.

HISTORICAL CONTEXT

The fifteenth century saw medieval feudalism replaced by urban culture. Humanism became firmly established. Important historical events were the English victory at Agincourt (1415), the fall of Constantinople (1453), the close of the Hundred Years' War (1453), and Columbus's discovery of the New World (1492). The invention of movable type was ultimately to have a profound effect on the dissemination of ideas. Ghiberti, Donatello, Leonardo da Vinci, Botticelli, Van Eyck, and Raphael created great paintings, frescoes, and sculpture.

Humanism became even more firmly entrenched in the philosophy of the sixteenth century. Religiously, the period was dominated by the Protestant Reformation and the Catholic Counterreformation. Each followed from the deliberations of the Council of Trent (1545–1563). The century's political landscape was determined by a unusual number of strong–willed monarchs: Charles V and Philip II of the Holy Roman Empire, Francis I of France, and Henry VIII and Elizabeth I of England. The defeat of the Spanish Armada in 1588 shifted power toward England. It was a period of explora-

tion and included excursions by Sir Francis Drake, Sir Walter Raleigh, Cortez, Magellan, De Soto, and Balboa. Important names in Italian and Germanic art include Leonardo da Vinci in the early sixteenth century, Cellini, Michelangelo, Titian, Tintoretto, Veronese, Dürer, Grünwald, and Holbein. In science, Copernicus and Galileo are the most famous names. Literature is represented by the Dutch theologian and humanist Erasmus; by Machiavelli in Italy; Rabelais, Montaigne, and Ronsard in France; Cervantes in Spain; and Shakespeare, Spenser, and Bacon in England.

11

The Fifteenth Century

The fifteenth century witnessed the final transition from the Middle Ages to the Renaissance, an evolution reflected generally in the arts, literature, and philosophy. The centers of musical activity shifted from central France and Italy to England, northern France, and the Franco–Flemish region.

ENGLISH AND BURGUNDIAN MUSIC

English composers first developed a style that broke with medieval manners of stylistic expression. Their influence was felt by musicians at the Burgundian courts, who enjoyed the munificent patronage of the dukes Philip the Good (1396–1467) and Charles the Bold (1433–1477).

Musical Characteristics

One can make observations about the period's musical characteristics. (1) There was a preponderance of three–part composition in the early fifteenth century. (2) Melodic and rhythmic interest was characteristically in the top part. (3) Many of the compositions were essentially solo songs with textless (instrumental) parts below. (4) There was a marked trend toward a *homophonic* texture (also called *chordal style* or *familiar style*), with a topmost melody supported by chordal harmonies. (5) Melodic progression was characterized by numerous thirds (see Example 11.1). (6) Triple meter was more commonly employed than in the fourteenth century. (7) Passages of parallel sixth chords (first–inversion triads), called *discant* in England and *fauxbourdon* on the Continent, were typical, as illustrated in Example 11.2. (8) Cantus firmi were less frequently employed than in Franco–Flemish music after 1450. (9) Imitation was infrequently used. (10) The Landini cadence (7–6–1 cadence) was still quite common.

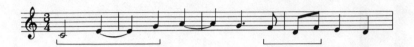

Example 11.1. Melodic Progression

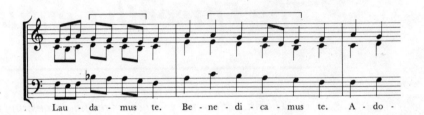

Lau - da - mus te. Be - ne - di - ca - mus te. A - do -

Example 11.2. Discant or Fauxbourdon

Genres

The genres found in the first half of the fifteenth century were essentially those of the late Middle Ages, but new styles and techniques evolved.

Mass

Polyphonic settings of the Ordinary of the mass became a standard liturgical form. Composers sometimes employed Gregorian chant tenor parts, and they also began to use secular tunes as cantus firmi.

Motet

The isorhythmic motet was still used occasionally, but it was gradually replaced by styles emphasizing the top voice, or else a homophonic texture that included fauxbourdon.

Carol

A popular fifteenth–century form in England was the two–part *carol*. It was sung to a religious poem of numerous stanzas with the same music, and a refrain called a *burden*.

Secular Polyphony

The main type of polyphonic secular music during the entire fifteenth century was the *chanson*, which was a general term referring to compositions that used secular French texts. Most chansons were like solo songs, with the principal melody in the top part. The most common sectional structure was that of the rondeau (*ABaAabAB*).

Composers

The principal English composer of the first half of the fifteenth century was John Dunstable (ca. 1390–1453). Others were Leonel Power (d. 1445),

John Cooke (fl. 1419), and Thomas Damett (ca. 1389–ca. 1436). The continental composers of the Burgundian school were Guillaume Dufay (ca. 1400–1474) and Gilles Binchois (ca. 1400–1460).

FRANCO–FLEMISH MUSIC

Although Burgundian composers continued their creative activities well past the middle of the century, the Franco–Flemish (also, Netherlands, Low Countries, or Flanders) school came to the fore in the late fifteenth century. Its techniques spread throughout Europe, establishing a style that later dominated sixteenth–century music.

Musical Characteristics

(1) Four–voice writing became more common from the middle of the century. To the tenor, heretofore the lowest part, now was added a lower part. Thus, the conventional designation of parts, from top to bottom, was *cantus* or *superius*, *altus*, *tenor*, and *bassus*. (2) There was more stylistic equality among parts, creating a balanced polyphony. (3) Imitation played a more prominent role than ever before. (4) New types of canons were created. (5) Fauxbourdon and Landini cadences disappeared. (6) Pairing of voices in alternating passages, called *duet style* or, simply, *voice pairing*, was a common procedure. (7) Alternating passages of homophony and rhythmically diversified polyphony were typical. (8) Authentic (V – I) and plagal (IV – I) cadences became more common than modal cadences. (9) Great attention was paid to representing the normal speech patterns of the text, or to accurate *declamation* of the text. (10) In general, composers of the late fifteenth and early sixteenth centuries initiated a more expressive style, which they called *musica reservata*, that was intended to reflect as powerfully as possible the nuances of text.

Genres

Franco–Flemish composers developed new techniques rather than new genres.

Canon

Canonic form, exploited in the fourteenth–century caccia but abandoned in the early fifteenth century, became important again in the late fifteenth century. In addition to canons at various pitch and time intervals, new imitative devices appeared: (1) *augmentation* (an increase of the time values of the notes in the imitating voice); (2) *diminution* (a decrease of the time values); (3) *inversion* (imitation of ascending intervals by descending inter-

vals and vice versa); (4) *retrograde motion* (backward motion of the imitating voice, called *cancrizans* or *crab canon*); (5) *mensuration canons* (the same melody carried by several voices at different rates of speed); (6) *double canons* (in four parts with two different melodies, each canonically imitated); and (7) combinations of these techniques. Canons were employed mainly in settings of the mass and in some motets.

Mass

In addition to a canonic setting of the mass, called *prolation mass*, another type was the *cantus firmus mass* or *cyclical mass*, in which the same melody was used for each successive section of the Ordinary. The cantus firmus was usually a Gregorian chant, but secular tunes were also employed, the most popular of which was "L'Homme Armé," used by composers from Dufay to the end of the sixteenth century. Masses were usually given the title of the cantus firmus (for example, *Missa L'Homme Armé* or *Missa Salve Regina*). Some masses were based on newly composed cantus firmi. Masses not based on a cantus firmus were called *Missa Sine Nomine*. Still another procedure, called *soggetto cavato*, was the derived construction of a theme from the vowels of a name or phrase.

Motet

Motets were composed for the Proper of the mass and some of the Offices. Cantus firmi were used less often in motets than in polyphonic settings of the Ordinary. Franco–Flemish motets often included sections in homophonic style, in duet style, in imitative style, and in free nonimitative counterpoint. Changes from one style to another corresponded to divisions of the text.

Secular Music

The chanson continued to be the principal type of secular music. It became less sectionalized, as it had been in the earlier rondeaux and virelais, and had a more cohesive structure. Monophonic and polyphonic secular songs, in Germany called *Lieder* (singular *Lied*), flourished from the late fifteenth century to the end of the sixteenth century.

Composers

The principal Franco–Flemish composers of the late fifteenth and early sixteenth centuries were Antoine Busnois (ca. 1430–1492), Johannes Ockeghem (ca. 1410–1497), Jacob Obrecht (ca. 1450–1505), Heinrich Isaac (ca. 1450–1517), Pierre de la Rue (ca. 1460–1518), Alexander Agricola (1446–1506), Loyset Compère (ca. 1445–1518), and Josquin Desprez (ca. 1440–1521), acknowledged by his own time to be the greatest of them all.

MANUSCRIPTS AND DOCUMENTS

Many important collections belong to the fifteenth and early sixteenth centuries. The *Old Hall Manuscript* contains masses and motets by English composers. The *Trent Codices* contain 1,585 compositions in six volumes by some seventy–five composers of the fifteenth century. The first collection of motets for the entire church year, by Isaac, is the *Choralis Constantinus* (early sixteenth century). The first printed polyphonic music, the *Odhecaton*, published in Venice by Ottaviano dei Petrucci (1466–1539) in 1501, contains late fifteenth–century polyphonic chansons. The first dictionary of musical terms, *Terminorum Musicae Diffinitorium* (ca. 1475), was compiled by Johannes Tinctoris (ca. 1435–1511), a noted theorist, composer, and commentator on the music of his time. Important collections of German monophonic and polyphonic secular music are *Liederbücher* (song books) of *Lochamer*, *Munich*, and *Glogauer*.

Scores and Recordings	English Motet: NAWM 29 Mass: HAM 63 Secular music: HAM 85 and 86 Burgundian Motet: NAWM 30; NAWM 31; NSI 7 Mass: NAWM 39 Chanson: NAWM 45 and 46 Franco–Flemish Motet: NAWM 32; NAWM 33 Mass: NAWM 40; NAWM 41; NSI 10 Chanson: NAWM 48; NAWM 49; NSI 9

12

The Sixteenth Century

The sixteenth century was an era of great achievements in all the humanities. In music, vocal polyphony reached a pinnacle of expressiveness that stands among the highest in the history of Western music. Among the most important musical developments were the following. (1) Although Franco–Flemish techniques continued to dominate both sacred and secular music throughout Europe, other national schools emerged over the course of the century. (2) The technique of vocal polyphony was highly developed. (3) Vocal style was dominant, but the beginning of an independent instrumental style was evident. (4) Religious music was still dominated by the Roman Church, but Protestant music, principally in Germany, France, and England, began a development that culminated with the end of the Baroque. (5) Secular music rose to a new eminence under the patronage of the nobility. (6) Modality still influenced both sacred and secular music, but the trend was strongly toward major and minor tonalities. (7) Triadic, chordal structures came to permeate sixteenth–century music. (8) Textures varied from homophonic to contrapuntal and were generally characterized by balanced polyphony with equality of parts.

ROMAN CATHOLIC MUSIC

Forms and styles of liturgical music, founded by the Franco–Flemish composers in the early sixteenth century, had a continuous and widespread development throughout the century.

Musical Characteristics (1) Equality of voice parts was the characteristic texture. (2) The number of parts ranged from three to eight or more, but five–part texture was the

most common. (3) The texture sounds full because triads gave the music a rich harmonic *sonority* (or, overall blend of sound). (4) As in the fifteenth century, homophony often alternated with contrapuntal sections. (5) Treatment of dissonant intervals was strict, and confined to the following devices: *passing tones*, *neighboring tones*, *anticipations*, *suspensions*, and *cambiatas* (see Example 12.1). The dissonant intervals were seconds and sevenths between any two voices, and fourths between the lowest–sounding voice and any other. Passing tones, neighboring tones, anticipations, and the dissonant tone in cambiatas always appeared in rhythmically weak positions; the dissonance of a suspension always appeared on a strong beat. (6) Although instruments were undoubtedly used in performance, the music was written a cappella with no instruments indicated. (7) The music was mostly diatonic, but chromaticism began to appear late in the century. (8) Latin continued to be the language of the Roman Catholic Church, but vernacular languages were occasionally used outside Italy.

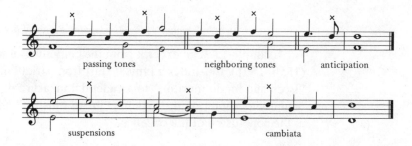

Example 12.1. Treatment of Dissonance

Genres

Masses and motets dominated religious music. Some nonliturgical religious forms also belong to the period.

Mass

Cantus firmus masses on Gregorian chants and secular melodies and *sine nomine* masses were the principal types. Another form, which appeared in the late fifteenth century, was the *parody mass* (or *imitation mass*). In this form, part of a preexistent motet or a secular chanson was musically altered to fit the liturgical text. Composers borrowed from their own or another's compositions. Complete canonic masses were less common after the early sixteenth century.

Motet

Motet construction did not change appreciably from that employed by the Franco–Flemish composers early in the century. In imitative motets each successive phrase or line of text introduced a new musical motive that was then imitated in other voices, permeating the texture. These *points of*

imitation overlapped in such a way that a new text phrase (with a new musical motive) was heard while the preceding phrase and motive was still developing, giving an on–flowing motion and continuity to the music. This procedure is illustrated in Example 12.2, an excerpt from the motet *Ave Maria* by Josquin Desprez (ca. 1440–1521). One line of text ends with the word "mulieribus," and the next line begins with "et benedictus" accompanied by a new theme introduced in the bass and imitated in successive voices.

Example 12.2. Overlapping Points of Imitation

Example 12.3, an excerpt from the beginning of a motet by Jacob Handl (1550–1591), illustrates a typical shift from strict homophony on the words "Ecce quo modo moritur," to a cadential measure of rhythmically independent counterpoint on the syllable "ju" of "justus," and back to homophony at the conclusion of the cadence.

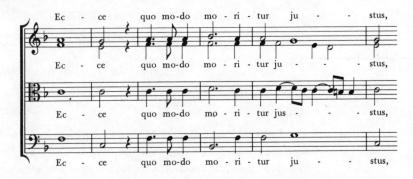

Example 12.3. Change of Texture

Nonliturgical Genres

Religious songs of praise, called *laude*, were given simple homophonic settings. The texts were sometimes in Latin, other times in Italian.

Schools and Composers

Despite the continued influence of Franco–Flemish composers, there were important regional schools of Catholic liturgical music.

Franco–Flemish School

Franco–Flemish composers continued to hold important musical posts throughout Europe. Among these the best–known were Orlande de Lassus (1532–1594), Philippe de Monte (1521–1603), and Clemens non Papa (ca. 1510–ca. 1555).

Roman School

At the head of Catholic music in Rome stands Giovanni Pierluigi da Palestrina (ca. 1525–1594) whose name is traditionally synonymous with the perfection of sacred polyphony. His successors were Marc Antonio Ingegneri (ca. 1547–1592), Felice Anerio (ca. 1560–1614), and Giovanni Nanino (ca. 1550–1623).

Spanish School

Cristóbal Morales (ca. 1500–1553) and Tomás Luis de Victoria (ca. 1548–1611) were the principal Spanish composers. Their music is passionate, with an intense religious fervor about it, and a characteristically stark quality.

Venetian School

The most notable feature of the music by composers at the Church of San Marco in Venice was the use of impressive antiphonal effects produced by split choirs (*cori spezzati*). Adrian Willaert (ca. 1490–1562), a Flemish–born musician, was the founder of the Venetian school. Late Renaissance music, foreshadowing Baroque style, was composed by Andrea Gabrieli (ca. 1510–1586) and his nephew Giovanni Gabrieli (1557–1612).

English School

An extensive literature of Catholic masses and motets was created by English composers, most of whom also wrote Protestant and secular music. The leading name among these is William Byrd (ca. 1543–1623). Earlier composers were John Taverner (ca. 1490–1545), Christopher Tye (ca. 1505–1572), Robert White (ca. 1538–1574), and Thomas Tallis (ca. 1505–1585).

German School

Catholic Church music did not flourish in Germany, mainly because of the Protestant Reformation. Nevertheless, there were several illustrious German composers who contributed substantially to Catholic literature: Ludwig Senfl (ca. 1486–ca.1543), Jacob Handl, and Hans Leo Hassler (1562–1612), a product of the Venetian school, who wrote polychoral music.

REFORMATION MUSIC

Perhaps the most cataclysmic event in the history of the Christian Church was the Protestant Reformation in the sixteenth century. Although church music was dominated by Roman Catholicism during the century, Protestantism also stimulated musical creativity.

Germany

The Reformation movement dates from Martin Luther's Ninety–Five Theses in 1517, and subsequent political and theological attacks on the Roman Church. A musician of some stature, Luther believed strongly in the value of music in worship and thought that the congregation should participate in the service, including hymn singing.

Chorale

The most important musical contribution of the Lutheran Reformation was a new type of religious song called *chorale*. These hymns were intended primarily for congregational singing. There were four sources of chorale tunes: (1) the body of Gregorian chant modified by metrical settings, (2) preexisting tunes, usually secular, (3) nonliturgical German religious songs existing before the Reformation, and (4) newly composed hymns. The first two of these substituted new German religious texts for the original ones, a process known as *contrafactum*.

Chorales were monophonic at first, then they were set in simple four–part harmony with the chorale melody uppermost, and finally, they were used in more elaborate contrapuntal settings for performance by chorus. Contrapuntal arrangements of chorales played on the organ, usually preliminary to congregational singing, were called *chorale preludes*.

Composers

The principal composers of Lutheran chorales and polyphonic settings were Sixt Dietrich (ca. 1493–1548), Johann Walter (1496–1570), who was Luther's musical collaborator, Johannes Eccard (1553–1611), Hans Leo Hassler, and Michael Praetorius (ca. 1571–1621).

France

Music played a less significant role in Protestant movements in Switzerland under Zwingli and in France under Calvin, neither of whom was favorably disposed toward music in worship. The Huguenot movement, however, produced an important literature of psalms set to music.

Psalms

Biblical psalms were translated into French verse by Clément Marot (ca. 1496–1544) and Théodore de Beze (1519–1605), and set to melodies by Loys Bourgeois (ca. 1510–ca. 1560). They were intended for unison singing by

the congregation and for use in the home. Also, four–part harmonizations as well as more elaborate contrapuntal arrangements were made.

Composers

The principal composers of Psalter music were Loys Bourgeois, Claude Goudimel (ca. 1505–1572), Claude Le Jeune (ca. 1528–1600), and, in Holland, Jan Pieterszoon Sweelinck (1562–1621).

England

Henry VIII officially broke with the Roman Church in 1534, which led to the establishment of the Anglican Church.

Genres

The English counterpart of the Catholic mass was called the *Service*, the texts of which were set polyphonically. Anglican chant was derived mostly from Catholic chant. English texts were substituted for Latin, and the melodies were given metrical organization. In addition to Services, there were two Protestant forms of polyphony: (1) the *cathedral anthem* (or full anthem), which was like the Catholic motet but with English text, and (2) a later form, the *verse anthem*, in which solo and choral sections alternated, and organ or string accompaniments were used.

Psalm singing was commonly practiced in England, too. The most important Psalter in England was by Thomas Sternhold and John Hopkins (first published ca. 1549). The 1612 Psalter by Henry Ainsworth (1570–ca. 1622) was the one brought to the New World by the Pilgrims in 1620.

Composers

The principal composers of Anglican music were Christopher Tye, Thomas Tallis, and William Byrd, all of whom also wrote Catholic music, and Orlando Gibbons (1583–1625), who composed both types of Protestant anthems.

SECULAR MUSIC

The current of Renaissance secular polyphonic music, which began in the fifteenth century, continued its course into wider geographical areas. It became more diversified in form and style in an ever–expanding literature that flowed without interruption well into the seventeenth century.

Musical Characteristics

(1) As in the fourteenth century, secular music again rivaled sacred music, largely because of the widespread Renaissance spirit of humanism

but also because the writing of nonreligious poetry was flourishing. (2) The rise of national schools was even more pronounced in secular than in sacred music, although the influence of Franco–Flemish composers was still strong. (3) Secular music thrived in all European courts under the patronage of nobility. (4) It should be remembered that Renaissance secular music was intended as entertainment for amateur performers rather than as concert music. (5) It was composed and performed as chamber music for a few participants rather than for large choral ensembles.

Italian Music

Secular music, which dominated the Trecento, was not again significant in Italy until the sixteenth century, when Italian forms and styles influenced those of other countries.

Genres

In the late fifteenth century, popular vocal forms, referred to collectively as *vocal canzoni*, included the *frottola* in northern Italy, the *villanella* in southern Italy, *canti carnascialeschi* (carnival songs), and *strambotti*. These uncomplicated forms were usually in four parts, strongly metrical, with dancelike rhythms, and predominantly homophonic. They were the forerunners of the sixteenth–century *Italian madrigal* (unrelated to the fourteenth–century madrigal). As the Italian madrigal developed during the sixteenth century and into the seventeenth century, it became more stylized, more contrapuntally elaborate, with more exaggerated emotional content. The use of musical devices suggesting representation of words or ideas in the text, called *madrigalisms*, was characteristic. Some late Renaissance madrigals exploited striking chromatic effects in homophonic passages.

A special class of madrigals called *madrigali spirituali* were nonliturgical compositions based on religious texts.

A style of madrigal called *balletto* was developed briefly in the latter part of the century. It featured dancelike rhythms and contained refrains consisting of nonsense syllables such as "fa–la–la."

A few madrigal cycles called *madrigal comedies* were composed at the end of the century. They were groups of madrigals based on pastoral subjects, loose plots, or humorous dialogues. *L'Amfiparnasso*, by Orfeo Vecchi (ca. 1550–ca. 1604), is the most famous of these. *Il trionfo di Dori* is an important collection of madrigals by different composers.

Composers

Composers of canzoni and madrigals in the first half of the century were Philippe Verdelot (ca. 1475–ca. 1552), Costanzo Festa (ca. 1490–1545), Adrian Willaert (ca. 1490–1562), and Jacques Arcadelt (ca. 1505–1568). Late sixteenth– and early seventeenth–century composers were Cipriano de Rore (1515–1565), Orlande de Lassus, Philippe de Monte, Giaches de Wert (1535–1596), Luca Marenzio (ca. 1553–1599), Giovanni Gastoldi (ca. 1555–

1622), and Baldassare Donato (ca. 1525–1603), noted for balletti; Don Carlo Gesualdo (ca. 1561–1613), famous for chromatic madrigals; and Claudio Monteverdi (1567–1643), whose madrigals represent the culmination of that form.

French Music

Although French secular music was somewhat influenced by Italian models, it retained a distinctly Gallic flavor.

Genres

The polyphonic chanson, first developed by Franco–Flemish composers, and the solo chanson with contrapuntal accompaniment continued in favor. Some chansons were homophonic; others employed elegant counterpoint with imitation. The *chanson rimée* had regular metric rhythms. The *chanson mesurée*, a late sixteenth–century type, employed rhythms in which stressed syllables were given twice the note values of unstressed syllables, resulting in frequently shifting meters. A characteristic of many chansons, especially those using imitative counterpoint, was a repeated–note motive at the beginning of the initial theme (see Example 13.2).

Composers

Principal names are Clément Janequin (ca. 1485–1558), noted for his *descriptive chansons*, Nicholas Gombert (ca. 1495–ca. 1560), Claudin de Sermisy (ca. 1490–1562), Pierre Certon (d. 1572), Claude Le Jeune, Thomas Crécquillon (ca. 1490–1557), Orlande de Lassus, Claude Goudimel (1514/20–1572), Guillaume Costeley (ca. 1530–1606), and Jacques Mauduit (1557–1627).

English Music

Secular music in England flourished somewhat later than on the Continent and continued to develop until nearly the middle of the seventeenth century.

Genres

The *English madrigal* received its initial impetus from Italy when a collection of Italian madrigals with English translations was published in 1588 in London. English madrigals usually employed a five–voice texture set to texts on pastoral and amorous subjects. Like French chansons they were mostly in a light and gay style. They employed madrigalisms, as in Italian madrigals.

A strophic form of madrigal called *ballett*, derived from the Italian balletto, contained "fa–la–la" refrains in lively contrapuntal style after each homophonic stanza.

The terms *canzonet* and *ayre*, which appear among English madrigal compositions, do not constitute types clearly distinct from the madrigal proper. In the late sixteenth and early seventeenth centuries, the *lute ayre*

was much in vogue; it was a solo song with a contrapuntal lute accompaniment.

The most famous collection of English madrigals, entitled *The Triumphs of Oriana*, was patterned after the Italian *Il Trionfo di Dori*. Each madrigal concludes with the words "Long live fair Oriana," a reference to Queen Elizabeth I, to whom the collection was dedicated. It represents the peak of English madrigal composition by the most illustrious composers of the period.

Composers

The English madrigal school is represented by these composers: Thomas Morley (ca. 1557–1602), who wrote madrigals, canzonets, and balletts, William Byrd, John Wilbye (1574–1638), Thomas Weelkes (1576–1623), John Ward (1571–1638), John Bennet (fl. 1599–1614), Thomas Bateson (ca. 1570–1630), and Orlando Gibbons. Composers of lute ayres were Francis Pilkington (ca. 1570–1638); Thomas Campion (1567–1620), and the most important of all, John Dowland (1563–1626).

German Music

German secular music in the sixteenth century was influenced by Franco–Flemish and Italian composers.

Genres

The *polyphonic lied* was the central type. For the most part, it was a four–voice texture with imitative counterpoint. Popular songs were often the melodic basis. Another popular form in the fifteenth and sixteenth centuries was the *quodlibet*, in which several different popular tunes and their texts were humorously and incongruously combined in a contrapuntal manner.

Composers

The composers of polyphonic lieder in the late fifteenth and early sixteenth centuries were Adam von Fulda (ca. 1445–1505), Heinrich Finck (ca. 1444–1527), Heinrich Isaac (ca. 1450–1517), Paul Hofhaimer (1459–1537), and Ludwig Senfl. In the latter part of the sixteenth and early seventeenth centuries, the composers were Orlande de Lassus, Johannes Eccard, Hans Leo Hassler, and Melchior Franck (ca. 1579–1639).

Spanish Music

Little is known about indigenous Spanish secular music before the late fifteenth century. Burgundian and Franco–Flemish composers were probably well known in Spain.

Genres

The principal Spanish form was the *villancico*, the counterpart of the Italian frottola. It was a four–part composition, predominantly homophonic, with a regular metric construction. It was based on a three–stanza poem,

musically structured according to the formula *ABBA* in which the first stanza (*A*), called *estrihillo*, was followed by the second stanza in two couplets to the same music (*B*), called *copla* or *mudanza*, and the concluding last stanza, called *vuelta*, was sung to the same music as the first stanza. Villancicos may have been performed as solo songs with instruments playing the lower parts. The earliest literature of solo songs with *vihuela* (Spanish lute) accompaniments flourished in Spain during the sixteenth century.

Composers

The principal composer of villancicos was Juan del Encina (1468–ca. 1529). Some of his music is contained in a collection entitled *Cancionero del Palacio*. The leading composer of Spanish lute songs was Luis de Milán (ca. 1500–ca. 1561).

TREATISES

Among important treatises dealing with the theory and practice of music, the most important are *Practica musicae* by Franchinus Gaffurius (1451–1522); *Musica getutscht* by Sebastian Virdung (b. ca. 1465), a treatise dealing mainly with instruments but important also because it discusses methods of transcribing vocal music to instrumental media; *Dodecachordon* by the Swiss theorist Henricus Glareanus (1488–1563), who, dealing with the subject of scales and modes, recommended the Ionian and Aeolian modes, thus reflecting the current trend toward major and minor tonalities; *Le Istituzioni harmoniche* by Gioseffo Zarlino (1517–1590); and Morley's *A Plaine and Easie Introduction to Practicall Musicke*, which addresses a number of subjects relating to compositional techniques and performance.

Scores and Recordings

Catholic Music

 Mass: NAWM 42, 43, and 44; NSI 12

 Motet: NAWM 34, 35, 36, 37, and 38; NSI 14

Reformation Music

 Psalms: HAM 126 and 132

 Cathedral Anthem: HAM 169 and 171

 Verse Anthem: HAM 151 and 172

Secular Music

 Italian Madrigal: NAWM 56, 57, 58, 59, and 60; NSI 15

 Frottola: NAWM 56

 Canto Carnascialesco: NAWM 51

 Balletto (Italian): HAM 158

 Chanson: NAWM 53 and 54; NSI 13

 English Madrigal: NAWM 61; NSI 17

 Ballett (English): HAM 159, 170

 Lute Ayre: HAM 162 and 163b

 Polyphonic Lied: NAWM 52

 Quodlibet: HAM 80

 Villancico: HAM 97 and 98

 Spanish Lute Song: HAM 123

13

Instrumental Music

Although instrumental music in the Renaissance never matched the quantity or quality of vocal music, it is important because it reveals the rise of interest in instrumental media and the first realization of an independent instrumental idiom. Among important characteristics of this music's development are the following. (1) With a few notable exceptions, instrumental music generally stayed within the limits defined by vocal idioms. (2) Improvisation played an important role in performance, especially in melodic ornamentation. (3) As in the Middle Ages, instruments were freely employed in the performance of vocal music, though they were not often specified. They were used to double or replace voice parts, and vocal compositions were even performed entirely by instruments. (4) Published transcriptions of vocal music for instrumental performance were numerous. (5) Some instrumental genres were directly derived from vocal ones; others were instrumentally conceived.

Where a distinctly instrumental style occurs in Renaissance music it is manifested in these ways: (1) rapid and long scale passages; (2) numerous wide skips; (3) melodic range wider than vocal limitations; (4) in lute and keyboard music, contrapuntal parts freely added or dropped out without rests indicated; (5) extensive ornamentation (coloration, embellishment, and figuration); and (6) a much freer treatment of dissonance. Most of these characteristics are illustrated in Example 13.1, an excerpt from a keyboard piece.

Example 13.1. Instrumental Style

INSTRUMENTS OF THE RENAISSANCE

There was a steady improvement in instrument–building technology during the Renaissance. The instruments in most common use fall mainly into three categories: strings, winds, and keyboard instruments. String and wind instruments were manufactured in families consisting of instruments ranging in size from the highest to lowest registers.

Bowed Strings

Renaissance *viols*, ancestors of the seventeenth–century violin family, were fretted instruments with six strings tuned in fourths with a third in the middle (*A d g b e' a'*). They were used in various ensembles called consorts, consisting entirely of viols, or mixed consorts, with recorders and other instruments.

Plucked Strings

The lute was the most popular solo instrument. It had a pear–shaped body and an angled neck. Lutes were fretted instruments with six strings tuned, like viols, in fourths with a third in the middle (*G c f a d' g'*). Lute music was written in a special kind of notation called *tablature*, which indicated the string and fret for a given note. Lutes were used as solo instruments, accompanying instruments, and in some ensemble music.

In Spain, the guitarlike *vihuela* was the principal plucked stringed instrument.

Wind Instruments

The most important Renaissance wind instrument was the *recorder*, an end–blown wooden flute. Recorders, made in all sizes from treble to bass, were used in various kinds of ensemble music. The *shawm* and *krummhorn* were double–reed woodwinds. *Cornets*, made of wood or ivory, were soft–toned instruments. Various kinds of trumpets and trombones were in use, but they were limited to the natural tones of the harmonic series. Such instruments were confined to fanfares or to outdoor festival music for large ensembles.

Keyboard Instruments

Large church organs were built in the Renaissance, but only in Germany did they have pedalboards. *Positive organs* (also called *regals*) had been in common use since the Middle Ages, but the portative organ (a smaller, portable organ) disappeared before the end of the fifteenth century.

String keyboard instruments were of two types: *clavichord* and *harpsichord*. The latter were also designated as *spinet*, *virginal* (English), *clavecin* (French), *clavicembalo* (Italian), and *Klavier* or *Clavier* (German terms that also included the clavichord).

A considerable solo literature was composed for all the keyboard instruments. The organ was also used to accompany vocal polyphony but not in

instrumental ensembles. The harpsichord and clavichord were less often used as accompanying instruments or in ensembles.

Ensembles

Renaissance instrumental ensembles were almost entirely small chamber groups, rarely orchestras. Specific instrumentation of ensembles was almost never indicated in the scores.

GENRES

The fact that Renaissance composers were not much concerned with distinctions between instrumental and vocal media is attested to by inscriptions such as "per cantar e sonar" (for singing and playing), which appeared on title pages. A large portion of sixteenth–century instrumental music consisted of arrangements of sacred and secular vocal compositions, but originally composed instrumental pieces were numerous and some new instrumental forms evolved.

Dance Music

The earliest extant dance music was largely intended to accompany social dancing, but during the second half of the sixteenth century stylized dance music was favored. Generally, dance music had heavily stressed rhythms, and structures consisting of several repeated sections. Renaissance dances were often composed in pairs or groups of three. In dance pairs, the first dance was in slow tempo, the second in fast tempo with change of meter. Both dances often used the same tune. The most popular dance pair was the *pavane* (also *padovano*, *paduana*) in slow duple time, and *gaillard*, in fast triple time. An Italian dance pair was the *ronde* and *saltarello*. German dance pairs were designated as *Tanz und Nachtanz* or else *Der Prinzen Tanz–Proportz*. Other dances were *passamezzo*, *basse–danse*, *branle* (also *bransle*) and, toward the close of the century, *allemande* (*alman*) and *courante* (*corrento*).

Dance music was composed for various ensembles, lute, and harpsichord.

Cantus Firmus Forms

Compositions based on Gregorian chants, chorales, or secular songs were composed for organ, harpsichord, and sometimes ensembles of viols. They occasionally had liturgical functions as *verses* or *versets* played by the organist between stanzas of a hymn sung by the congregation or choir. Most cantus firmus instrumental music was conservatively styled in a vocal idiom.

Imitative Forms

In this category belong a number of genres that made prominent use of contrapuntal imitation. Organ transcriptions of motets were common. Original organ pieces composed in motet style were called *ricercare*. Such pieces were also composed for lute and instrumental ensembles. An imitative form derived from the French polyphonic chanson was called *canzona* (or *canzona francese*). Canzonas, composed for instrumental ensembles (*canzona da sonar*), harpsichord, or organ (*canzona d'organo*), were more lively in rhythm and tempo than the ricercare, and they employed the characteristic repeated–note motives of the chanson. Other imitative forms were the *fantasia* (also *fantasy*, *fancy*) and *capriccio*.

Example 13.2. Canzona Style

Improvisational Forms

Instrumental types that relied on conveying a sense of improvisation were the *prelude* (also *praeludium*, *praeambulum*). Such pieces were composed for lute or one of the keyboard instruments.

Variation Forms

Genres based on the principle of variation are the oldest to have a continuous history to the present. They were first developed by the Spanish vihuelists and later in the sixteenth century by the English virginalists. It was perhaps in variations that composers first fully explored instrumental idioms. Variations were constructed in several different ways. (1) *Cantus firmus variations* were based on a given melody restated a number of times with little or no change, but with each statement the melody was accompanied by different counterpoint and in a different voice. (2) The *theme and variations* form was based on a popular tune that itself was modified with each restatement. (3) English *hexachord variations* used the first six notes of a scale as a theme. Variations of this type were usually entitled *Ut re mi fa sol la*, after the solfège symbols, and were common in virginal music. (4) A variation form called *ground* was based on a short theme of four to eight measures in the bass with continuous and changing counterpoint above.

SCHOOLS AND COMPOSERS

As a general rule, most composers of Renaissance instrumental music wrote little vocal music, and they usually specialized in one medium. Notable exceptions were some of the English virginal composers and some of the Venetian composers late in the century.

Germany
A long line of German organ composers began with Conrad Paumann (ca. 1410–1473), whose *Fundamentum Organisandi* contained two–part organ pieces. Other organ composers were Hans Buchner (1483–1538), Hans Kotter (ca. 1485–1541), Leonhard Kleber (ca. 1495–1556), Paul Hofhaimer (1459–1537), and Arnolt Schlick (ca. 1460–after 1521).

Lute composers were Hans Judenkünig (ca. 1450–1526), Hans Gerle (ca. 1500–1570), and Hans Neusiedler (ca. 1508–1563).

Composers of instrumental ensemble music were Elias Nikolaus Ammerbach (ca. 1530–1597), Valentin Haussmann (ca. 1565–ca. 1614), and Melchior Franck (ca. 1579–1639).

Spain
The leading Spanish vihuela composer was Luis de Milán (ca. 1500–ca. 1561). His contemporaries were Luys de Narváez (fl. 1530–1550), Enriquez de Valderrábano (fl. mid–sixteenth century), and Miguel de Fuenllana (d. ca. 1568). Antonio Cabézon (1510–1566) was the outstanding composer of Spanish organ music.

Italy
Francesco Spinacino (fl. 1507) and Ambrosio Dalza (fl. 1508) were early sixteenth–century lute composers. More important was the organ music of Claudio Merulo (1533–1604), Girolamo Cavazzoni (ca. 1525–ca. 1577), Annibale Padovano (ca. 1527–1575), Andrea Gabrieli (ca. 1510–1586), Giovanni Gabrieli (ca. 1554–1612), and Giovanni de Macque (ca. 1548–1614). Composers of instrumental ensemble music were Florentio Maschera (ca. 1540–ca. 1584) and the two Gabrielis.

France
The first French music printer, Pierre Attaingnant (ca. 1494–ca. 1551), published numerous collections of organ, lute, and clavecin music by unnamed composers. Jean Titelouze (ca. 1562–1633) composed cantus–firmus organ pieces based on Gregorian chant.

England
The English virginal school includes the names of Hugh Aston (ca. 1485–1558), Giles Farnaby (ca. 1563–1640), William Byrd (1543–1623), John Bull (ca. 1562–1628), and Orlando Gibbons (1583–1625). The most important among several collections of virginal music is *The Fitzwilliam Virginal Book*.

Organ music, less important in England, is represented by John Redford (ca. 1485–1547) and John Bull in the early seventeenth century. English lute music was composed mainly by John Dowland (1562–1626), Francis Pilkington (ca. 1562–1638), and Thomas Campion (1567–1620). Orlando Gibbons also composed fantasias for viols.

Scores and Recordings

Examples of instrumental music are listed here according to form rather than school or medium. Medium is indicated by the symbols *l* (lute), *h* (harpsichord), *o* (organ), *v* (viols), and *e* (ensemble).

Dance

NAWM 62; HAM 83 (*e*), 102 (*h*), 103 (*h*), 104 (*h*), 105 (*l*), 137 (*e*), 154 (*e*), 167b (*e*), and 179 (*h*); NSI 11 (*e*)

Cantus Firmus

NAWM 65 (*e*); HAM 100 (*o*), 117 (*o*), 120 (*o*), 133 (*o*), 176 (v), and 180 (*o*)

Canzona

NAWM 63 (*e*); HAM 88 (*e*), 118 (*o*), 136 (*e*), and 175 (*e*)

Fantasia

NAWM 64; HAM 121 (*l*) and 181 (*o*)

Ricercare

HAM 99 (*l*), 115 (*e*), 116 (*o*), 119 (v), and 173 (*e*)

Toccata

HAM 153 (*o*) and 174 (*o*)

Prelude

HAM 84 (*o*), 135 (*o*), and 178 (*h*)

Variations

HAM 122 (*l*), 124 (*l*), 134 (*o*), 154b (*h*), 177 (*h*), and 179 (*h*)

Transcriptions of Vocal Music

HAM 81b (*o*) and 160 (*h* and *l*)

14

Musical Notation

The history of musical notation is an evolution toward accurate symbolic representation of two musical factors: pitch and rhythm. Progress was generally slow and, until the Renaissance, methods and styles of writing music varied considerably from one locality to another. Modern notation dates from the early seventeenth century. Prior to 1600, various other systems had been used. The principal systems of Western notation before the modern one were neumatic, modal, and mensural notation.

NEUMATIC NOTATION

Although numerous attempts at notation were made in pre–Christian times and during most of the first millennium of the Christian Era, they were largely unsuccessful. The history of Western notation began near the end of the ninth century.

Neumes

Plainsong notation was first recorded by signs called *neumes*. They originated as chironomic inflection symbols: acute (ʹ), grave (ʽ), and circumflex (^). Placed above words of a text, neumes served merely as reminders of the general upward or downward direction of a melody already known. The number of neumatic note forms increased to more than a dozen signs.

Diastematic Notation

At first, neumes were written only above some of the words of a text and *in campo aperto* ("in the open field," or without any indication of relative pitch). By the early tenth century, neumes were written in relatively high or low positions, and were known as *diastematic* or *heighted* neumes (see

Example 14.1). These provided a more accurate guide to melodic contours, but they still did not indicate exact pitch, intervals, or duration of notes.

Example 14.1. Diastematic Notation

St. Gall, *Cantarorium* (late ninth century), cod. 359, fol. 125. Reproduced from Carl Parrish, *The Notation of Medieval Music*, Plate II. Reprinted by permission from W. W. Norton.

Staff Notation

The first important step toward indicating exact pitch, initiated near the end of the tenth century, was the introduction of a horizontal line representing the tone F, above or below which neumes were written (see Example 14.2). This was the origin of the *staff*. Soon thereafter, two–line staves in color were used to indicate the tones F (upper line, red) and C (lower line, green or yellow). By the eleventh century four–line staves were described by Guido d'Arezzo (ca. 997–1050). This is the staff used in modern Gregorian notation (see Example 14.3). More and more lines were added, up to eleven or more, then separated into two staves by eliminating the Middle C line. Eventually, by about the thirteenth century, five–line staves were favored.

Clef Signs

Medieval scribes used the letters *C*, *F*, and *G* placed on one of the staff lines to indicate the pitch of that line and, by extension, the pitches of all the other lines. Modern clefs are derived from these same letters in old script.

MODAL NOTATION

Notation from the end of the twelfth century to about the middle of the thirteenth century is referred to as *modal notation* because it was based on the rhythmic modes. Although it was capable of indicating the relative duration of a note, considerable ambiguity still existed because the shape of the note had to be interpreted in the context of a modal pattern in order for the performer to determine duration.

Notes

Modal notation is also called *square notation* because of its notehead shapes, which were distinct from the various forms used in neumatic notation. Three types of notes were the *long* (or *longa* ❚), the *breve* (or *brevis* ■), and *semibreve* (or *semibrevis* ◆). These notes were used singly and in groups called *ligatures*.

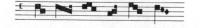

Example 14.4. Ligatures

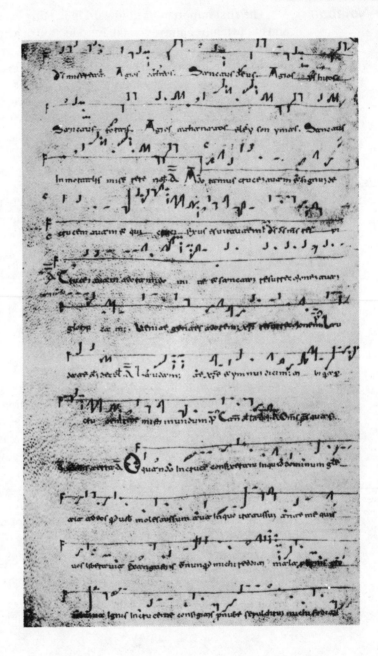

Example 14.2. One–Line Neumatic Notation.

Reproduced from Homer Ulrich and Paul Pisk, *A History of Music and Musical Style*, p. 36. Reprinted by permission from Harcourt, Brace & World.

III. — On Solemn Feasts. 2.
(Kyrie Deus sempiterne)

Example 14.3. Modern Plainsong Notation.

"Kyrie Deus Sempiterne," reproduced from *Plain Song for Schools*, p. 12. Reprinted by permission from J. Cary & Co., London.

Perfection

Modal notation was based on a concept of triple division called *perfection*, in which a note of one denomination was equal to three of the next–smaller denomination.

Music in Modal Notation

Music written in modal notation included some of the troubadour and trouvère songs, clausulae, organa, conducti, and some of the earliest motets. Gregorian chant and some secular monophonic songs continued to be written in the older neumatic notation.

MENSURAL NOTATION

Notation in use from the second half of the thirteenth century to the end of the sixteenth century is referred to as *mensural notation* (measured notation). The thirteenth century witnessed the transition from modal to mensural notation. The thirteenth and fourteenth centuries were periods of rapid and often complex evolutions. Problems and uncertainties still existed, but mensural notation finally achieved a high degree of accuracy in representing relative duration.

Franconian Notation

Notation in the second half of the thirteenth century is called *Franconian notation* after Franco of Cologne (fl. 1250–1280) who described the current system in his *Ars Cantus Mensurabilis* around 1260. The Franconian system used the same kinds of black noteheads as did modal notation (long, breve, and semibreve). The breve became the basic time unit and its division was still predominantly perfect (triple). Around 1280, Petrus de Cruce (fl. ca. 1290) was using more than three semibreves to a breve.

Choirbooks

Until about 1230, polyphonic music was notated in *score* in which the various parts were arranged one above the other on one or more staves. This plan was abandoned in favor of *choirbook* arrangement. The two upper parts of a three–voice composition were placed either on opposite pages or else in two columns on a single page, and the tenor part was notated on one continuous staff across the bottom of the page (see Example 14.5). In composition for more parts, they were all similarly arranged on a single folio opening. The reason for this change was probably that the textless tenor part, which had fewer notes, left too much valuable parchment space in the score form, whereas in the choirbook arrangement it could be greatly condensed. Performers would gather around this single large book, which might be three feet high, and read their individual parts. Choirbooks remained in use until about the middle of the sixteenth century.

Example 14.5. Franconian Notation and Choirbook Arrangement.

Three–voice motet: "Plus joliement/Quant le douz/Portare." Reproduced from *Chansonnier de Montpellier*, Ms. H 196. Reprinted by permission from Le Conservateur en Chef, Bibliothèque Universitaire, Section de Médecine, Montpellier, France.

Ars Nova Notation

French and Italian composers in the fourteenth century developed mensural notation still further and established the basic principles that remained in effect throughout the Renaissance.

Characteristics

In his *Ars Nova* (ca. 1322), Philippe de Vitry (1291–1361) recognized duple and triple meter as being equally important. The late fourteenth century used a system of great complexity, referred to as *mannered notation*. The long was less often used, and the *minim* (♩) and *semiminim* (♪) were added. Notes colored red in the manuscripts were used to indicate imperfection (duple division) and also to indicate a change of proportion as, for example, three red notes equal to two black notes of the same denomination.

Mode, Time, and Prolation

In the fourteenth–century system, each note was subject either to duple or triple division. The relation of long to breve was called *mode*; the relation of breve to semibreve was called *time* (or *tempus*); and the relation of semibreve to minim was called *prolation*. A long was usually equal to two breves (*imperfect mode*). A breve could equal two semibreves (*imperfect time*) or three semibreves (*perfect time*). A semibreve could equal two minims (*minor prolation*) or three minims (*major prolation*). These five relationships are represented in Example 14.6, a table of note values.

Example 14.6. Note Values in Mode, Time, and Prolation

Mesuration Signs

Time and prolation were represented by two signs each, one for triple and one for duple division. Perfect time was represented by a full circle (◯), imperfect time by a half–circle (C). Major prolation was represented by three dots, minor prolation by two dots. Thus, time and prolation were combined in four ways.

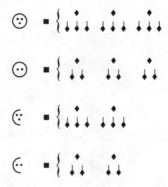

Example 14.7. Mensuration Signs

An additional sign, a half circle with a vertical line drawn through the center (₵), indicated that notes were to get half the normal value. This was called *alla breve*. The sign and the term are both still used today, as is also the C for $\frac{4}{4}$ meter.

Dots

In addition to indicating prolation in mensuration signs, dots were also used in two other ways: (1) a dot (called *punctus*) following a note could indicate the separation of basic note units (called *point of division*) comparable to the modern bar line; or (2) it could indicate the addition of half the note's value (called *point of addition*), just as it does today.

Renaissance Notation

From about the middle of the fifteenth century to the end of the sixteenth century, mensural notation was standardized in what is called *classical mensural notation*. The complexities of *Ars Nova* notation largely disappeared. White breves, semibreves, and minims (□ ◊ ♦) replaced the former black notes. The semiminim had a new form (↓), and the *fusa* (⌠) was added. Mensuration signs were the same as before except that a single dot (⊙ or ⊙) now indicated major prolation, and no dot (○ or C) meant minor prolation. Sixteenth–century notation is shown in Example 14.8.

Example 14.8. Classical Mensural Notation.

Tenor and contratenor parts of *Missa l'Homme Armé*, "Patrem Omnipotentum," Faugues. Biblioteca Apostolico–Vaticana, Cappella Sistina 14, fol. 143r. (Retouched, reproduced by permission of The Institute of Medieval Music.)

Partbooks

In the second half of the sixteenth century, partbooks replaced choirbooks. In the newer plan, single parts for a number of different compositions were bound together in one volume. Thus, four–part music would require four separate books, one each for superius, altus, tenor, and bassus parts. The disadvantage of this system is obvious, and in the seventeenth century part music came once again to be written in score.

KEYBOARD AND LUTE NOTATION

The history of notation thus far has dealt exclusively with vocal music. With the exception of early Greek notation, there was no special notation for instrumental music or intended instrumental parts until the early fourteenth century.

Organ Tablature

The earliest keyboard music is preserved in the *Robertsbridge Codex* (early fourteenth century), which contains two–part organ pieces written on a staff with the upper part in notes and the lower part in letters. This system, commonly called *German organ tablature*, was the means of writing organ compositions until the end of the sixteenth century.

Lute Tablature

Renaissance composers of lute music devised a special kind of notation called *lute tablature*. Instead of writing notes or letters on a staff, they used six parallel horizontal lines that represented the six strings of a lute. Since the lute was a fretted instrument, letters or numerals placed on a line indicated where the finger stopped the string. Numerals were used in Spanish and Italian tablatures, letters in French, English, and most German tablatures. The cipher (*0*) in numeral tablature and the letter *a* in alphabet tablature indicated the open string to be played. Hence, the number *2* or the letter *c* on a line indicated the second half–step above the open string. Rhythmic signs were placed above the tablature lines (see Example 14.9). Similar tablatures were occasionally used also for viols.

UNQUIET THOUGHTS

Example 14.9. English Lute Tablature and Transcription.

Dowland, "Unquiet Thoughts." Reprinted from *English Lute–Song Writers*, vol. 1, p. 2, by permission from Stainer & Bell, London.

Harpsichord Notation

Music for harpsichord was notated in keyboard score, usually on two five–line staves, the same as it is today.

PART FOUR

THE BAROQUE

(1600–1750)

15

Introduction to the Baroque

1573–1590	Florentine Camerata
1581	Vincenzo Galilei's *Dialogo della musica antica et della moderna*
1597	Peri and Rinuccini collaborate on *Dafne*
1600	Peri, Caccini, Rinuccini: *Euridice*
1602	Caccini's *Le Nuove musiche*
1605	Monteverdi: *Fifth Book of Madrigals*
1607	Monteverdi: *Orfeo*
1615	Giovanni Gabrieli: *Symphoniae sacrae*
1617	Schein: *Banchetto musicale*
1618–1648	Thirty Years' War
1619	Schütz: *Psalmen Davids*
1637	First public opera house opens
1642	Monteverdi: *L'Incoronazione di Poppea*
1643	Death of Monteverdi
1644	Rossi: *Orfeo*
1650	Carissimi: *Jephtha*
1660	English Restoration
1669	Paris Academy of Music founded
1670	Molière–Lully: *Le Bourgeois gentilhomme*
1672	First public concert, London
1672	Death of Schütz
1681	Corelli's first trio sonatas published
1686	Lully's *Armide* produced

1689 Purcell: *Dido and Aeneas*

1695 Death of Purcell

1700 Corelli: Op. 5, solo sonatas

1707 Death of Buxtehude

1711 Handel: *Rinaldo*

1712 Vivaldi: Concertos, Op. 3

1712 Handel moves to London

1722 Rameau's *Traité de l'harmonie*

1722 J. S. Bach: *Well–Tempered Clavier*, Book I

1723 J. S. Bach becomes kapellmeister at Leipzig

1725 Death of Alessandro Scarlatti

1725 Paris, Concert Spirituel, series of public concerts

1725 Fux: *Gradus ad Parnassum*

1726 Vivaldi: *The Seasons*

1728 Gay–Pepusch: *The Beggar's Opera*

1729 J. S. Bach: *St. Matthew Passion*

1733 Pergolesi: *La Serva padrona*

1737 Rameau: *Castor et Pollux*

1741 Death of Vivaldi

1742 Handel: *Messiah*

1747 J. S. Bach: *A Musical Offering*

1750 Death of J. S. Bach

1759 Death of Handel

1764 Death of Rameau

1767 Death of Telemann

*T*he Baroque saw the rise of drama. Theater, painting, architecture, and music were all characterized by grandiose concepts, magnificent gestures, ornate design, and an overall theatrical quality. These effects were often created by vivid contrasts. The grand and the small, the brilliant and the dull, the extraordinary and the ordinary all coexisted. Historians have come to characterize this tendency as Baroque dualism. This concept was manifest right at the transformation of the Renaissance into the Baroque, when musi-

cians recognized the concordance of two styles, the old (stile antico) and the new (stile moderno). The greatest master of the early period, Claudio Monteverdi (1567–1643), composed comfortably in both of these, which he respectively called the first practice (prima prattica) and the second practice (seconda prattica). Essentially, the old practice was that of vocal counterpoint, while the new practice continued development of homophony, vocal and instrumental. Both received extensive treatment in the Baroque, although historically the new style was to be the wave of the future. Stile moderno itself embodied the notion of dualism, specifically in the use of stile concertato. The concertato style was a pervasive ideal in which different media were in cooperative opposition to one another, either simultaneously or in alternation: vocal against instrumental, solo against ensemble. This principle was manifest in the use of different dynamic levels, which were always graphically and sharply contrasted (terraced dynamics). Dualism was at play even in the relationship of melody and bass. The bass, which became more prominent during the Baroque, consisted of both melodic underpinning and outlined harmonies. Such is implicit in the concept of the basso continuo, the lowest part in most Baroque ensembles. Harmonies were organized around the opposing functions of the dominant (implying tension) and the tonic (implying resolution). Although this relationship was generally observed in practice during the whole period, it was not recognized in theory until the late Baroque in Rameau's Traité de l'harmonie (1722). Functional harmonies were necessary for the full development of tonality, the most important contribution of the period. As a result, modulation (a harmonic progression that begins in one key and ends in another) became commonplace.

Musicians in the Baroque employed dualistic concepts first utilized by those in the Renaissance. Primary among these was that of word and sound. Instrumental music provided the Baroque with one of its principle problems: how to shape and organize without the benefit of a text. Stile concertato and tonality were parts of the answer. The Doctrine of the Affections provided the rest of it, by abstractly associating ideas capable of articulation with abstract musical ideas. Even the use of tempo indications (e.g., adagio, allegro) and dynamic markings (forte, piano, etc.), both new to the Baroque, reflected composers' concerns with heightening the emotional content of abstract music.

The Baroque saw the decline of the church and the aristocracy as primary benefactors of musical life. They were still important institutions, no doubt, and composers like J. S. Bach (1685–1750) received their lives' support from them. The cosmopolitan George Frideric Handel (1685–1759) was more typical, though, and his livelihood often came from the public. Operas, invented as entertainment for the private elite, became public in 1643. Concerts, originally for the privileged, later sponsored by private musical organizations, were first opened to the public in 1672. A rising and influential

middle class demanded and received music appropriate to its taste and pocketbook.

HISTORICAL CONTEXT

Important historical events of the Baroque were the Thirty Years' War in Germany (1618–1648), the reign of Louis XIV of France from 1643 to 1715, the English Civil War (1642–1649), the Commonwealth and Protectorate (1649–1660), and the Restoration (1660). It was a time of worldwide colonization. Illustrious names in science were Newton, Harvey, Galileo, Bacon, Kepler, and Leibnitz. The foremost philosophers were Locke, Descartes, Pascal, and Spinoza. Leading artists of the period were the Dutch painter Rembrandt and the Flemish Reubens and Van Dyck, the English Hogarth, and, of the Spanish school, El Greco and Velasquez. English literature was represented by Milton, Dryden, Defoe, Addison, Swift, Pope, and Samuel Johnson; French literature, by Corneille, Racine, and Molière.

16

Opera and Vocal Chamber Music

The end of the sixteenth century first saw a conscious revolt against Renaissance polyphony, which the antagonists wanted to replace with entirely new techniques. The innovations that followed, instigated by a group of Florentine intelligentsia who called themselves the Camerata, *included monody (accompanied solo song), recitative, and a new concept of drama with music later called* opera *(literally, "work"). Monody was given an early example in a 1602 collection by Giulio Caccini (ca. 1545–1618), entitled* Le Nuove musiche. *From this collection early seventeenth–century music practice took its name.*

Opera was the central innovation of Italian nuove musiche. It soon influenced virtually all types of Baroque music. Other secular vocal forms were solo songs and chamber cantatas.

OPERA

The association of music and drama goes back to Antiquity. Greek tragedies employed choruses, and dialogue may have been sung. Medieval liturgical dramas, mystery plays, and miracle plays were at least partly sung. Renaissance plays made use of musical interludes between acts, called *intermezzi* or *intermedi*. Madrigal comedies of the late sixteenth century approached the idea of musical narrative and dialogue, though they were not intended for stage performance.

Operas, like plays, are performed on a stage, and they include acting, costumes, scenery, props, and lighting. The text of an opera is called a *libretto*. The musical components are (1) solo song, in opera first called *monody*, later *aria*; (2) ensembles of two or more solo voices, called *duet*, *trio*, and so on; (3) *recitative*, a declamatory style of singing dialogue; (4) *chorus*; (5) the *orchestra*, which accompanies singing and provides instrumental introductions and recurring interludes (*ritornelli*); (6) the *overture*, the instrumental introduction to an opera; and (7) in some operas, formal dances called *ballets*.

Italy

The main developments in Italian opera were centered, more–or–less consecutively, in four Italian cities: Florence, Rome, Venice, and Naples.

Florentine Opera

In the last decade of the sixteenth century, the Florentine *Camerata* sought to revive ancient Greek tragedy. Although, as classical scholars, they were aware of the function of music in drama, they also realized that the prevailing polyphonic madrigal style was not suitable for dramatic expression. Consequently they initiated a new style of singing called *stile rappresentativo* (theater style) for their dramas, which became the earliest operas.

Dafne, probably the first opera but now lost, was written in 1597 by the Florentine poet Ottavio Rinuccini (1563–1621) and set to music composed by Jacopo Peri (1561–1633). The first still–extant opera is *Euridice* written collaboratively by Camerata members Rinuccini, Peri, and Caccini in 1600 for the wedding celebration of Henry IV of France and Maria dé Medici in Florence. In the following year, each composer published his own version of the opera. Both Peri and Caccini differentiated only subtly between monody and recitative.

The most important opera composer in the first half of the seventeenth century was Claudio Monteverdi (1567–1643), whose *Orfeo*, in 1607, assimilated the new techniques of the Camerata and achieved much greater dramatic expression. His music is the first in which there is a clear division between aria and recitative.

Roman Opera

Rome became the center of opera development in the 1630s. Roman opera was based more on religious subjects than on Greek mythology, and it made more use of choruses. Distinctions between recitative and aria were finely drawn.

The principal composers were Stefano Landi (ca. 1586–1639), who composed *Saint Alexis* (*Santo Alessio*), and Luigi Rossi (1598–1653), whose principal opera was another *Orfeo*.

Venetian Opera

Shortly before the middle of the century, Venice assumed the leadership that it retained to the end of the century. Until the first public opera house, Teatro San Cassiano, was opened in Venice in 1637, opera had been primarily a spectacle for the wealthy.

The principal characteristics of Venetian opera were (1) more emphasis on formal arias; (2) the beginning of *bel canto* ("beautiful singing") style, and more attention to vocal elegance than to dramatic expression; (3) less use of choral and orchestral music; (4) complex and improbable plots; (5) elaborate stage machinery; and (6) short fanfarelike instrumental introductions, the prototypes of the later overture.

The principal composers of the Venetian school were Pier Francesco Cavalli (1602–1676), who wrote *Giasone*, and Marc' Antonio Cesti (1623–1669), whose most important opera was *Il Pomo d' oro*. Claudio Monteverdi's last operas, produced in Venice, were *Il Ritorno d' Ulisse* and *L'Incoronazione di Poppea*. Later Venetian composers were Antonio Sartorio (ca. 1630–1680) and Giovanni Legrenzi (1626–1690).

Neapolitan Opera

A school of composers in Naples emerged in the second half of the century and dominated European opera in the early eighteenth century. In general, Neapolitan operas were more formalized and artificial from the dramatic standpoint. They consisted mainly of *da capo arias* (*ABA* sectional structure). Another type of aria introduced by the Neapolitans was the *siciliana*, in slow tempo, $\frac{6}{8}$ meter, and usually a minor key. Choruses were almost nonexistent, and the orchestra was relegated to a subordinate accompanying role. Less important than arias, recitatives were composed in two styles: (1) "dry recitative" (*recitativo secco*), which was a declamatory melody with sparse basso continuo accompaniment, and (2) "accompanied recitative" (*recitativo accompagnato*, also called *recitativo strumento*), which employed a more active orchestral accompaniment for especially dramatic passages of dialogue. Still another style of operatic song was the *arioso*, a dramatic compromise between recitative and aria. *Castrati* (male sopranos) reigned supreme as the opera stars of the day, and they were responsible for the excesses of showy virtuosity with improvised display of vocal gymnastics. The Italian overture, called *sinfonia*, was established as a formal plan in three sections: fast–slow–fast. The sinfonia was the forerunnner of the later classical symphony.

The central figure of Neapolitan opera was Alessandro Scarlatti (1660–1725), who composed some 114 operas. Other composers were Alessandro Stradella (1642–1682), Carlo Pallavicini (1630–1688), Francesco Provenzale (1627–1704), Agostino Steffani (1654–1728), Nicola Porpora (1686–1768), Leonardo Vinci (1690–1730), Attilio Ariosti (1666–ca. 1740),

and Giovanni Bononcini (1670–1747). German–born George Frideric Handel (1685–1759), in London, was the last composer of Neapolitan–style operas in the Baroque.

French Opera and Ballet

France developed an indigenous opera to a greater extent than any other country outside Italy, but that development did not come until the second half of the seventeenth century.

French opera was strongly influenced by two flourishing national institutions: the court ballet, and the dramas of Corneille, Racine, and Molière. As compared to Italian opera, the outstanding traits of French opera were (1) use of ballet; (2) greater importance of the drama; (3) more use of the orchestra and instrumental music; (4) shorter and simpler dancelike airs; (5) careful attention to accentuation of the text; (6) more expressive and melodic recitative; (7) less emphasis on virtuosity; and (8) the *French overture*, which became an important instrumental form in the Baroque. The French overture consisted of two sections, each repeated: the first in slow tempo and dotted rhythm, the second in lively tempo and of imitative texture. Later, the French overture included a third section in slow tempo, similar to the first.

Ballet

Court dances with costume and scenery, but without singing or spoken dialogue, were common in the Renaissance. The earliest extant ballet music was the *Ballet comique de la Reine* in 1581. Royalty customarily took part in the performances of ballets that flourished in the court of Louis XIV at Versailles. Jean Baptiste Lully's (1632–1687) *Ballet de la nuit* was a court ballet. Lully and Molière collaborated to create a new form, the *comédie–ballet*, which was a combination of play and ballet. *Le Bourgeois gentilhomme* was the most famous of these. Later, Lully introduced ballets into his operas, which he called *tragédies–lyriques* or *opéra–ballets*.

Composers

The first opera in the French language was called *Pastorale* and was written in 1659 by Abbé Pierre Perrin (ca. 1620–1675), librettist, and Robert Cambert (ca. 1628–1677), composer. It marked the opening of the Royal Academy of Music in Paris.

Lully was the leading composer of French opera and ballet in the second half of the seventeenth century. In addition to his court ballets and comédie–ballets, his principal works (tragédies–lyriques) were *Cadmus et Hermione*, *Alceste*, *Amadis*, and *Armide*.

The principal operas by Jean Philippe Rameau (1683–1764), who represents the culmination of French Baroque opera, are *Hippolyte et Aricie* and *Castor et Pollux*.

English Dramatic Music
Indigenous serious opera never achieved the popular following in England that it did in Italy and France. Many Italian operas were performed in London. The principal types of theater music in England were the *masque*, *incidental* and *entr'acte music*, and *ballad opera*.

Opera

Two works represent virtually the entire repertory of serious English opera. One was *Venus and Adonis* by John Blow (1649–1708); the other was *Dido and Aeneas* by Henry Purcell (1659–1695), the most important English composer of the middle Baroque.

Masque

A kind of theatrical court entertainment called *masque* was in vogue in England in the seventeenth century. Masques, which were lavish productions performed privately for nobility, are plays based on mythological and allegorical subjects, and they included songs (called *ayres*), poetry readings, dances, choruses, instrumental pieces, and occasionally recitatives. A famous masque was *Comus*, by poet John Milton, with music by Henry Lawes (1596–1662).

Incidental and Entr'acte Music

A significant amount of incidental music was written to be performed during the action of plays, and entr'acte music for performance between scenes or acts. The latter consisted of instrumental pieces, called *act tunes* or *curtain tunes*. Examples of incidental music are Purcell's music for *The Fairy Queen* (after Shakespeare's *A Midsummer Night's Dream*) and *King Arthur*. Entr'acte music is represented by *Instrumental Musick used in "The Tempest"* by Matthew Locke (ca. 1630–1677) and Purcell's music for *Dioclesian*. Incidental and entr'acte music for some plays was so extensive that they approached true opera.

German Dramatic Music
A dearth of indigenous opera in Germany was due to the impact of Italian opera in that country, and also to the cultural disruption of the Thirty Years' War. Furthermore, there was little German libretto literature of sufficient quality.

Aside from an early opera by Heinrich Schütz (1585–1672), *Daphne* (now lost), nearly all operatic activity in Germany consisted of Italian operas performed by Italian companies. Even German composers were for a while content to write operas in Italian style to Italian texts. *Costanza e fortezza* by Johann Fux (1660–1741) was such an opera. Italian opera flourished in Vienna, Munich, and Dresden.

German opera, called *Singspiel*, began in Hamburg, where an opera house opened in 1678 with *Adam und Eva* by Johann Theile (1646–1724).

Other names connected with Hamburg opera were Reinhard Keiser (1674–1739) and Georg Philipp Telemann (1681–1767).

COMIC OPERA

Comic opera emerged in the early eighteenth century primarily as a reaction to Italian serious opera (*opera seria*). It was a dramatic genre in which elements of humor, parody, and satire were prominent.

Comic opera differed from serious opera in several respects: (1) Light, frivolous, and humorous subjects were used; (2) commonplace characters replaced the exalted or heroic figures of serious operas; (3) except in Italian comic opera, spoken dialogue replaced the recitatives of serious opera; (4) popular tunes replaced the dramatic and formal arias; (5) ensemble finales of soloists and chorus became common features at the conclusions of acts; and (6) characters, aria texts, and melodies of serious operas were often parodied.

Comic opera was generally more indigenous than serious opera, and it developed somewhat differently in different European countries.

Italian Opera Buffa

Comic opera in Italy, called *opera buffa*, originated as intermezzi between acts of serious operas. Early in the eighteenth century it emerged as an independent form, principally in Naples. Opera buffa employed recitative more than spoken dialogue. Choral finales were typical. A famous opera buffa was *La Serva padrona* by Giovanni Pergolesi (1710–1736). Other composers of them were Alessandro Scarlatti and Baldassare Galuppi (1706–1785).

French Opéra Comique

French comic opera, known as *opéra comique*, originated in the early eighteenth century as a form of popular entertainment. The tunes in opéra comique were called *vaudevilles*. However, originally composed comic operas were not produced in France until the second half of the eighteenth century. An early opéra comique was *Le Devin du village* (1752), by philosopher–musician Jean Jacques Rousseau (1712–1778).

English Ballad Opera

A form of comic opera, called *ballad opera*, flourished in England in the second quarter of the eighteenth century. They employed well–known tunes, often borrowed from the serious Italian operas that they parodied. The most famous ballad opera is *The Beggar's Opera*, by librettist John Gay (1685–1732), with songs arranged by John Pepusch (1667–1752).

**German
Singspiel**

The word singspiel meant serious opera at the beginning of the eighteenth century. About the middle of the century it came to designate German comic opera. The first singspiels were translations of English ballad operas, but in the second half of the eighteenth century they were originally composed works. The principal composer was Johann Adam Hiller (1728–1804).

**Spanish
Zarzuela**

Serious opera did not develop in Spain. A popular dramatic form, akin to opera buffa, was the zarzuela, an example of which is *Celos aun del ayre matan* by Juan Hidalgo (ca. 1612–1685).

VOCAL CHAMBER MUSIC

Though less important than opera, a considerable literature of nontheatrical vocal music was composed in the Baroque. Classified as vocal chamber music, it was for a few performers and an intimate audience in a small room. Two general types of vocal chamber music are *solo songs* and *chamber cantatas*.

Solo Song

By 1600 an impressive literature of solo songs with lute accompaniment already existed in Spain and England. Solo songs continued to be composed during the Baroque, principally in Italy, Germany, and England.

Italian Song

The Baroque was ushered in by Italian monody, the first collection of which was Giulio Caccini's *Le Nuove musiche* with its solo songs and instrumental accompaniment. Also in the early Baroque were the Italian solo madrigals such as Claudio Monteverdi's *Fifth Book of Madrigals*. Such works were the forerunners of the Italian secular cantata in the second half of the century.

German Lied

In the second half of the seventeenth century an important school of lied composers developed. Lieder were often published in sets. The composers were Adam Krieger (1634–1666), Johann Theile, Philipp Erlebach (1657–1714), Johann Scholze (also known as Sperontes, 1705–1750), and Georg Philipp Telemann.

English Song

Two collections of English solo songs were *Amphion Anglicus* by John Blow and *Orpheus Britannicus* by Henry Purcell.

A favorite form among seventeenth–century English composers was the *catch*, an a cappella vocal canon or round, often based on ribald and humorously witty texts. John Blow, William Lawes (1602–1645), Henry Purcell, and many other composers wrote catches.

Chamber Cantata

In the second half of the seventeenth century an important form of secular vocal music emerged in Italy—the chamber cantata (*cantata da camera*). Chamber cantatas were short, nontheatrical compositions (that is, not performed on a stage with acting, scenery, costumes, and dialogue), based on texts of a somewhat narrative character. Composed for one or two solo voices with basso continuo accompaniment, they consisted of secco recitatives alternating with da capo arias, usually two or three of each.

Composers

Alessandro Scarlatti, with more than six hundred chamber cantatas, represents the summit of Italian cantata composition. Most Italian opera composers wrote cantatas, including Luigi Rossi, Giacomo Carissimi (1605–1674), Marc′Antonio Cesti, Giovanni Legrenzi, and Alessandro Stradella.

French chamber cantatas, which were influenced by Italian models, were composed by Marc–Antoine Charpentier (ca. 1645–1704), André Campra (1660–1744), Louis Clérambault (1676–1749), and Jean Philippe Rameau.

German composers of chamber cantatas (*Kammerkantate*) were Reinhard Keiser, Georg Philipp Telemann, and Johann Sebastian Bach (1685–1750), who composed some twenty secular cantatas, the most famous of which are the *Coffee Cantata*, the *Peasant Cantata*, and the *Wedding Cantata*.

In England, Henry Purcell composed nine secular cantatas for two or more voices, and, for special occasions, a large number of works called *odes*, for solo voices, chorus, and orchestra. These works fall outside the category of chamber music because of the larger resources involved.

Scores and Recordings

Several of the following examples are drawn from larger works.
Opera: NAWM 70–82, 121, and 122; NSI 16, 19, and 22
Madrigals: NAWM 66–68

17

Religious Music

Although overshadowed and strongly influenced by opera, religious music constituted a significant portion of Baroque literature. It falls into two broad classes: liturgical and nonliturgical music.

LITURGICAL MUSIC

Liturgical music, composed for use in a church ritual, continued to develop in both branches of Christian religion. The forms and styles of opera permeated Catholic and Protestant music alike.

Catholic Music

More than any other type of music, Catholic music manifested Baroque dualism. Throughout the seventeenth century the conservative stile antico existed side–by–side with stile moderno, often within the works of a single composer.

Mass and Motet

Settings of the Ordinary and motets for the Proper and Offices were composed in both styles. The a cappella tradition was preserved in the Sistine Chapel in Rome, and elsewhere there were strong adherents of the Renaissance polyphonic style. On the other hand, masses and motets were also composed in the new dramatic style, and were often musically indistinguishable from opera. They used solo voices (e.g., in arias and duets), concertato effects with one or more choruses, and instrumental groups; there was no place, however, for recitative in the mass. Polychoral writing, which began in the Venetian school late in the sixteenth century, was not neglected in the seventeenth century.

Schools and Composers

The earliest example of stile moderno church music, *Cento concerti ecclesiastici*, composed in 1602 by Lodovico Grossi da Viadana (1564–1645), was a collection of a "hundred church pieces" for one or more solo voices with basso continuo. An example of the imposing Baroque style was a festival mass composed by Orazio Benevoli (1605–1672) in fifty–three parts, for two eight–part choruses, soloists, and instrumental choirs with basso continuo. Most Italian opera composers wrote church music. An example of late–Baroque dramatic style is *Missa di Santa Cecilia* by Alessandro Scarlatti (1660–1725).

Munich, Salzburg, Prague, and Vienna became important centers of church music outside Italy. Among numerous Italian and Austrian composers were Claudio Monteverdi (1567–1643) at San Marco in Venice, Christoph Strauss (ca. 1575–1631), Johann Stadlmayr (ca. 1575–1648), Giovanni Valentini (1582–1649), Antonio Bertali (1605–1669), Johann Schmelzer (ca. 1620–1680), Johann Kerll (1627–1693), Antonio Draghi (ca. 1634–1700), Marc Antonio Ziani (ca. 1653–1715), Alessandro Scarlatti, Giovanni Pergolesi (1710–1736), Antonio Caldara (ca. 1670–1736), and Johann Fux (1660–1741), who was one of the more conservative composers and the author of a famous treatise on counterpoint entitled *Gradus ad Parnassum*. Perhaps the greatest, and certainly the most famous, masterpiece in all Baroque Catholic music is the *Mass in b minor* by J. S. Bach (1685–1750).

French composers of Catholic music, mostly motets in cantata form, were Jean–Baptiste Lully (1632–1687), Marc–Antoine Charpentier (1634–1704), Michel Richard de Lalande (1657–1726), and François Couperin (1668–1733).

Protestant Music

The main developments in Protestant church music took place in Germany.

Church Cantata

The principal form of Protestant church music was the church cantata (*Kirchenkantate*), which became an integral part of the Lutheran service in the second half of the seventeenth century. Texts were taken from chorales and biblical passages. In the early eighteenth century, Erdmann Neumeister (1671–1756) and others wrote cycles of cantata texts. There were solo cantatas for one or more voices with continuo accompaniment, and there were cantatas on a larger scale employing solo voices (arias and duets), recitative, chorus, and orchestra. Chorale melodies were used extensively in choruses and in some arias. Lutheran cantatas concluded with the singing of the chorale by congregation and choir.

Composers

The leading composer of German Protestant music in the seventeenth century was Heinrich Schütz (1585–1672). His church music, in diverse forms and styles, ranged from conservative Renaissance–style motets to polychoric music and larger works that approached the cantata form. He made little use of chorale melody. His most important works include Latin motets (*Cantiones sacrae*), German motets (*Kleine Geistliche Konzerte*, also called sacred concertos) for solo voices with organ accompaniment, and *Symphoniae sacrae* for various media.

Schütz's predecessors were Hans Leo Hassler (1564–1612), Michael Praetorius (1571–1621), Johann Hermann Schein (1586–1630) and Samuel Scheidt (1587–1654). Middle– and late–Baroque composers were Franz Tunder (1614–1667), Andreas Hammerschmidt (ca. 1611–1675), Dietrich Buxtehude (1637–1707), Johann Pachelbel (1653–1706), Johann Kuhnau (1660–1722), and Georg Philipp Telemann (1681–1767). The master of the church cantata was J. S. Bach, who composed over two hundred cantatas.

English Church Music

Anglican services and anthems continued to be composed in the Baroque. The older cathedral anthem in Renaissance motet style and the later verse anthem reflected Baroque dualism. Although they used solo voices, chorus, and instrumental accompaniment, verse anthems were more conservative and less influenced by opera than most church music on the Continent. Principal composers were John Blow (1649–1708), Henry Purcell (1659–1695), Pelham Humfrey (1647–1674), and William Croft (1678–1727).

Instrumental Church Music

Two forms of instrumental church music, the *organ chorale prelude* and the *church sonata*, will be discussed under organ music and chamber music, respectively, in the following chapter.

NONLITURGICAL MUSIC

Nonliturgical music is music based on religious subjects but not intended to be performed as part of a church service. The principal category of nonliturgical music is *oratorio*.

Oratorio

About the middle of the seventeenth century, oratorio emerged as a religious form distinct from opera and liturgical music.

Components

In its mature form, oratorio employed most of the musical components of opera: arias and duets for solo voices, recitative, chorus, overture, and other instrumental pieces; but, except in its earliest stages, it made no use of dramatic scenery, or costumes. Oratorio differs from opera in two additional respects: it employs a narrator (called *testo* or *historicus*) who tells the religious story in recitative, and it makes considerably more use of chorus than opera does.

Two types of Italian oratorios were the *oratorio Latino*, with Latin texts, and *oratorio volgare*, with Italian texts. The former disappeared in the second half of the seventeenth century.

Origins

Religious plays with music were common in the Middle Ages and Renaissance. In the late sixteenth century, Filippo Neri, a priest, organized informal devotional meetings held in a Roman prayer chapel called the *oratory*, where laudes and religious dialogues were performed. One of the latter was an allegorical play with monodic music by Emilio dé Cavalieri (ca. 1550–1602), entitled *The Play of Soul and Body* (*La Rappresentazione di anima e di corpo*), produced in Rome in 1600. This work is considered to be the earliest prototype of oratorio. Later, the religious operas of the Roman school, such as Landi's *Santo Alessio*, approached the realization of true oratorio, except that they were fully staged theater works.

Composers

The first composer of oratorios was Giacomo Carissimi (1605–1674), whose *Jephte*, *Judicium Salomonis*, and others were composed on Latin texts.

Marc–Antoine Charpentier, a French pupil of Carissimi, wrote oratorios in both French and Latin (*Le Reniement de St. Pierre*). Successors of Carissimi were Antonio Draghi, Alessandro Stradella (1642–1682), Alessandro Scarlatti, Antonio Lotti (ca. 1667–1740), Antonio Caldara (ca. 1670–1736), and Leonardo Leo (1694–1744).

The culmination of Baroque oratorio is represented by George Frideric Handel (1685–1759), who in his later years abandoned opera for oratorio, and established a long tradition of that form in England. His eminence in the field of oratorio rests primarily on his superb mastery of choral technique. Best known among his more than twenty oratorios are *Samson*, *Israel in Egypt*, *Judas Maccabaeus*, *Solomon*, and the famous *Messiah*, composed in Dublin in 1741.

Passion Music

Presentation of the Easter story, the Passion, according to the gospels of the Evangelists Matthew, Mark, Luke, and John, has a long history dating

back to the early Christian Era. Musical settings of the Passion sometimes have been liturgical, sometimes nonliturgical in oratorio form.

Gospel Recitation

From about 300 to 1100 a.d. it was common practice to have the gospels recited in church during Holy Week.

Plainsong Passion

In the twelfth century the Passion story was presented as a play in which the part of Christ was sung in a low register by a priest, the part of the Evangelist–narrator was sung in a middle register by another priest, and the part of the crowd (*turba*) was sung in a high register by a third priest. This was done in a psalmodic chant style.

Polyphonic Passion

In the Renaissance, composers began using polyphony, at first setting only the exclamations of the turba in motet style. Polyphonic Passions were composed by most of the sixteenth–century masters, including Giovanni Pierluigi da Palestrina (ca. 1525–1594).

Oratorio Passion

With the advent of dramatic styles in the seventeenth century, it was not long before Passions were composed in oratorio fashion. Early examples are the *Resurrection Story* and the *Seven Last Words* by Heinrich Schütz.

Chorale Passion

The importance of the chorale in the Lutheran service ultimately affected settings of the Passion, and, early in the eighteenth century, chorales were added as reflective elements in oratorio Passions. A famous chorale Passion is J. S. Bach's St. Matthew Passion, in which the chorale "O Sacred Head" by Hans Leo Hassler is used in this way.

Religious Songs

Apart from chorales and arias from oratorios and cantatas, religious solo songs constituted a relatively small and unimportant part of Baroque religious music.

Scores and Recordings

The following items are mostly selections from larger works.

Mass: NAWM 91

Cantata: NAWM 90; NSI 26

Oratorio: NAWM 86 and 89; NSI 23

Motet: NAWM 83 and 85

Sacred concerto: NAWM 84 and 87

Verse anthem: NAWM 88

18

Instrumental Music

During the Baroque, instrumental music for the first time became as important as vocal music, in quality as well as in quantity.

MUSICAL DEVELOPMENTS

Between 1600 and 1750 notable developments took place in various aspects of instrumental concepts and practice. Some characteristics apply more–or–less equally to the entire period; others evolved gradually or else made their appearance late in the period.

Instrumental Idiom

Although awareness of the special properties and capacities of instruments was evident to a limited extent in some Renaissance music, instrumental idiom was fully developed during the Baroque.

Basso Continuo

The *basso continuo* (or *thoroughbass*), a purely instrumental concept, lent a characteristic prominence to bass parts in all categories of ensemble music. It is one of the most distinct and consistent features of the Baroque as a whole. Functioning as both melodic and harmonic bass, it was played by a combination of two kinds of instruments: (1) one or more melodic instruments (viola da gamba, cello, or bassoon) and (2) a keyboard instrument (organ or harpsichord) or lute. The basso continuo part was written in the bass clef with numerals and accidentals below the notations, a musical shorthand known as *figured bass*. It was the duty of the keyboard or lute performer to fill in the harmony dictated by the numerals, a procedure called *realizing* the figured bass. Numerals indicated the characteristic interval above the bass note. For instance, a 6 indicated a first–inversion chord, a 7

designated a seventh chord. Absence of a numeral meant a chord in root position. A sharp, flat, or natural sign by itself indicated the corresponding alteration of the third of the chord. A line through a numeral indicated a raised upper note of that interval. Some of these signs are illustrated in Example 18.1, a figured bass, along with its harmonic realization.

Example 18.1 Figured Bass and Realization

Improvisation

Improvisation was an important discipline in the Baroque, and generally more important in instrumental than in vocal music. In addition to originally improvised music on solo instruments, it played an important role in the realization of figured bass, in ornamentation, and in improvisations on a given theme. These improvisatory aspects create problems today in the performance and understanding of Baroque music.

Variation

The principle of thematic variation permeated much instrumental music, even in forms that were not primarily based on structural variation.

Sequence

Repetition of melodic patterns on successively higher or lower pitches became a typical feature of instrumental music in the middle Baroque. Harmonic progressions suggested by melodic sequences were often used to modulate to other keys.

Ensemble Media

A clearer distinction between chamber and orchestral media was established in the late seventeenth century.

Tuning

Equal–tempered tuning of keyboard instruments replaced the older method, called *meantone intonation*, in the late Baroque. J. S. Bach's (1685–1750) *Well–Tempered Clavier*, in two volumes, each containing twenty–four preludes and fugues in all the major and minor keys, was composed partly to demonstrate the equal utility of all the keys in the new system of tuning.

INSTRUMENTS OF THE BAROQUE

Most of the instruments used in the Renaissance continued to be used throughout the Baroque, but all underwent further technological improvement during the period. The violin family emerged toward the end of the seventeenth century.

Keyboard Instruments

Keyboard instruments were used for basso continuo parts and for solo music. Three keyboard types were clavichord, harpsichord, and organ.

Clavichord

The clavichord produced tone by means of a metal wedge that struck the string when the key was depressed (see Example 18.2). It had a weak tone but was capable of producing delicate shades of dynamics. It was used principally in Germany and was limited to solo and small–ensemble music in the home.

Example 18.2 Clavichord action.

Harpsichord

The harpsichord was known under several names: *clavecin* (French), *clavicembalo* (Italian), *virginal* (English, 16th and early seventeenth centuries), and by the German words *Klavier* or *Clavier*, which meant either harpsichord or clavichord. The harpsichord usually had two manuals (keyboards). Its tone, produced by quills that plucked the strings mechanically when a key was depressed, was stronger than that of the clavichord, but it was incapable of producing dynamic shading. Being the principal basso continuo instrument, the harpsichord was one of the most distinctive sounds in Baroque ensemble music. It was perhaps the most favored medium for solo compositions.

Piano

The piano, originally called *gravicembalo col piano e forte*, was invented in 1709 by Bartolomeo Cristofori (1655–1731) in Florence. Despite the significance of the new hammer and escapement action, the piano was not

generally used until late in the eighteenth century, and virtually no Baroque music was composed for this instrument.

Organ

The Baroque organ possessed a greater variety and power of tone than the Renaissance organ. It was primarily associated with church music, both as solo and accompanying instrument. There was a remarkable growth of idiomatic organ literature.

Stringed Instruments

Types of stringed instruments in general use between 1600 and 1750 changed appreciably.

Viols

Instruments of the viol family were the principal strings during the seventeenth century, but around 1700 they were being replaced by the new instruments of the violin family.

Violin Family

The eighteenth century found viols replaced by violins, violas, and cellos. The bass viol (contrabass or double bass) was retained from the viol family. The master violin makers came from three families in Cremona, Italy, the most famous members of which were Nicolo Amati (1596–1684), Giuseppe Bartolomeo Guarneri (1698–1744), and Antonio Stradivari (1644–1737). The violin sound became the dominant timbre in late–Baroque ensemble music.

Lute

The lute lost its place of eminence during the seventeenth century. A small amount of lute music was composed in France and Germany. In Spain, the vihuela was replaced by the guitar.

Wind Instruments

The principal woodwind instruments were the oboe, bassoon, and flute. The older end–blown recorders were still being used in the late Baroque, but the transverse flute was also commonly employed as a solo and ensemble instrument.

Brass instruments included various kinds of trumpets, horns, and trombones, which were employed mostly in large ensembles, rarely as solo instruments.

Percussion Instruments

Timpani were the only percussion instruments in general use, and they were employed only in unusually large orchestras.

INSTRUMENTAL GENRES

Most instrumental genres of the first half of the seventeenth century were first developed in the Renaissance. New ones emerged mainly in the second half of the century.

Terminology

It must be emphasized that terminology regarding form in the Baroque was often loosely applied and ambiguous. A given term sometimes implied one type in the early Baroque and something quite different later on. In some instances a single term was applied to several different genres; in others, different terms were used for one type of composition. In the following classifications it will be noted that overlapping occurs: a form name in one category may appear again in another classification.

Imitative Forms

In this category are contrapuntal forms based primarily on systematic imitation of one or more themes.

Early Forms

Forms that carried over from the Renaissance were the *ricercare, canzona, fantasia,* and *capriccio.* Compositions so named were composed for keyboard instruments and ensembles. The contrapuntal fantasia was primarily for ensembles of viols. The sectional canzona was the forerunner of the sonata. After 1650 these older forms were generally replaced by the fugue.

Fugue

By the end of the seventeenth century the monothematic *fugue* (also *fuga*) had reached a certain degree of standardization. Each voice in turn introduced the theme, alternating between *subject* in the tonic key and *answer* in the dominant key. *Episodes* between statements of the subject were characteristically modulatory, and sequential in structure. Within this general framework, there was much flexibility of procedure and style. Fugues were composed in all media, including choral ensembles. They were composed as independent pieces and also as movements in larger works.

Variation Forms

The principle of thematic variation was used in several genres outside this classification, including canzona, dance suite, and cantus firmus compositions. Keyboard instruments were the principal media for variation forms. In Italy during the first half of the seventeenth century, variations on a popular theme were called *partitas* (a term also used later for suites). Other terms for Baroque variations were *passacaglia, chaconne,* and *ground.* The latter form, used chiefly in England, was a short recurrent theme in the bass

over which the counterpoint continuously changed. Pieces called passacaglia and chaconne sometimes used this plan, and at other times they were somewhat free variations on a harmonic progession.

Cantus firmus variations, especially important in Germany, consisted of restatement of a chorale melody in its entirety, each statement in a different contrapuntal setting.

Dance Suite

As in the Renaissance, dance music was an important category. Stylized, nonfunctional dances were mostly composed in groups called *suites* or *partitas*. Media for dance music were harpsichord, chamber ensemble, and orchestra.

There was no standard number, type, or order of movements in the suite. With few exceptions, the movements of a suite were all in the same key. The form of individual dance movements was almost always *binary*. Baroque binary form consisted of two sections, each repeated. The first section modulated to the dominant key (or relative major); the second section began in the contrasting key and modulated back to the tonic key at the end. The dance movements most commonly appearing in the late Baroque were the *allemande* (or *allemanda*), *courante* (or *corrente*), *sarabande* (or *sarabanda*), and *gigue* (or *giga*).

Allemande

The allemande was usually moderately fast, in duple meter, and began with an eighth– or sixteenth–note upbeat. It was probably of German origin (*allemande* is the French word for "German").

Courante

The courante was in triple meter, sometimes combining or alternating $\frac{3}{2}$ and $\frac{6}{4}$ meters. It was in a faster tempo than the allemande (*courant* means "running" in French). It, too, usually began with a short upbeat.

Sarabande

The sarabande, of Spanish origin, was in triple meter and a slow tempo, and employed one or both of these rhythmic patterns: ♩.♪♩ and ♩♩.♩

Gigue

The gigue was usually the final dance in the late Baroque suite. It was normally in compound triple meter ($\frac{6}{8}$, $\frac{9}{8}$, or $\frac{12}{8}$) and lively tempo. Its texture was generally more imitative than that of the other movements.

Other Dances

One or more of the following dances were often included in suites, usually between the sarabande and gigue: gavotte, bourrée, minuet, loure,

polonaise, rigaudon, and passepied. It was not uncommon for a dance movement to be followed by an ornamental version, called a *double*.

Nondance Movements

Baroque suites usually began with a prelude. Other nondance movements appearing in suites were fugues, variations, and airs.

Chorale Prelude

The most important category of German Baroque organ music was the *chorale prelude*, a form of instrumental church music. The term chorale prelude is used here to include all organ compositions in which the material was derived from a chorale melody identified in the title. The four main types of chorale preludes are *cantus firmus*, *coloration*, *partita*, and *fantasia*.

Cantus Firmus Chorale

The most common type presented the chorale melody continuously as a cantus firmus in longer note values against faster–moving counterpoint, either derived from or independent of the chorale melody. The cantus firmus could appear in any part, including that of the foot pedals. In some chorale preludes the phrases of the chorale were separated by short interludes of continuing counterpoint in the accompanying parts. Another style introduced each phrase of the chorale in imitative counterpoint preceding the cantus firmus in longer notes.

Coloration Chorale

The type known as coloration chorale stated the chorale melody in the top part as a cantus firmus, but in a highly ornamented version that disguised the original melody.

Chorale Partita

Sets of variations on a chorale tune were called chorale partitas. In each variation, called a *verse*, the chorale melody itself was modified, or else it was kept intact as a cantus firmus while the style of accompanying counterpoint changed.

Chorale Fantasia

A composition in which the counterpoint in all parts was freely derived from a chorale melody was called a chorale fantasy (or fantasia). Chorale preludes of this type were sometimes written as trios with one part for each manual (keyboard) and a third part in the pedals. These were called *chorale trios*. *Chorale fugues* or *fughettas* derived subjects freely from one or more phrases of a chorale that were treated in fugal style but without a continuous cantus firmus in any voice.

Improvisatory Forms

Keyboard compositions bearing the titles *toccata*, *prelude*, or *fantasia* appeared frequently in the Baroque. These terms implied no specific struc-

ture or style, nor was there any basic distinction among them. The predominant characteristic was an improvisatory effect. Such pieces variously included sections featuring sustained chords, rapid scales, figuration, and contrapuntal textures. They lacked any distinct thematic material and any formal unity. In the late Baroque they were often paired with a fugue in the same key, resulting in such titles as *Toccata and Fugue in d minor* and *Fantasia and Fugue in g minor*. The genre was associated with Italy in the early Baroque, but had spread by the end of the seventeenth century.

Sonata

No word in Baroque terminology is more imprecise than *sonata*. In the course of the Baroque it had quite different implications of style, form, and medium.

Origin

The term "sonada" appeared as early as 1535 in a collection of lute music by Luis de Milán (ca. 1500–ca. 1561). A famous early composition that contained the word is *Sonata pian' e forte* (1597) for two choirs of brass instruments, composed by Giovanni Gabrieli (ca. 1554–1612). Thus, in its early use, "sonata" meant nothing more than a composition for instrumental medium—as opposed to cantata, a vocal composition.

Between 1600 and 1650 instrumental canzonas were composed in several sections contrasting in tempo and meter. These sections became longer and fewer, ultimately evolving into separate movements so that by 1650 the canzona had merged with the sonata, and the latter term replaced the former.

Media

In the second half of the seventeenth century, multimovement sonatas were written for small chamber media: unaccompanied *solo sonatas* for violin or cello, accompanied solo sonatas for different instruments with basso continuo, and *trio sonatas*, the most important chamber media in the middle and late Baroque. The latter were written on three staves for two solo instruments and basso continuo played by a cello and keyboard instrument.

Sonata da chiesa

The *sonata da chiesa* (literally, *church sonata*) evolved in Italy after 1650. It consisted of several movements contrasting in tempo and texture. By the late Baroque the church sonata was mostly in four movements with tempos indicated according to the slow–fast–slow–fast plan. The trio church sonata was intended to be performed (like ricercare, canzoni, and toccatas) in parts of the service, and it employed the organ in the continuo part. Some of the movements, especially the last, had a distinctly dancelike character, though they were not labeled as such.

Sonata da camera

The *sonata da camera* (literally, *chamber sonata*), or partita, was in effect a suite of dance movements bearing such titles as (in Italian) allemanda, corrente, sarabanda, giga, and so on. Trio chamber sonatas employed the harpsichord for the continuo part.

In the late Baroque, the distinction between church and chamber trio sonata forms became less clear, and sonatas often included dance names for some movements and only tempo indications for others.

Tower Sonatas

In Germany in the seventeenth century pieces called *tower sonatas* (*Turmsonaten*) were composed for small ensembles of wind instruments. They were intended for performance at certain hours of the day from municipal towers or church steeples. This literature is represented by a collection titled *Hora Decima*, by Johann Pezel (1639–1694).

Keyboard Sonatas

Solo sonatas for harpsichord, introduced at the end of the seventeenth century, constitute a relatively small portion of Baroque instrumental literature. Johann Kuhnau (1660–1722) in Germany was one of the principal composers.

Orchestral Music

A clearer distinction between chamber and orchestral media became evident toward the end of the seventeenth century. Form terminology typically lacked standardization in such genres as sinfonia, overture, and concerto, terms that occasionally applied to smaller instrumental media.

Concerto

The term *concerto* was first used to designate a composition for voices with separate instrumental parts as, for example, in *Cento concerti ecclesiastici* by Lodovica da Viadana (1560–1627). Around the mid–seventeenth century the term came to mean an instrumental composition in which there were opposing instrumental groups in typically Baroque concertato style.

Concerto Grosso

The most important form of Baroque orchestral music was the *concerto grosso*. Exemplary of Baroque dualism, it was constructed on the basis of a group of two or three solo instruments (*concertino*) opposing the full orchestra (*ripieno* or *tutti*), often in alternating and contrasting sections within a movement.

Solo Concerto

The latest to develop was the concerto for one instrument and orchestra. At the end of the Baroque it was standardized in a three–movement form.

The fast–slow–fast plan of movements has remained constant until the present.

Other Orchestral Forms

Orchestral music was also composed in the form of overtures (French overture and Italian sinfonia), individual dances, and dance suites. No small portion of Baroque orchestral music was that written as components of operas, oratorios, and other large vocal works.

The Orchestra

The Baroque orchestra also lacked standardization. It was composed mainly of strings; wind and percussion instruments were used sparingly. The basso continuo was consistently the bass part of the orchestra. There was generally a lack of color definition in Baroque orchestration: instruments of different kinds doubled on each part.

SCHOOLS AND COMPOSERS

In the following summary the most important composers are listed according to nationality and, insofar as possible, identified with particular forms of media.

Italy

Composers of keyboard music were Girolamo Frescobaldi (1583–1643) in the first half of the seventeenth century and Bernardo Pasquini (1637–1710) in the second half.

Principal names in instrumental ensemble music were Maurizio Cazzati (ca. 1620–1677), Alessandro Stradella (1644–1682), Giovanni Vitali (1632–1692), Giuseppe Torelli (1658–1709), Francesco Geminiani (1687–1762), and Arcangelo Corelli (1653–1713), the most important composer of middle–Baroque ensemble music for strings. Antonio Vivaldi (1678–1741) dominated the field of solo concerto music in the late Baroque. The violin music of Giuseppe Tartini (1692–1770) spans both the late–Baroque and Preclassical periods.

Germany

Two composers of lute music were Esaias Reusner (1636–1679) and Leopold Weiss (1686–1750).

German composers of organ music, prominent throughout the Baroque, include Samuel Scheidt (1587–1654), the Dutch composer Jan Pieterszoon Sweelinck (1562–1621), Franz Tunder (1614–1667), Jan Reinken (1623–

1722), Dietrich Buxtehude (1637–1707), Johann Philipp Krieger (1649–1725), Georg Böhm (1661–1733), Johann Pachelbel (1653–1706), and Johann Kuhnau (1660–1722).

Composers of harpsichord music were Johann Froberger (1616–1667), Johann Caspar Ferdinand Fischer (ca. 1665–1746), whose *Ariadne Musica* of 1715 is a collection of preludes and fugues predating J. S. Bach's *Well–Tempered Clavier*, and Johann Kuhnau, whose *Frische Klavierfrüchten* of 1696 were the first harpsichord sonatas.

Ensemble music was composed by Johann Schein (1586–1630), Johann Rosenmüller (ca. 1619–1684), noted for solo and trio sonatas, Heinrich von Biber (1644–1704), whose fifteen solo violin sonatas employ unusual tuning of the strings called *scordatura*, Georg Muffat (1653–1704), Johann Jacob Walther (ca. 1650–1717), Johann Fux (1660–1741), and Evaristo dall'Abaco (1675–1742). Special mention should be made of Georg Philipp Telemann (1681–1767), who was one of the most versatile and prolific composers of the entire Baroque era, and who wrote instrumental music in all media and forms.

Johann Sebastian Bach (1685–1750)

Johann Sebastian Bach's organ chorale preludes in all forms, toccatas, preludes, fantasias, and fugues are the culminating works of Baroque organ music. His harpsichord music—suites, partitas, inventions, preludes, and fugues—also represent pinnacles in the representative genres. Bach's ensemble music includes accompanied and unaccompanied solo sonatas, six *Brandenburg Concertos* (concerti grossi), four orchestral suites, and concertos for violin and one to four harpsichords. The *Musical Offering* and the *Art of the Fugue* are unique masterpieces that, along with the *Well–Tempered Clavier*, are the ultimate achievements in Baroque counterpoint.

France

Denis Gaultier (1603–1672) was the principal French composer of lute music in the Baroque.

French clavecin music, noted for its rococo ornamentation (called *agréments*), delicacy, and refinement, consisted mostly of compositions in dance forms with fanciful titles. Principal names in the clavecin school were Jacques Champion de Chambonières (ca. 1601–1672), Jean–Henri d'Anglebert (1635–1691), and François Couperin (1668–1733). The culmination of French harpsichord music in the late Baroque was Jean–Philippe Rameau (1683–1764).

Organ music was composed by Jean Titelouze (1563–1633), Henry Du Mont (1610–1684), Nicolas Lebègue (1631–1702), Nicolas Gigault (ca. 1627–1707), Guillaume Nivers (ca. 1632–1714), André Raison (ca. 1650–1719), François Couperin, Louis Marchand (1669–1732), and Louis–Claude Daquin (1694–1772).

Marin Marais (1656–1728), viola da gambist for Louis XIV, wrote five books of pieces for that instrument. Jean–Marie Leclair (1697–1764) was the principal French composer of violin sonatas, trio sonatas, and concertos. French orchestral music from Jean-Baptiste Lully (1632–1687) to Rameau was largely dance music from operas and ballets.

England

The early seventeenth century in England was dominated by the last of the Elizabethan virginalists and the continuing tradition of ensemble music for viols. Thomas Tomkins (1572–1656) wrote keyboard pieces and string fantasias. In the latter category is also the music of John Jenkins (1592–1678), Henry Lawes (1596–1662), William Lawes (1602–1645), Matthew Locke (ca. 1630–1677), and Henry Purcell (1659–1695), whose fantasies in three, four, and five parts represent the last of the Renaissance–style consort music. Purcell also composed keyboard works, sonatas for chamber ensembles, and incidental and entr'acte music for orchestra.

Geroge Frideric Handel (1685–1759)

George Frideric Handel, though more important in the fields of opera and oratorio, composed seventeen harpsichord suites, solo sonatas for flute, recorder, violin, and oboe, and trio sonatas. His orchestral music includes twelve concerti grossi, twelve organ concertos, six woodwind ("oboe") concertos, and the famous *Water Music* and *Fireworks Music*.

Spain

The most important instrumental music in Spain in the Baroque was composed for organ by Juan Cabanilles (1644–1712), Sebastían Aguilera de Heredia (ca. 1565–1627), and José Elías (fl. 1715–1751).

Scores and Recordings

Organ: NAWM 97–101

Keyboard music: NAWM 102–106; NSI 25 and 27

Sonatas: NAWM 92 and 93

Concertos: NAWM 94–96; NSI 20 and 24

PART FIVE

THE CLASSICAL PERIOD

(1750–1820)

19

Introduction to the Preclassical and Classical Periods

1742	C.P.E. Bach: *Prussian Sonatas*
1752	Quantz: *On Playing the Flute*
1752	War of the Buffoons, Paris
1753–1762	C.P.E. Bach: *Essay on the True Art of Playing Keyboard Instruments*
1761	Haydn enters service of Esterházy
1762	Gluck: *Orfeo ed Euridice*, premiered in Vienna
1763	First major tour by Mozart (at age seven)
1768	Mozart: *Bastien und Bastienne*, his first singspiel
1770	Mozart's first string quartets
1770	Concertos for the piano by J. C. Bach
1771	Haydn: Op. 17 string quartets
1774	Gluck: *Orphée et Euridice*, premiered in Paris
1774	Goethe's *Sorrows of Young Werther*
1775–1783	American Revolution
1776	Charles Burney's *General History of Music*
1776	John Hawkins's *General History of the Science and Practice of Music*
1781	Leipzig Gewandhaus concerts begin
1784	Grétry: *Richard the Lion–Hearted* (first rescue opera)
1785	Mozart: *Haydn Quartets*

1786 Mozart: *The Marriage of Figaro*

1787 Death of Gluck

1787 Mozart: *Don Giovanni*

1788 Mozart: Symphonies nos. 40 and 41

1789–1794 French Revolution

1791–1795 Haydn: *London Symphonies*

1791 Mozart: *The Magic Flute*

1791 Death of Mozart

1796 Beethoven: Op. 2, first piano sonatas

1798 Haydn: *The Creation*

1798 Beethoven begins composing Op. 18 string quartets

1799 Beethoven: Symphony no. 1

1800 Haydn: *The Seasons*

1802 Beethoven's "Heiligenstadt Testament"; beginning of "Second Period"; "Moonlight" Sonata (Op. 27, no. 2)

1803 Beethoven: Symphony no. 3 ("Eroica"); *Fidelio*

1804 Beethoven: "Waldstein" Sonata (Op. 53)

1806 Beethoven: Op. 59, "Rasumovsky" string quartets

1808 Beethoven's Symphony nos. 5 and 6 premiered on same program

1809 Death of Haydn

1812 Beethoven: Piano Concerto no. 5 ("Emperor") premiered

1816 Beethoven's "Third Period" begins

1823 Beethoven: *Diabelli Variations*

1824 Beethoven: Symphony no. 9

1826 Beethoven: String Quartet no. 14 in c# minor (Op. 131)

1827 Death of Beethoven

This period was one of the most dynamic in the history of Europe. New ways of thinking, generally referred to as the Enlightenment, led the individual to assume an importance not held before. The era was therefore secular, rational, egalitarian, cosmopolitan, humanitarian, and progressive, and all of those tendencies found reflection in music. European art music became largely secular, it sought for a "natural" order and balance, it was accessible to large groups and classes of people as never before, it eventually achieved a continental style, and it came to venerate new ideas and expressions.

THE PRECLASSICAL PERIOD

The early years of the Classical period present a confusing array of stylistic trends. One finds diverse concepts of musical style, form, and medium at play, often simultaneously. These styles are collectively referred to as Preclassical. Primary among these are the *Rococo*, the *Empfindsamer Stil*, and, for lack of a more specific term, the *Preclassical*.

Rococo

The Rococo style was developed in France and ran from about 1720 to about 1775. It was a light, elaborate, and ornate style specifically opposed to the ponderous and grandiose Baroque style. Characteristically, it was less contrapuntal and relied more on ornamentation for its effect. Also called *style galant*, it was first heard in the works of the French clavecin school (especially François Couperin [1668–1733]) and other late–Baroque composers (Jean–Philippe Rameau [1683–1764] and Georg Philipp Telemann [1681–1767]).

Empfindsamer Stil

In Germany after 1750, the style galant came to be known as the Empfindsamer Stil, with an added element of heightened expressiveness. The highly emotional quality of this style reached a peak in the 1760s and 1770s, and is sometimes described as *Sturm und Drang* (storm and stress), a term applied to German literature of the period. Two of the sons of J. S. Bach (1685–1750) were important exponents of the Empfindsamer Stil: Wilhelm Friedemann Bach (1710–1784) and the highly–influential Carl Philipp Emanuel Bach (1714–1788).

Preclassical

Music that more generally represents the transition from the Baroque to the Classical is referred to as representative of the Preclassical style. Changes in concepts of form, style, and medium took place roughly from about 1740 to 1770. No clear line of distinction can be drawn between late

Baroque and Preclassical and early Classical style. Mixtures of styles often appeared in the works of the same composers.

Basic Changes

The old forms of the Baroque were gradually replaced by new sectional structures. Baroque counterpoint was generally abandoned in favor of homophonic textures. The basso continuo disappeared. New instrumental media emerged. These changes were the result of experimentation by numerous composers in different geographical regions.

Composers

Another of J. S. Bach's sons, Johann Christian Bach (1735–1792), achieved great renown in London, where he was one of the first to write for the piano. Giuseppe Tartini (1692–1770) was a prolific Preclassical composer of violin concertos and sonatas. Johann Quantz (1697–1773) wrote an important treatise on flute playing and composed flute sonatas and concertos during this period. Domenico Scarlatti (1685–1757), the son of Alessandro Scarlatti (1660–1725), spent most of his adult life in Spain, where, under almost no influence, he composed some 555 highly inventive harpsichord sonatas (which he called *essercizi*), generally in binary form and of homophonic texture. Other Preclassical composers were Gottlieb Muffat (1690–1770), Johann Gottlieb Graun (1703–1771), Carl Heinrich Graun (1704–1759), Domenico Alberti (ca. 1710–1740), Franz Xaver Richter (1709–1789), who composed early string quartets, and Leopold Mozart (1719–1787), the father of Wolfgang Amadeus Mozart (1756–1791).

The Preclassical period encompasses the developments of the symphony. There were four centers of orchestral playing especially important in the rise of the Preclassical symphony. Ignaz Holzbauer (1711–1783), Johann Stamitz (1717–1757), and Christian Cannabich (1731–1798) were associated with the city of Mannheim, whose orchestra was highly regarded. The so–called *Mannheim School* was one of the first to utilize the musical effects called *crescendo* (a gradual increase in dynamic level) and *decrescendo* (a gradual dynamic decrease), both clearly contrary to the fundamental Baroque principle of terraced dynamics. The chief composer in Milan was Giovanni Battista Sammartini (or San Martini, 1701–1775). In Vienna the important names were Georg Matthias Monn (1717–1750), Georg Wagenseil (1715–1777), and Karl Ditters von Dittersdorf (1739–1799). Johann Schobert (ca. 1735–1767) composed symphonies and sonatas in Paris. The Belgian François–Joseph Gossec (1734–1829) came to Paris to conduct Rameau's orchestra and composed symphonies, string quartets, and other genres.

THE CLASSICAL PERIOD

The adjective "Classical" has several quite different musical connotations: (1) the art and literature of ancient Greece, (2) the antonym of "Romantic"—that is, music before the nineteenth century, (3) the synonym of "art" music, and (4) in a more limited sense, the period from about the middle of the eighteenth century to about 1820, sometimes referred to as the "Viennese Classical period." It is in the latter sense that "Classical" is used in music history.

Classicism implies the ideals of the Apollonian cult of ancient Greece: objectivity, ethos, emotional restraint, and balance and clarity of form. Although these notions are to some extent reflected in certain other periods of music history, they are most clearly evident in the Classical period, and more so in instrumental music than in vocal music.

Characteristics of the Classical Style

In addition to these general traits, the music of the Classical period developed certain specific characteristics.

Form

Principles of sectional structure, particularly in sonata form, were firmly established in the late eighteenth century.

Texture

Classical textures were typically homophonic, with a single melodic line accompanied by nonmelodic or less melodic materials. A much–favored accompaniment pattern was the so–called *Alberti bass* (named for Domenico Alberti [1710–ca. 1740]), a broken–chord figure illustrated in Example 19.1.

Example 19.1. Alberti Bass

Counterpoint did not entirely disappear, however; fugues and other contrapuntal forms were occasionally composed. Another aspect of Classical texture was the predominance of thin, light sonorities as opposed to the predominantly massive sonority of Baroque music.

Melodic Style

Replacing the long continuous, autonomous melodic lines of Baroque music, Classical melody was composed of short (usually four measures) interlocking phrases, set off by well–prepared cadences. Melodic material was generally *thematic*—that is, capable of further development. Generally it was more diatonic than Baroque music.

Harmony

On the whole, Classical harmony was less complex than that of the Baroque. It made more use of principal triads (tonic, dominant, subdominant chords), and diatonic harmony was more typical than chromatic. Chord structure was predominantly triadic; seventh chords were used sparingly, and ninth chords hardly at all.

Instrumentation

It was during the Classical period that the potential of the piano was first realized. The harpsichord had been totally eclipsed by the turn into the nineteenth century. The clarinet was developed during the period and Mozart composed for it some of its best music. Other instruments that received special attention were the flute and the bassoon, which, along with the clarinet and oboe, came to constitute the woodwind section of the Classical orchestra.

Improvisation

With the diminished importance of the basso continuo, improvisation became less important. Harmony gradually became written out. Composers more specifically and more consistently indicated ornamentation, phrasing, dynamics, and other details formerly left to the discretion of the performer.

Absolute Music

The Classical period favored *absolute music* (as opposed to *program music*)—that is, instrumental music that invited no association beyond itself. Classical instrumental music generally bore only such abstract inscriptions as "sonata," "symphony," and "quartet."

Four Major Composers

The Classical period was graced by four composers of the highest accomplishment: Gluck, Haydn, Mozart, and Beethoven.

Gluck (1714–1787)

Christoph Willibald von Gluck, the least versatile of the four, was a master of opera and opera reform.

Haydn (1732–1809)

Franz Joseph Haydn was the most prolific of the major composers. More than any other single composer, he established the form and instrumentation

of the Classical symphony and developed the string quartet. His principal fields were symphony, chamber music (especially string quartets and divertimenti), concerto, piano sonata, oratorio, church music, and opera, although the latter are little–known today.

Mozart (1756–1791)

Wolfgang Amadeus Mozart surely possessed one of the most fertile musical minds of all time. More than any composer of his generation he fashioned a European style out of national and regional styles. Unlike Haydn, Mozart rebelled against the system of patronage and attempted, with only fair success, to fashion a living from commissions for and royalties from his music. His principal fields were symphony, concerto, chamber music, sonata, and mass. His operas represent perhaps the pinnacle of the genre.

Beethoven (1770–1827)

Ludwig van Beethoven, like Mozart and Haydn, is one of the most important composers of Western art music. His position in music history is especially significant in that he guided the transition from late Classical to a Romantic style, and expressed so fiercely the individual's right to artistic freedom that aristocratic patronage waned as a means of composers' livelihoods. He expanded the concept of sonata form and made it a vehicle of powerful expression. He was unsurpassed in the techniques of thematic development and variation. His main areas of composition were symphony, concerto, string quartet, and piano sonata. He wrote an oratorio, an opera, and one festival mass.

HISTORICAL CONTEXT

The last half of the eighteenth century and the first quarter of the nineteenth century was a period marked by the rise of democratic forces manifested chiefly in the French Revolution. Other military conflicts of the era were the Seven Years' War (1756–1763); the French and Indian Wars in North America; the conflict between England and the American colonies, culminating in the Declaration of Independence (1776) and the American Revolution, and continuing in the War of 1812; and the Napoleonic Wars in Europe. The period known as the Age of Reason and the Enlightenment was dominated by the rationalist philosophies of Kant, Diderot, and the French Encyclopedists. Other eminent writers were Voltaire, Rousseau, Lessing, Herder, and Adam Smith, whose *The Wealth of Nations* (1776) was a

milestone in economic thinking. History, as we understand it today, was first being written; Gibbons completed his *Decline and Fall of the Roman Empire* and Boswell his *Life of Johnson*. Cultural history was also being written by Winckelmann (*History of Ancient Art*), Burney (*General History of Music*), and Hawkins (*General History of the Science and Practice of Music*). Artists of the period were Watteau, Goya, David, Reynolds, Gainsborough, and Copley. Scientific achievements included the development of the first vaccine, and the discoveries of oxygen, hydrogen, electricity, electromagnetic induction, and ultraviolet rays. The invention of the steam engine, spinning jenny, cotton gin, electric motors, and generators were factors in the Industrial Revolution, which began in England around 1760.

Scores and Recordings

Keyboard Sonata
> D. Scarlatti: NSI 27; NAWM 107
> C.P.E. Bach: NAWM 108

String Quartet
> Richter: NAWM 111

Symphony
> Sammartini: NAWM 113
> Johann Stamitz: NAWM 114

Concerto
> J. C. Bach: NAWM 119

20

Instrumental Music

The most significant changes in form and genre during the Classical era took place in instrumental music.

THE SONATA CYCLE

The term *sonata cycle* here means the basic plan of instrumental compositions in three or four movements. Sonata cycle is a concept that, with certain modifications, applies to virtually all instrumental genres of the Classical period: solo sonatas, symphonies, concertos, string quartets, and others.

First Movement The Classical first movement is in a fast tempo, usually marked "allegro." Its sectional structure, perhaps the most significant one–movement scheme to emerge in the eighteenth century, is called *sonata form* (variously, *sonata–allegro form*, and *first–movement form*). Sonata form is an abstraction, first defined in 1787 long after it was in general use. In reality, composers only occasionally follow exactly the formal conventions defined here below. The process that led to this balanced form was so important to the musical thinking in the period that it is sometimes referred to as the *sonata principle*. It may be found in rondos, in theme and variations, even in operas.

Sonata form is almost always found in the first movement of Classical–period instrumental pieces. It may also exist in other movements and in other tempos. Sonata form is a dramatic play between *theme* and *key*. This is worked out in a general three–part structure that consists of (1) the exposition, (2) the development, and (3) the recapitulation.

Exposition

The exposition in sonata form presents the basic thematic and tonal materials of the movement. The *main theme* (or *main theme group*) is presented in the key of the movement (or the *tonic key*). This material is followed by a transition called the *bridge* (or *bridge passage*) that modulates to the *dominant key* (or *relative major key* if the movement is in a minor key). The *second theme* (or *subordinate theme*) is then presented in the contrasting dominant key. The exposition may conclude with still another theme, called the *closing theme*, or *codetta*. The end of the exposition is marked by a double–bar repeat sign, but in many modern performances the exposition is not repeated.

Development

There is no standard practice regarding procedures followed in the development section. It utilizes any or all of the material from the exposition, which is "developed" in various ways. Themes or motives are treated in different keys, registers, textures, and timbres. The development section may also contain any number of nonthematic *episodes*. It concludes in the tonic key and moves without pause into the recapitulation.

Recapitulation

The recapitulation is a general (not exact) restatement of the exposition, but with all subsections remaining in the tonic key.

Optional Sections

The first movement sometimes begins with an *introduction* in slow tempo. Introductions do not normally introduce the thematic material of the movement. Sonata–form movements, especially those by Ludwig van Beethoven (1770–1827), quite often conclude with a *coda* that follows the closing theme of the recapitulation.

Second Movement

The Classical second movement has three characteristics: (1) it is in slow tempo (e.g., adagio, lento); (2) it is in a closely related key, usually the subdominant or dominant key in relation to the key of the work as a whole; and (3) it has a more melodic quality than the other movements. Forms commonly used in second movements are *ternary (ABA)*, *rounded binary (AABA)*, *theme and variations*, *sonatine* (sonata form without a development section), and *sonata form*.

Third Movement

The most common third movement form in a Classical four–movement work is a *menuetto* (or *minuet*). It is in the tonic key, $\frac{3}{4}$ meter, and played in a moderately fast tempo. It is a ternary form, called *minuet and trio* (or *song form and trio*), in three main sections: minuet, trio, and minuet repeated.

Each section is itself in rounded binary form. Thus, the minuet movement normally follows this plan:

Minuet	Trio	Minuet ("da capo")
a:‖:*ba*:‖	*c*:‖:*dc*:‖	*aba* (played without repeats)

The trio is often in a contrasting or relative key to the minuet, and has a lighter texture.

In a few Haydn works and in most Beethoven compositions in the sonata cycle, the third movement is called *scherzo*. It follows the same sectional structure, tempo, and meter as the minuet but is characteristically less dancelike and in a more playful or humorous style.

The order of the two middle movements was sometimes reversed so that the minuet or scherzo came second and the slow movement third. The minuet or scherzo was omitted in sonata–cycle compositions with only three movements.

Fourth Movement

The last movement, the *finale*, in a Classical three– or four–movement sonata cycle work is in the tonic key, with a lively tempo, and usually in sonata form, rondo structure (*ABACA* etc.), or a combination (*ABACABA*). It was typically less intensive than the first movement, although Beethoven gradually came to assign it weight equal to or greater than the first movement.

THE SYMPHONY

The development of the Classical symphony was one of the major musical achievements of the eighteenth century.

Form

The prototype of the Classical symphony was the Italian overture form called *sinfonia*. In the early eighteenth century the sinfonia was a three–section, fast–slow–fast structure. As an orchestral composition independent of operas it emerged as three separate movements in the same order of tempos. Among Preclassical composers, it gradually took on the shape of the sonata cycle. A minuet was added as the third movement in a four–movement work.

The Orchestra

Two aspects of orchestral media are (1) *instrumentation* (the instruments specified in an orchestral score) and (2) *orchestration* (the manner in which those instruments are employed).

Instrumentation

By the end of the eighteenth century the symphony orchestra consisted of four woodwind instruments in pairs (flutes, oboes, clarinets, and bassoons), trumpets, horns, and timpani, also in pairs, and a string choir consisting of first and second violins, violas, cellos, and string basses.

Orchestration

Strings were still the dominant color. First violins carried the thematic material. Second violins and violas were most often assigned harmonic material. Cellos and basses were consistently doubled, written as one part on the same staff, but with the basses sounding an octave lower than the cellos. Woodwinds became more important, as advances in instrument building produced instruments better able to play in tune; they were generally scored in harmonic passages. Brass instruments, without valves, were almost entirely confined to tutti passages and to harmonic rather than melodic or thematic material.

Composers

The enormous output of orchestral literature by Preclassical composers provided the foundation on which the Classical symphonies of Haydn, Mozart, and Beethoven were created.

Haydn (1732–1809)

Franz Joseph Haydn wrote more than a hundred symphonies, the earliest of which are representative of Preclassical form and orchestration. He favored slow introductions to his first movements.

Mozart (1756–1791)

Wolfgang Amadeus Mozart produced forty–one symphonies, among which the most famous are the last four: the "Prague" Symphony (no. 38 in D Major), no. 39 in E♭ Major, no. 40 in g minor, and no. 41 in C Major (nicknamed the "Jupiter" Symphony).

Beethoven (1770–1827)

As a body of music, Ludwig van Beethoven's nine symphonies transcend Classical form and style; only the first and the eighth follow the prevailing conventions of form and structure. As he did in other media, Beethoven expanded the sonata cycle and infused it with his dynamic personality. In four of his symphonies (the third, fifth, sixth, and ninth) he added new instruments to Classical instrumentation. His Sixth Symphony (the "Pastoral" Symphony), in five movements, was one of the first *programmatic* symphonies, in which nonmusical concepts, ideas, or images were conveyed by the music; in this case the images had to do with nature. The Ninth Symphony, which departed still further from Classical tradition, was scored for a number of additional instruments (piccolo, contrabassoon, four horns,

three trombones, triangle, cymbals, and bass drum), and for solo voices and chorus in the finale.

THE CONCERTO

The solo concerto carried over from the Baroque but it differed in style and in structure of movements.

Form

The Classical concerto, like the Baroque solo concerto, was in three movements, and followed the fast–slow–fast plan. Unlike the Classical symphony, it omitted the minuet movement.

First Movement

The first movement of the Classical concerto was in sonata form but contained notable differences. There were two separate expositions, called the *double exposition*. The first introduced the principal themes by the orchestra alone, and all in the tonic key; in the second exposition the solo instrument presented the thematic material in a more brilliant and ornamental version. Generally, the development and recapitulation sections followed sonata–form conventions. Near the end of the recapitulation, a *cadenza* was presented by the solo instrument. This section was signaled by the orchestral suspension of forward motion on an unresolved chord marked by a *fermata* (⌢), a symbol for a pause. Cadenzas were freely improvised, virtuosic development of thematic material. In the nineteenth century, cadenzas came to be written out beforehand by the composer or the performer.

Second Movement

The second movement of the concerto, like that of the symphony, was in a contrasting key and slow tempo. Its style was more lyrical and less virtuosic than either the first or last movements.

Third Movement

The concerto finale was most commonly in rondo form, and in a lively tempo. Its style was somewhat lighter than the other movements. Occasionally a cadenza was included.

Composers

The principal concerto literature of the Classical period was composed by Haydn, Mozart, and Beethoven. Haydn wrote twenty concertos for piano, nine for violin, six for cello, and others for flute, baryton, horn, clarino, and trumpet. Mozart's concerto output included twenty–five for piano, eight for

violin, and others for violin and viola, bassoon, flute, flute and harp, horn, and clarinet. Beethoven composed five for piano, among which the last, nicknamed the "Emperor," is the most famous, the Violin Concerto in D Major, and the Triple Concerto for violin, cello, and piano.

CHAMBER MUSIC

Unlike orchestral music, chamber music is composed for small ensembles consisting of only a few players and usually only one instrument to a part. It was an especially significant category of music literature in the Classical period.

Divertimento

Compositions variously called *divertimento*, *serenade*, *feldpartita*, *notturno* (night piece), and *cassation* were written in great quantities during the Preclassical and Classical eras. There was apparently no rigid distinction of meaning among the terms. The genre might have derived from a form of military band music. They were composed for various media ranging from small chamber ensembles to small orchestras. The number of movements ranged from three to ten, and included minuets, other dances, marches, and standard sonata–form movements. Intended mostly for informal entertainment and outdoor performance, they were lighter and less sophisticated than symphonies. Haydn wrote over sixty and Mozart about thirty compositions in this category.

String Quartet

A most–favored chamber medium in the Classical period was the string quartet, which consisted of two violins, viola, and cello. String quartets were written in four–movement Classical sonata cycle. The principal composers of Classical string quartets were Luigi Boccherini (1743–1805), Haydn, Mozart, and Beethoven.

Other Chamber Media

Instrumental combinations less extensively employed in the Classical period were the mixed quartet (three string instruments and one other instrument, usually piano, flute, clarinet, or oboe), string trio and mixed trio, string quintet, and mixed quintet.

The sonata for violin and piano became important in the Classical period. The piano more often assumed the dominant role, the violin functioning almost as an *obbligato* (accompanying) instrument. Haydn wrote twelve violin sonatas, Mozart thirty–five, and Beethoven ten.

Keyboard Music Solo sonatas for harpsichord or piano constituted an important literature in the Preclassical period, especially in the work of Carl Philipp Emanuel Bach (1714–1788), Wilhelm Friedemann Bach (1710–1784), Johann Christian Bach (1735–1782), and Domenico Paradies (or Paradisi, 1707–1791). The fifty–two piano sonatas by Haydn and the seventeen by Mozart are mostly three–movement works without a minuet. The piano sonatas of Muzio Clementi (1752–1832) and the Bohemian–born Jan Ladislav Dussek (1760–1812) influenced Beethoven, whose thirty–two piano sonatas represent the culmination of the genre. In addition to sonatas, Mozart wrote fifteen sets of variations, and Beethoven twenty–one sets.

Scores and Recordings In several cases the following are examples drawn from larger works.

Symphony
 Haydn: NSI 29; NAWM 115 and 116
 Beethoven: NSI 35; NAWM 118
Concerto
 Mozart: NSI 30; NAWM 120
Divertimento
 Mozart: NSI 31
String Quartet
 Beethoven: NSI 33
Piano Sonata
 Clementi: NAWM 109
 Dussek: NAWM 110
 Beethoven: NSI 34

21

Opera and Religious Music

The distinction between Baroque and Classical styles is less clearly marked in large vocal forms than in instrumental music. While Classical instrumental music holds a prominent place in today's repertory, relatively few operas, oratorios, and church compositions, among the prodigious quantity composed, are heard today.

OPERA

Neapolitan opera, which dominated the first half of the eighteenth century, began to merge with Preclassical developments around 1720, also the beginning of opera reform.

Opera Seria

Italian *opera seria* became a production in which musical formality and vocal virtuosity took precedence over dramatic considerations. Characteristics of this genre include 1) a three-act structure; 2) rigid alternation of arias/duets and recitativo secco; 3) action developed in the recitatives and musical commentary provided by the arias and duets; 4) plots drawn from ancient Greek or Latin sources featuring passionate and heroic, "larger–than–life" conflicts; 5) standard casting of two pairs of lovers and a few subordinate roles; and 6) an orchestra whose role was solely to accompany the singers. This rigid form is sometimes called *Metastasian opera*, after the Italian poet Pietro Metastasio (1698–1782), who provided standardized opera librettos for many eighteenth–century composers.

Reactions against this situation were evident well before the mid–eighteenth century. The first treatise to acknowledge artificialities in Italian opera was a satire by Benedetto Marcello (1686–1739) published in 1720,

entitled *Il Teatro alla moda* (*The Fashionable Theater*). Reforms, however, did not occur suddenly, nor were they universally adopted by eighteenth–century composers.

Aspects of Reform

Departures from early eighteenth–century practice are found in some, but by no means all, operas in the second half of the century. In the operas of those composers sympathetic to reform, some characteristics were held in common. (1) There was greater concern for the dramatic aspects of opera, and less attention to formal musical aspects. (2) Structures became more flexible and there was a trend away from stereotypical operas consisting mainly of arias with intervening recitatives. (3) Rigid da capo arias appeared less frequently, and gave way to more diversified forms. (4) Secco recitatives were less utilized; accompanied recitatives grew in favor. (5) Choral ensembles were increasingly employed. (6) The orchestra, no longer relegated to mere accompanying status, assumed a more expressive role. (7) Ostentatious vocal virtuosity was less evident, and solo singers began to lose some of their autocratic domination over opera performance.

Composers

The first composers to reflect limited reforms were Niccolò Jommelli (1714–1774) and Tommaso Traetta (1727–1779). The central figure in opera reform, though, was Christoph Willibald Gluck (1714–1787). After composing some twenty Italian operas in the prevailing style, he put reform ideas into practice with *Orfeo ed Euridice* in 1762. In the preface to his next opera, *Alceste*, he summarized his objectives of reform. His reform operas heeded the Classical ideals of simplicity and naturalness. Avoiding the absurd and complex plots of the opera seria, Gluck set to music the simplified Classical librettos of Raniero Calzabigi (1714–1795). The quality of Gluck's music raised opera to a new artistic level while at the same time it wholly served the drama. His later reform operas, all produced in Paris, were *Iphigénie en Aulide*, *Armide*, and *Iphigénie en Tauride*.

Other composers, roughly contemporary with Gluck but not in the current of reform, were Johann Adolph Hasse (1699–1783), who was probably the most popular and successful composer of his time, Niccolò Piccini (1728–1800), Giuseppe Sarti (1729–1802), Antonio Sacchini (1730–1786), Johann Christian Bach (1735–1782), Etienne–Nicolas Méhul (1763–1817); Luigi Cherubini (1760–1842), whose principal operas were *Médée* and *Les Deux journées*; and Gasparo Spontini (1774–1851), who wrote *La Vestal*.

Comic Opera

The forms of comic opera were established during the first half of the eighteenth century: opera buffa in Italy, opéra comique in France, ballad opera in England, singspiel in Germany, and zarzuela in Spain. These forms

continued to flourish in the second half of the eighteenth century and were given added impetus as a result of popular revolt against Italian opera seria.

Italy

In the Preclassical and Classical periods, opera buffa developed a rapid style of nearly spoken recitative called *parlando*. Ensemble finales were characteristic. Toward the end of the eighteenth century, elements of opera seria appeared in buffa operas. Principal composers were Niccolò Piccini (*La Buona figliuola*), Giovanni Paisiello (1740–1816), who wrote *Nina*, Domenico Cimarosa (1740–1801), whose *Il Matrimonio segreto* was his most popular work, and Wolfgang Amadeus Mozart (1756–1791).

France

Opéra comique used spoken dialogue instead of recitative. It began to acquire romantic and sentimental qualities. Social and political themes were frequently introduced. Principal composers were Egidio Duni (1709–1775), François Andre Danican–Philidor (1726–1795), Pierre–Alexandre Monsigny (1729–1817), and André Ernest Modeste Grétry (1741–1813), whose *Richard Coeur–de–Lion* was a forerunner of romantic nineteenth–century "rescue" operas.

England

After a heyday of ballad opera in the first half of the eighteenth century, there was a decline of opera in England. Thomas Augustine Arne (1710–1778) was important as a composer of popular operas.

Germany

An important composer of German singspiel operas was Johann Adam Hiller (1728–1804). *Fidelio* by Ludwig van Beethoven (1770–1827) is of the rescue–opera type.

Spain

In Spain the *tonadilla*, comparable to Italian opera buffa, superseded the older zarzuela of the early eighteenth century. Principal composers were Luis Misón (d. 1766), Pablo Esteve y Grimau (ca. 1730–1794), and Blas Laserna (1751–1816).

Mozart (1756–1791)

The pinnacle of eighteenth–century opera was achieved by Mozart. His immortality in this field rests not only on reform but on the consummate greatness of his music and his phenomenal sense of theater. Among the thousands of operas produced in the eighteenth century, Mozart's are the only ones in the standard repertory today. *Idomeneo* and *La Clemenza di Tito* (*The Mercy of Titus*) are opera seria. His German operas are *Die Entführung aus dem Serail* (*The Abduction from the Seraglio*) and *Die Zauberflöte* (*The Magic Flute*). His most famous buffa operas are *Le Nozze di Figaro* (*The*

Marriage of Figaro) and *Così fan tutte* (*So Do They All*). *Don Giovanni*, called a *dramma giocoso*, is a mixture of opera seria and opera buffa elements.

RELIGIOUS MUSIC

From 1750 to 1820, religious music was much less important than instrumental music and opera. As in the late Baroque, operatic styles and forms were absorbed into the genre.

Oratorio

With a few exceptions, oratorio was an empty tradition after George Frideric Handel (1685–1759). Relatively few works of lasting value were composed. After about 1780, oratorios were almost indistinguishable from operas; some were even staged and acted in costume. The most important works of the period were *Der Tod Jesu* by Karl Heinrich Graun (1704–1759), *The Israelites in the Wilderness* by Carl Philipp Emanuel Bach (1714–1788), and two oratorios by Franz Joseph Haydn (1732–1809), *The Return of Tobias* and *The Creation*, which was based on Genesis and an adaptation of Milton's *Paradise Lost*. Haydn's *The Seasons* is a secular oratorio. His oratorios, like those of most other composers in the second half of the eighteenth century, reveal the strong influence of Handel. Beethoven's *Christ on the Mount of Olives* is a late–period oratorio.

Church Music

The influence of opera on church music was even more strongly manifested than it was in the late Baroque. Nearly all composers of Classical church music were opera composers. Masses were operalike compositions for solo voices, chorus, and orchestra. Arias and duets were in no way different from those in opera, except for the texts. Generally, there was a strong secular element in the style. Some Baroque characteristics persisted in church music: fugal choruses and basso continuo parts. Even orchestral forms were occasionally employed in masses.

Composers

Principal composers of church music were Johann Adolph Hasse, Giovanni Paisiello, with some 103 church compositions, Nicola Zingarelli (1752–1837), with over five hundred works, Giuseppe Sarti (1729–1802), and Luigi Cherubini. The three great Classical masters contributed to the literature of Catholic masses. Haydn wrote some fourteen masses, among which the *Lord Nelson Mass* is the best known. Mozart wrote fifteen masses,

including the *Mass in c minor*, the *Coronation Mass*, and his last masterpiece, the *Requiem Mass*. Beethoven's most significant work in this category was the monumental *Missa Solemnis*.

Scores and Recordings

Most of these examples are excerpts from larger works.

Mass
 Haydn: NSI 32
Requiem
 Mozart: NSI 38
Opera
 Gluck: NSI 29
 Mozart: NSI 35; NAWM 124

PART SIX

THE ROMANTIC PERIOD

(1820–1900)

22

Introduction to the Romantic Period

1808 Beethoven: Symphonies nos. 5 and 6

1808 Goethe's *Faust*, Part 1

1815 English defeat Napoleon at Waterloo

1815 Schubert: "The Erlkönig"

1816 Rossini: *The Barber of Seville*

1821 Weber: *Der Freischütz*

1824 Beethoven: Symphony no. 9

1827 Death of Beethoven

1827 Schubert: *Winterreise*

1827 Victor Hugo's preface to *Cromwell*, a manifesto of Romanticism

1828 Death of Schubert

1829 Performance of Bach's *St. Matthew Passion* by Mendelssohn

1829 Steam locomotive is perfected

1830 Revolutions in France, Belgium, Italy, Germany, and Brazil

1830 Berlioz: *Symphonie fantastique*

1832 Chopin: Études, Op. 10

1832 Robert Schumann: *Carnaval*, Op. 17

1839 New York Philharmonic Society established

1839 First daguerrotype taken

1843 Berlioz's *Treatise on Instrumentation and Modern Orchestration*

1848 Revolutions in Europe

1848	*Communist Manifesto* by Marx and Engels
1849	Wagner's *Art and Revolution*
1849	Death of Chopin
1850	Bach Gesellschaft founded
1851	Verdi: *Rigoletto*
1856	Death of Robert Schumann
1859	Wagner: *Tristan und Isolde*
1859	Darwin publishes *The Origin of Species*
1861–1865	American Civil War
1869	Death of Berlioz
1870–1871	Franco–Prussian War
1873	Brahms: Op. 51 string quartets
1874	Mussorgsky: *Boris Godunov*
1875	John Knowles Paine appointed first American Professor of Music (Harvard)
1876	*Tom Sawyer* by Mark Twain
1876	First performance of *The Ring of the Nibelungen* at Bayreuth
1881	Death of Mussorgsky
1883	New York Metropolitan Opera opened
1883	Death of Wagner
1886	Death of Liszt
1887	Verdi: *Otello*
1888	Richard Strauss: *Don Juan*
1888	Franck: Symphony in d minor
1892–1895	Dvořák in the United States
1893	Tchaikovsky: Symphony no. 6 ("Pathétique")
1897	Death of Brahms
1899	Freud publishes *The Interpretation of Dreams*
1899	Schoenberg: *Verklärte Nacht*
1901	Death of Verdi
1905	Richard Strauss: *Salome*
1908	Mahler: *Das Lied von der Erde*
1911	Death of Mahler

1914–1918 World War I

1949 Death of Richard Strauss

1957 Death of Sibelius

The nineteenth century is generally known as the Romantic period, but aspects of Romanticism appeared before 1800 and continued well into the twentieth century. There is so much overlap that some composers are considered Classical by one account and Romantic by another, with Beethoven probably the most problematic. There is a current tendency among historians to consider the Romantic period a natural result of the Classical era, even part of the same movement. If we characterize the Romantic period as subjective, emotional, intuitive, and Dionysian, and the Classical as objective, rational, scientific, and Apollonian, the traits should be seen as complementary rather than opposed. And in its veneration of individualism and nationalism, the nineteenth century was clearly a child of the Enlightenment. Some important cultural concepts did receive special attention in the nineteenth century, though. Much more than the eighteenth century, it was an age that yearned for transcendence, the unattainable, the boundless (a tendency sometimes designated by the German word sehnsucht*), and had a penchant for the strange, the mysterious, the supernatural, and the remote. It also venerated the unfettered imagination. These characteristics are manifest throughout nineteenth–century philosophy, literature, drama, art, music, and popular culture. Related to this is a dichotomony between man and nature that was explored during this period.*

MUSICAL CHARACTERISTICS

Features of nineteenth–century music set it apart from other periods. (1) Composers became socially and economically more independent, and some even prospered from the sale and performance of their music; they no longer depended on the patronage of church and aristocracy, in fact most music was written for the middle class, a truly immense audience. (2) Music was generally composed for two kinds of venues: the public concert hall and opera house on the one hand, and the private, intimate salon or parlor on the other. (3) There were notable extremes of length in composition: large, extensive, grandiose works (symphonies, concertos, oratorios, and, espe-

cially, operas) and miniatures (solo songs, piano pieces). (4) Preferred genres were the solo song with piano accompaniment, opera, piano works, and orchestral works; chamber and choral media were less favored. (5) Composers purposefully developed a greater individuality of style than ever before. (6) They felt a fundamental affinity between music and words; hence, there were important developments in song, opera, choral symphony, and program music. (7) More than in any earlier period, composers placed a special value on originality in their work. (8) Virtuosity was a familiar trait in much instrumental music; the virtuoso performer was much admired as the image of the Romantic hero. (9) Nationalism was a significant trend: composers consciously fostered national styles by using folklore as subjects for operas, songs, and program music, and by incorporating folk tunes and folk styles in their compositions.

In addition to the above characteristics, there were significant developments in compositional styles and techniques.

Melody

Romantic melody generally has qualities of warmth and expressiveness, a more lyric style, and more flexible phrase structure. It often has a searching, seeking, restless quality.

Harmony

Harmony is an important vehicle for Romantic expression. The nineteenth century saw expansion of harmonic idiom in terms of chord structure and progression, toward a richer harmonic language. Dissonance was more extensive and more freely treated; seventh and ninth chords appeared more frequently. Chromaticism and modulation played important roles.

Tonality

Nineteenth–century music was still basically tonal, but key feeling, often obscured by extended chromatic modulations and the use of remotely related keys, became less distinct toward the end of the century, a trend that paved the way for radically new concepts of tonality in the twentieth century.

Texture

Romantic textures, as in Classical music, were basically homophonic. Counterpoint, when used, was of secondary importance. In terms of sonority, nineteenth–century music was notable for a marked increase in richness and density of sound.

Dynamics

Romantic composers discovered the inherent possibilities of dynamics for expression. Wider range of dynamic levels and more extensive use of crescendo and diminuendo were characteristic of the period.

Form

Conventional musical form was generally less important than content and subjective expression. Consequently, sectional structures were freer, more variable, and often less distinct than in the Classical era. Although

sonata form and other Classical forms were still employed, they were much more flexible.

MUSIC EDUCATION

The nineteenth century was the first in which much of the population received a general music education. This was especially the case in the United States. In 1837 Boston became the first American city to include education in music as part of the public school curriculum. By midcentury many American cities and towns had followed suit. Training of professional musicians began in the 1860s when Oberlin College–Conservatory and the Peabody Conservatory were opened. The study of music at the academic level dates from 1875, when Harvard appointed John Knowles Paine (1839–1906) professor of music, making him the first to hold that position in an American college. By century's end several colleges and universities had established departments of music and schools of music.

Musicology The Romantic period had a deep fascination for the dark and distant past, which in one form manifested a developing interest in musical history. The music of Bach and Palestrina was rediscovered during this period and came to be widely appreciated. The impulse to know more about music history stimulated the rise of a scholarly discipline known as *musicology*, which involves research into the musical past. Pioneers in establishing musicology were Raphael Georg Kiesewetter (1773–1850), Karl Friedrich Chrysander (1826–1901), Hermann Kretzschmar (1848–1924), Hugo Riemann (1849–1919), Guido Adler (1855–1941), Peter Wagner (1865–1931), Johannes Wolf (1869–1947), Friedrich Ludwig (1872–1930), and Oscar Sonneck (1873–1928).

HISTORICAL CONTEXT

The cultural, economic, political, and social orders of the nineteenth century were affected by advances in science and engineering: photography, food canning, the railway and steamboat, steel production, electricity, the

telephone, telegraph, phonograph, and other innovations. The spread of technology augmented the Industrial Revolution in Europe, which, in turn, created new social, economic, and political conditions, such as the growth of industrial capitalism and the advent of socialism. Nineteenth–century conflicts were the Crimean War (1854–1856), the Civil War in the United States (1861–1865), and the Franco–Prussian War (1870–1871). The most important movement in art was French Impressionism, beginning in the second half of the century and represented by Manet, Degas, Monet, Renoir, Pissaro, and the sculptor Rodin. Allied with this movement were the French symbolist poets Verlaine, Mallarmé, and Rimbaud. The principal philosophers were the Germans Hegel, Schopenhauer, and Nietzsche. An important social historian and theorist was Karl Marx. It was a period of great Romantic literature: in Great Britain, Byron, Wordsworth, Scott, Thackeray, Dickens, Hardy, Carlyle, Coleridge, and Keats were prominent; in Germany, Schiller, Goethe, Richter, Heine, Novalis, Tieck, and E.T.A. Hoffmann; in France, Lamartine, Musset, Hugo, and Flaubert; in the United States, Emerson, Thoreau, Longfellow, Poe, Melville, Hawthorne, and Mark Twain.

23

Opera

Many aspects of Romanticism affected nineteenth–century opera. Especially significant were the rise of nationalism, the use of romantic subjects, and the highly emotional treatment of them. Important changes in structure and style took place. The main centers of operatic activity were Italy, France, and Germany.

ITALIAN OPERA

Since its inception at the beginning of the seventeenth century, opera had been at the center of Italian musical interest and had become a tradition firmly implanted in the life of the people. Opera was Italy's most important contribution to nineteenth–century music; other fields were almost totally neglected.

Some generalizations can be made about nineteenth–century Italian opera. (1) Because of its strong national tradition, Italian opera was more conservative and less subject to Romantic innovations than in northern countries. (2) The distinction between opera seria and opera buffa was maintained well into the century, but the latter was unimportant in the second half. (3) The reforms initiated by Christoph Willibald Gluck (1714–1787) had little consequence on nineteenth–century Italian opera, but some French influence was evident in the growing importance of the orchestra, orchestral color, and more use of the chorus. (4) There was a better balance between drama and music as dramatic integrity once again became an established objective. (5) The rigid alternation of aria and recitative was replaced by more complex forms like the *scena*, in which the dramatic character of the text shaped the music. (6) Dramatic and musical continuity increased,

though it was less evident in Italian opera than in Germany. (7) Italian composers generally avoided plots based on supernatural and bizarre subjects. (8) Serious operas were mostly melodramas with violent emotional situations; escape, rescue, and redemption were typical themes. (9) Virtuosity for its own sake was less prominent than in the eighteenth century. (10) Melody was the all–important vehicle for dramatic and Romantic expression; this regard for "beautiful singing" gave the genre its name, *bel canto opera*.

The founder of early Romantic serious Italian opera was Johann Simon Mayr (1763–1845), a German who lived most of his life in Italy. Through his efforts many of the aforementioned characteristics of nineteenth–century Italian opera were effected. In general there were fewer important nineteenth–century Italian opera composers and they were far less prolific, but more nineteenth– than eighteenth–century operas remain in today's repertory.

Rossini (1792–1868)

Gioachino Rossini's music retained traces of classical style: clarity and simplicity of texture and form. His greatest gift was in opera buffa. Principal works were *L'Italiana in Algeri*; *La Cenerentola* (*Cinderella*); *Il Barbiere di Siviglia* (*The Barber of Seville*), a masterpiece of sparkling wit and comedy; and *La Gazza ladra* (*The Thieving Magpie*). *Guillaume Tell* (*William Tell*), produced in Paris, is a French grand opera.

Donizetti (1797–1848)

Gaetano Donizetti wrote some seventy operas, which include serious and comic operas, in Italian and in French. He is best known for the serious operas *Lucia di Lammermoor*, *Lucrezia Borgia*, and *Linda di Chamounix*; the comic operas *Don Pasquale* and *L'Elisir d'amore* (*The Elixir of Love*); and *La Fille du regiment* (*The Daughter of the Regiment*), a French opéra comique.

Bellini (1801–1835)

The least prolific among the triumvirate who dominated Italian opera before 1850, Vincenzo Bellini wrote eleven operas of generally high, serious emotional content. His lyric style is said to have influenced Frédéric Chopin (1810–1849). His best–known works are *La Sonnambula* (*The Sleepwalker*), *I Puritani* (*The Puritans*), and *Norma*, which includes the famous *cavatina* (a shorter, simpler aria) "Casta Diva."

Verdi (1813–1901)

The most important Italian composer of the second half of the nineteenth century, Giuseppe Verdi was the culminating figure of Italian opera. Italian nationalism was an important ingredient in his operas, and his popularity as a national figure is attested to by the fact that his name became an acrostic symbol (*Victor Emanuelo Re D'Italia*) of the *Risorgimento* movement headed by King Victor Emmanuel II. Verdi's operas in general exhibited great continuity, a prominent and dramatic use of the orchestra, little stylistic

distinction between recitative and aria, and certain characteristic structural traits: they were composed in four acts with choral finales to the second and third acts, and included a meditation or *preghiera* (prayer scene) opening the last act.

Verdi's six best–known operas are *Rigoletto*, *Il Trovatore* (*The Troubadour*), *La Traviata*, *Aïda*, which was commissioned for the celebration of the opening of the Suez Canal, *Otello* (with a libretto by Arrigo Boito [1842–1918] based on Shakespeare's *Othello*), and *Falstaff*, Verdi's last work, an opera buffa on a grand and profound scale. Still other Verdi operas are in modern–day repertory.

Verismo

At the end of the nineteenth century and the early decades of the twentieth century, there was a strong current of realism in Italian opera, called *verismo opera*. These operas featured common people in familiar situations who react with decisiveness and great passion. Composers and works in this category were Pietro Mascagni (1863–1945), who composed *Cavalleria Rusticana* (*the Rustic Chivalry*): Ruggiero Leoncavallo (1857–1919), who composed *I Pagliacci* (*The Clowns*); and Giacomo Puccini (1858–1924), among whose ever–popular operas are *La Bohème*, *Tosca*, and *Madam Butterfly*.

FRENCH OPERA

Three types of opera existed in nineteenth–century France; opéra comique and grand opera in the first half of the century, and lyric opera in the second half.

Opéra Comique

The eighteenth–century distinction between serious and comic opera in France was retained during the first half of the nineteenth century. Toward the middle of the century, opéra comique began to develop in two directions: toward a more lyric and serious style on the one hand, and toward light, sentimental operettas on the other.

Composers

The principal composers and comic operas were Francis Boieldieu (1775–1834), *La Dame blanche* (*The White Lady*); Daniel François Esprit Auber (1782–1871), *Fra Diavolo*; Louis Ferdinand Hérold (1791–1833), *Le Pré aux cleres* (*The Field of Honor*); Hector Berlioz (1803–1869), *Béatrice et Bénédict*; Victor Massé (1822–1884), *Les Noces de Jeannette* (*The Mar-*

riage of Jeannette); and Charles Gounod (1818–93), *Le Médecin malgré lui* (*The Doctor Despite Himself*).

Grand Opera

In the second quarter of the nineteenth century, a new genre, distinct from opéra comique, was called *grand opera*. It was built around grandiose plots and made use of large ensemble scenes, expanded orchestral resources, and colorful pageantry. After midcentury, these characteristics became somewhat less pronounced, and grand opera merged with comic opera.

Composers

The principal exponent of grand opera was Giacomo Meyerbeer (1791–1864). His principal works were *Robert le diable* (*Robert the Devil*), *Les Huguenots*, *Le Prophète*, and *L'Africaine*. Other composers and works in the same category were Auber, *La Muette de Portici* (*The Deaf Girl of Portici*); Rossini, *Guillaume Tell*; and Jacques Halevy (1799–1862), *La Juive* (*The Jewess*). The pinnacle of grand opera was achieved by Berlioz in *Benvenuto Cellini*. His masterful *Les Troyens* (*The Trojans*) is outwardly a grand opera, but thoroughly transcends the genre in its dignity and seriousness of intention.

Lyric Opera

A hybrid genre known as *drame lyrique* (lyric drama) emerged in the second half of the nineteenth century. It combined the melodic appeal of opéra comique with some of the large–scale aspects of grand opera.

Composers

Gounod's *Faust* is a classic example of the lyric opera. *Carmen*, by Georges Bizet (1838–1875), one of the most popular operas of all time, is another drame lyrique, although it was originally classified as an opéra comique because it contained spoken dialogue, though there is no comic element in the work. Other important operas in the second half of the century were *Mignon* by Ambroise Thomas (1811–1896), *Manon*, *Werther*, and *Thaïs* by Jules Massenet (1842–1912), *Le Roi d'Ys* (*The King of Ys*) by Édouard Lalo (1823–1892), *Lakme* by Léo Delibes (1836–1891), *Les Contes d'Hoffmann* (*The Tales of Hoffman*) by Jacques Offenbach (1819–1880), *Samson et Dalila* by Camille Saint–Saëns (1835–1921), *Louise* by Gustave Charpentier (1860–1956), and *Fervaal* by Vincent d'Indy (1851–1931).

GERMAN OPERA

Germany, of secondary importance in eighteenth–century opera, rose to a position of eminence during the nineteenth century. The first half of the century was dominated by German Romantic opera; the second half by the music dramas of Richard Wagner (1813–1883).

Romantic Opera German operas borrowed much from French and Italian models, but they differed in a number of ways. (1) Subject material was drawn from medieval legends, folk tales, and fairy stories. (2) Plots leaned heavily on supernatural, mystic, and occult elements, and on wild and mysterious aspects of nature. (3) In addition to Italian–style arias, German composers employed folk tunes and melodies in folk style. (4) German Romantic operas made much more use of harmonic and orchestral colors to heighten dramatic interest.

Composers

The central figure in German Romantic opera was Carl Maria von Weber (1786–1826), whose principal works were *Der Freischütz*, *Euryanthe*, and *Oberon*. Other German Romantic operas were *Fidelio* by Ludwig van Beethoven (1770–1827), *Faust* and *Jessonda* by Ludwig Spohr (1784–1859), *Undine* by E.T.A. Hoffmann (1776–1822), *Hans Heiling* and *Der Vampyr* by Heinrich Marschner (1795–1861), *Zar und Zimmermann* (*Czar and Carpenter*) by Albert Lortzing (1801–1851), *Genoveva* by Robert Schumann (1810–1856), *Martha* by Friedrich von Flotow (1812–1883), *Die Lustigen Weiber von Windsor* (*The Merry Wives of Windsor*) by Otto Nicolai (1810–1849), and *Der Fliegende Holländer* (*The Flying Dutchman*) by Richard Wagner. *Hänsel und Gretel* by Englebert Humperdinck (1854–1921) is a popular fairy–tale opera.

Music Drama German opera in the second half of the nineteenth century was thoroughly dominated by the creative genius of Richard Wagner, who conceived of opera as the unification of the arts and called it *music drama*.

Wagner (1813–1883)

More than any other composer, Richard Wagner departed from operatic tradition. (1) His concept of opera was that it should be a fusion of stagecraft, the visual arts, literature, and music, which he called the *Gesammtkunstwerk* (total artwork). He postulated that this approach would lead to dramatic truth and unity surpassing anything in the operatic field. So great was his vision that it required the construction of a special theater, *Bayreuth*, to realize it. (2) Wagner wrote his own libretti, which, like earlier German Romantic operas, employed national folklore and legend, medieval plots, supernatural elements, and themes involving redemption, often with religious im-

plications. (3) Dramatic and musical continuity were characteristic of music dramas that abolished separate closed forms. (4) Specific distinctions between aria and recitative were abandoned. (5) Thematic recurrence in operas had been introduced earlier, but it was Wagner who exploited the *leitmotif*, a device to enhance the drama and unify the music. Leitmotifs ("leading motives") were musical themes that symbolized characters, objects, situations, emotions, or ideas. (6) Wagner greatly increased the size of the orchestra, gave it a more prominent and dramatic function, and made it an important factor in the characteristic continuity of music dramas. (7) Chromatic harmony, extended modulations, long, irregular phrases, contrapuntal textures, and slight use of chorus are other characteristics of Wagner's music dramas.

Wagner set forth his ideas in several treatises on the subject of music and drama: *The Artwork of the Future* and, most importantly, *Opera and Drama*. His early Romantic operas were *Die Feen* (*The Fairies*), *Das Liebesverbot* (*Forbidden Love*), *Rienzi*, *Der Fliegende Holländer* (*The Flying Dutchman*), *Tannhäuser*, and *Lohengrin*. The music dramas include an operatic tetralogy titled *Der Ring des Nibelungen* (*The Ring of the Nibelungen*), containing the four operas *Das Rheingold*, *Die Walküre*, *Siegfried*, and *Die Götterdämmerung* (*The Twilight of the Gods*). Other music dramas were *Tristan und Isolde* and *Parsifal*, his last opera. *Die Meistersinger von Nürnberg* is based on the life of Hans Sachs, a famous meistersinger.

Late Romantic Opera

No German or Austrian composer found it possible to escape entirely the shadow of Wagner. Important late–century composers like Gustav Mahler (1860–1911) and Anton Bruckner (1824–1896) chose not to write operas at all. Richard Strauss (1864–1949) enjoyed success with his operas in the early twentieth century, especially with *Salome* and *Elektra*, both of which scandalized audiences, and the sensuous *Der Rosenkavalier* (*The Cavalier of the Rose*). Hans Pfitzner (1869–1949) made a conscious effort to shed the influence of Wagner in his *Palestrina*, based on the life of the composer.

OTHER NATIONAL OPERA

In addition to the most significant developments in nineteenth–century opera in Italy, France, and Germany, there were some outstanding operas in other countries.

Russia

Russian nationalistic opera began with *A Life for the Czar* and *Russlan and Ludmilla* by Mikhail Glinka (1804–1857). The principal Russian operas were *The Stone Guest* by Alexander Dargomizsky (1813–1869), *Boris Godunov* by Modest Mussorgsky (1839–1881), *Prince Igor* by Alexander Borodin (1833–1887), *Eugen Onegin* by Peter Illich Tchaikovsky (1840–1893), and a number of operas by Nicolai Rimsky–Korsakov (1844–1908), including *Sadko*, and *Le Coq d' or* (*The Golden Cockerel*).

Czechoslovakia

National Bohemian operas included the comic opera *Prodana Nevesta* (*The Bartered Bride*) by Bedřich Smetana (1824–1884), *King and Collier* and *Rusalka* by Antonin Dvořák (1841–1904), and *Jenufa* and *From the House of the Dead* by Leoš Janáček (1854–1928).

England

The most important development in English musical theater in the nineteenth century were the operettas by William Gilbert (1836–1911) and Arthur Sullivan (1842–1900), which, because of their wit, humor, clever satire, and rollicking tunes, have remained popular. The best–known titles are *Trial by Jury*, *H.M.S. Pinafore*, *The Pirates of Penzance*, *Iolanthe*, *The Mikado*, *The Yeomen of the Guard*, and *The Gondoliers*.

Scores and Recordings

Italian opera
- Rossini: NAWM 137
- Bellini: NAWM 138
- Verdi: NAWM 142; NSII 14
- Puccini: NSII 22

French opera
- Meyerbeer: NAWM 139
- Bizet: NSII 20

German opera
- Weber: NAWM 140
- Wagner: NAWM 141; NSII 13

24

Vocal Music

The Romantic era produced some estimable vocal literature in addition to opera. The art song was the most important type; oratorio and choral music were relatively less important.

ART SONG

The art song is a category of vocal literature distinct from popular song, folk song, and operatic aria. Its appeal to nineteenth–century musicians is a clear manifestation of the Romantic affinity for lyric and intimate expression in concise forms.

Musical Characteristics

Nineteenth–century song composers took great pains with musical expression of the poetic text, and in no other field was there a closer tie between word and music.

Melody

As a vehicle for the expression of intimate poetic sentiment, vocal melody in the art song was characteristically lyric rather than dramatic. It enhanced the general mood of the poetry, and frequently "painted" nonmusical images as shown in the excerpt from "Alinde" (Example 24.1) by Franz Schubert (1797–1828), in which the phrase "The sun sank into the depths of the sea" is set to a descending melodic line, "sun" being the high point and "sea" the low point.

Die Son - ne sinkt__ in's tie - fe Meer

Example 24.1. Musical Tone–Painting

Accompaniment

The piano, which came into general use in the early nineteenth century, provided additional resources for romantic expression in the art song. The accompaniment functioned in four ways: (1) it provided harmonic and sometimes melodic support to the voice; (2) it punctuated the poetic form with interludes between stanzas and lines of the poem; (3) it further enhanced the mood and meaning of the text by harmonic, rhythmic, and even melodic material independent of the voice part; and (4) it did most of the tone–painting.

Form

The musical form of a song is partly determined by poetic structure. Two basic forms are *strophic form*, in which each stanza of the poem is set to the same music, and *through–composed form*, in which the music, more closely following changing ideas and moods of the poem, is different for each stanza. *Modified strophic form* is a compromise in which the successive stanzas are sung to modified versions of the same music. A few songs are only partly strophic; some stanzas have the same music and others are set to different music. For example, a four–stanza poem might correspond to a musical form such as *AABA*, *ABAB*, *ABCA*, or some other configuration.

Song Cycle

The nineteenth century produced a new genre in the *song cycle*, a group of poems by one poet, set to music by one composer. Song cycles have a central idea or mood, and usually a loosely narrative sequence of songs.

Poets

The art song was nourished by flourishing Romantic poetry. The poets whose names appear most frequently in nineteenth–century solo song literature are Johann Schiller, Heinrich Heine, Johann Wolfgang von Goethe, Wilhelm Müller, Eduard Möricke, Joseph von Eichendorff, Lord George Byron (whose English poems were often translated into German), and the French symbolist poets Paul Verlaine, Stéphane Mallarmé, and Charles Baudelaire.

Composers

German poets and composers dominated nineteenth–century song literature. German *lieder* (songs) far outnumbered songs in other lauguages. Early development of the lied occurred in the ballads of Johann Rudolf

Zumsteeg (1760–1802), which he modeled after the popular ballads of England and Scotland. Franz Joseph Haydn (1732–1809), Ludwig van Beethoven (1770–1827), and others also wrote and arranged ballads for English publishers and audiences. Franz Schubert is primarily responsible for the maturity of the lied. After him, the foremost lieder composers were Robert Schumann (1810–1856), Johannes Brahms (1833–1897), and Hugo Wolf (1860–1903).

Schubert (1797–1828)

During his short life Franz Schubert produced some six hundred songs. A master of melodic invention, he elevated the lied to a position of supreme artistry. His songs combined classical serenity and simplicity with romantic harmony and lyric, "sehnsucht" melody. Generally he favored strophic and modified strophic forms, as in "Das Wandern" ("The Wanderer") and "Du Bist die Ruh" ("Thou Art Repose"), respectively. His two song cycles, *Die Schöne Müllerin* (*The Maid of the Mill*) and *Winterreise* (*Winter Journey*) are masterpieces of the genre and contain some of Schubert's most beautiful songs.

Schumann (1810–1856)

Robert Schumann's songs are Romantic in every sense. An outstanding characteristic is the prominence of the piano, which at times outweighs the voice part. Piano introductions, interludes, and postludes are frequently long. Two of his song cycles are *Frauenliebe und Leben* (*Woman's Love and Life*) and *Dichterliebe* (*Poet's Love*).

Brahms (1833–1897)

Like Schubert, Johannes Brahms preferred strophic form, and his songs lean toward a folk style, less highly charged with emotion than those of Robert Schumann. He composed more than 260 songs, the *Magelone* song cycle, and *Vier Ernste Gesange* (*Four Serious Songs*) composed on biblical texts.

Wolf (1860–1903)

Hugo Wolf was a specialist in lieder. His flexible and irregular phrases and frequent chromaticism reflect the influence of Wagner, whom he venerated. His 250 lieder were mostly in through–composed form. He is noted for subtlety of musical expression. Though he composed no song cycles, he concentrated on one poet at a time (Eichendorff, Goethe, Mörike). In addition are the collections of songs on texts translated from Spanish poems (*Spanisches Liederbuch*) and Italian poems (*Italienisches Liederbuch*).

Other Lieder Composers

Other German composers who contributed to nineteenth–century song literature were Beethoven, whose song cycle was titled *An die Ferne Geliebte*

(*To the Distant Beloved*), Karl Loewe (1796–1869), who was a master of the strophic ballad form, Felix Mendelssohn (1809–1847), Robert Franz (1815–1892), Peter Cornelius (1824–1874), Gustav Mahler (1860–1911), and Richard Strauss (1864–1949).

French Art Song

The poems of Baudelaire, Mallarmé, and Verlaine were the chief inspiration for an excellent but limited French song literature that flourished mainly in the second half of the century. The principal composers were Charles Gounod (1818–1893), Gabriel Fauré (1845–1924) (*La Bonne chanson*, a song cycle), Ernest Chausson (1855–1899), and Henri Duparc (1848–1933). Hector Berlioz (1803–1869) preceded them all with his song cycles *Les Nuits d'été* and *Irlande*.

Russian Art Song

Late nineteenth–century Russian composers, better known for their contributions to other categories of music, produced some notable song literature. The most important of these were Peter Illich Tchaikovsky (1840–1893), Sergei Rachmaninoff (1873–1943), Alexander Gretchaninov (1864–1956), Reinhold Glière (1875–1956), and Modest Mussorgsky (1839–1881), who composed two fine song cycles: *Sunless* and *Songs and Dances of Death*.

ORATORIO AND CANTATA

Oratorios and cantatas did not attract Romantic composers to the extent that opera and solo song did. To the Handelian concept, which continued to dominate oratorio in the nineteenth century, were added Romantic subjectivity and expanded orchestral resources.

Composers

Felix Mendelssohn was the most eminent composer of nineteenth–century oratorios and cantatas, chiefly because of his mastery of choral technique. His fame in this field rests on two oratorios, *St. Paul* and *Elijah*, and the cantata *Erste Walpurgisnacht*. Other notable oratorios or cantatas of the century were Beethoven's *Christ on the Mount of Olives*, *The Last Judgement* by Ludwig Spohr (1784–1859), Robert Schumann's *Paradise and the Peri*, Berlioz's *L'Enfance du Christ* (*The Childhood of Christ*), *Legend of St. Elizabeth and Christus* by Franz Liszt (1811–1886), *The Beatitudes* by César Franck (1822–1890), Johannes Brahms's *German Requiem*, which employs

a biblical rather than liturgical text, *The Crucifixion* by John Stainer (1840–1901), *Judith*, *Job*, and *King Saul* by Hubert Parry (1848–1918), *The Dream of Gerontius* by Edward Elgar (1857–1934), and *Hora Novissima* by the American, Horatio Parker (1863–1919).

OTHER RELIGIOUS CHORAL MUSIC

The Romantic era was not one of the great periods in church music. The distinction between choral genres rested mainly on textual rather than formal and stylistic considerations. Psalms and other liturgical texts were set to music more often as festival works for concert performance than as functional church music. Like oratorio, Romantic church music made use of large choruses, solo voices, and orchestra, but unlike oratorio it did not employ narrator and recitative.

Composers The principal composers of masses and other music on Catholic liturgical texts were Beethoven (*Missa Solemnis*), Luigi Cherubini (1760–1842), Franz Schubert, Gioachino Rossini (1792–1868; *Stabat Mater*), Felix Mendelssohn (*Psalms* and *Lauda Sion*), Johannes Brahms (*Motets* for female chorus, Opp. 29, 74, and 110), Hector Berlioz (*Grande Messe des Morts* [*Requiem*] and *Te Deum*), Franz Liszt (*Graner Mass* and *Hungarian Coronation Mass*), Giuseppe Verdi (1813–1902; *Requiem*), Charles Gounod (*St. Cecelia Mass*), César Franck (*Psalms*), John Knowles Paine (1839–1906; *Mass in D*), Gabriel Fauré (*Requiem*), and Anton Bruckner (1824–1896). Mention should also be made of the Russian Dimitri Bortniansky, who composed religious choral works for the Greek Orthodox Church.

SECULAR CHORAL MUSIC

The rise of nationalism and interest in folk song provided impetus for secular choral music as did also the formation of numerous choral groups and societies. Choral media ranged from unaccompanied part songs to cantata–like works with solo voices and orchestra.

Composers Felix Mendelssohn, one of the foremost composers of Romantic choral music of all kinds, wrote some fifty unaccompanied part songs and *Erste Walpurgisnacht*, a secular cantata. Matching Mendelssohn's excellence in choral media, Johannes Brahms wrote numerous works for men's, women's, and mixed choruses, unaccompanied and with various accompanying media. Among his principal works are the *Rhapsody* for contralto, male chorus, and orchestra, *Song of Destiny*, *Song of Triumph*, *Nänie*, and the *Liebeslieder Waltzes* for mixed chorus (or four solo voices) with four–hand piano accompaniment. Other secular choral works are Hector Berlioz's *La Damnation de Faust* (*The Damnation of Faust*) and Robert Schumann's *Scenes from Goethe's "Faust"*. Choral media were also employed in a number of orchestral works by Beethoven, Liszt, Mahler, and others.

Scores and Recordings Some of these examples are excerpts from larger works.

Art Song

Schubert: NAWM 133; NSII 1

Robert Schumann: NAWM 134; NSII 10

Wolf: NAWM 135

Brahms: NSII 18

Mahler: NAWM 136

Fauré: NAWM 157

Mussorgsky: NAWM 158

Sacred Choral Music

Brahms: NSII 17

Bruckner: NAWM 143

25

Instrumental Music

Individualism, nationalism, program music, and virtuosity were especially prominent traits in instrumental music. Short piano miniatures and lengthy orchestral works were manifestations of Romantic extremes. The piano and the orchestra were the principal media; chamber music was relatively less important.

KEYBOARD MUSIC

The piano was to instrumental music what the art song was to vocal music. Attracting composer and performer alike, it was one of the most important media in all nineteenth–century music. The organ attracted little attention from composers

The Piano

Because of its capacity for sonority, dynamic range, and gradations between loud and soft—characteristics that the harpsichord lacked—the piano was the Romantic instrument par excellence. Not only was it the leading solo instrument but it was an important ingredient in chamber ensembles. It provided composer and performer with possibilities of expression ranging from the intimate to the grandiose, and from delicate lyricism to bombastic showiness. The damper pedal enabled composers to experiment with new harmonic effects, and the improved keyboard mechanism was a stimulus toward new idioms, techniques, and virtuosity.

Genres

As in other media, nineteenth–century piano composers were generally less concerned with musical form than with content and subjective expression.

Sonatas

After Ludwig van Beethoven (1770–1827) and Franz Schubert (1797–1828), the piano sonata attracted relatively few composers, and the Classical sonata cycle was largely abandoned in favor of single–movement pieces.

Dances

Stylized dances constituted a large portion of Romantic piano literature. The most common were the *waltz*, *Ländler* (an Austrian waltz, in a slow tempo), *mazurka*, *polonaise*, *ecossaise*, *polka*, *galop*, and other national dances.

Etudes

The *etude*, basically a study piece featuring some technical aspect of performance (e.g., scales, arpeggios, figurations, octaves, chords), was composed as a virtuoso piece for concert audiences.

Character Pieces

Short pieces conveying a general mood and those specifically programmatic with descriptive titles are classified as *character pieces*. These are the instrumental equivalents of the song. They include compositions with such titles as *arabesque*, *ballade*, *intermezzo*, *nocturne*, *romanza*, *lament*, *moment musicale*, *rhapsody*, *impromptu*, *bagatelle*, *songs without words*, and descriptive titles such as "Butterflies," "Colored Leaves," and many more.

Variations

After Beethoven, piano variations were largely extended virtuoso show pieces.

Performers

The nineteenth–century nurtured the rise of the concert pianist, of which there were many. Some of the more important were Franz Liszt (1811–1886), Louis Moreau Gottschalk (1829–1869), Henri Herz (1803–1888), Clara Wieck Schumann (1819–1896), Anton Rubinstein (1829–1894), Hans von Bülow (1830–1894), Carl Tausig (1841–1871), Ignace Jan Paderewski (1860–1941), and Sergei Rachmaninoff (1873–1943).

Composers

Beethoven (1770–1827)

Nineteenth–century piano literature began with Beethoven's monumental sonatas and variations.

Schubert (1797–1828)

Franz Schubert's piano style fused Classical form and reserve with Romantic lyricism and expression. His piano music includes eleven sonatas,

six impromptus, eight moments musicales, and some piano duets, but no concertos or programmatic works.

Mendelssohn (1809–1847)

In addition to two piano concertos and some preludes and fugues reflecting his admiration for J. S. Bach (1685–1750), Felix Mendelssohn's principal piano works were some fifty Romantic pieces called *Lieder ohne Worte* (*Songs without Words*), many of which were published with descriptive titles added by the publishers, such as the famous "Spinning Song."

Schumann (1810–1856)

Until about 1840, Robert Schumann devoted himself almost exclusively to piano composition. His works consist mainly of short character pieces with descriptive titles, grouped in collections entitled *Papillons* (*Butterflies*), *Kinderscenen* (*Scenes of Childhood*), *Carnaval*, *Fantasiestücke* (*Fantasy Pieces*), and others.

Chopin (1810–1849)

The most illustrious composer of piano music in the century, Frédéric Chopin was a specialist in that medium and composed little else. His music is eminently idiomatic, revealing his keen sense of the properties and capacities of the piano. He used no descriptive titles, and wrote mostly single–movement works. Outstanding characteristics are a homophonic texture, extensive chromaticism and modulation, superb melodic and harmonic ingenuity, limited virtuosity, and general refinement and delicacy of style. His compositions include nocturnes, scherzi, twenty–four preludes in all major and minor keys, waltzes, stylized Polish dances (polonaises and mazurkas), twenty–seven etudes, impromptus, three sonatas, and two piano concertos.

Liszt (1811–1886)

Franz Liszt was the foremost pianist–composer of the nineteenth century. His piano compositions generally fall in three categories: brilliant virtuoso compositions, pieces with quiet Romantic lyricism, and transcriptions of opera arias, lieder, symphonies, and Bach's organ fugues. His principal works are the *Hungarian Rhapsodies*, three piano concertos, twelve brilliant etudes entitled *Études d'exécution transcendante* (*Transcendental Etudes*), three sets of short poetic pieces titled *Années de pélerinage* (*Years of Pilgrimage*), and the *Petrarch Sonnets*.

Brahms (1833–1897)

Johannes Brahms's music, though Romantic in melody, harmony, texture and sonority, is nevertheless classically inclined in its formal details, avoidance of programmatic or literary allusions, and absence of showy virtuosity. Character pieces include ballades, rhapsodies, capriccios, and intermezzi.

He wrote three piano sonatas and several sets of variations, including *Variations on a Theme of Haydn* for two pianos.

Other Composers

Enormous quantities of piano music were composed during the nineteenth century. Although vastly popular at the time, the composers are less well known now. Among them are Johann Nepomuk Hummel (1778–1837), Carl Czerny (1791–1857), Friedrich Kalkbrenner (1785–1849), Sigismond Thalberg (1812–1871), and Adolf von Henselt (1814–1889). The sonatas and etudes, such as *Gradus ad Parnassum* by Muzio Clementi (1752–1832), and the music of John Field (1782–1837) were noteworthy contributions to piano literature. Other composers were the German Max Reger (1873–1916), the Norwegian Edvard Grieg (1843–1907), the American Edward MacDowell (1860–1908), the Frenchmen Gabriel Fauré (1845–1924) and César Franck (1822–1890), the Spaniards Isaac Albéniz (1860–1909) and Enrique Granados (1867–1916), the Italian Ferruccio Busoni (1866–1924), and the Russians Modest Mussorgsky (1839–1881), Anton Rubinstein (1829–1894), and Sergei Rachmaninoff (1873–1943), who was the last of the great Romantic pianist–composers.

Organ Music

After J. S. Bach, few composers wrote for the organ during the Classical and most of the Romantic periods. The most important developments took place in the late nineteenth century and mainly in France. Principal composers were Felix Mendelssohn, Franz Liszt, César Franck, Max Reger, and Charles Widor (1844–1937).

ORCHESTRAL MUSIC

The orchestra, one of the great media of the Romantic era, expanded in size, resources for color, and range of sonorities.

Instrumentation

Each of the four choirs added instruments beyond those of the Classical orchestra.

Woodwinds

More than two each of flutes, oboes, clarinets, and bassoons were used. Additional woodwinds were piccolo, bass clarinet, English horn, and contrabassoon.

Brass

The brass section (or, as it is called, *choir*) usually included four horns that, along with trumpets, trombones, and tubas, gave tremendous power and sonority to the orchestra. The advent of valves gave more versatility and melodic potential to brass instruments.

Percussion

To the Classical timpani were added many percussion instruments: bass and side drums and a large assortment of "color" instruments such as the harp, triangle, castanets, gongs, cymbals, chimes, bells, xylophones, and celestas.

Strings

No new instruments were added to the string choir, but it expanded in number to balance the larger woodwind and brass choirs. Unlike in Classical period scores, the string parts were written on five staves.

Orchestration

Composers sought new effects for expressive purposes. There was more use of solo passages, especially for individual woodwind instruments and horn. Special string effects were used: pizzicato, double–stopping, mutes, tremolo, harmonies, and others. The composers who contributed most notably to the technique of orchestration were Hector Berlioz (1803–1869), Franz Liszt, Richard Wagner (1813–1883), Gustav Mahler (1860–1911), Richard Strauss (1864–1949), and Nicholas Rimsky–Korsakov (1844–1908).

Genres

New concepts in orchestral form were added to the Classical symphony and concerto forms.

Symphony

Works entitled "symphony" were composed by most of the major Romantic composers. Only in the broadest outlines did they follow the sonata cycle of the Classical symphony. Composers varied the number of movements, used more contrasting keys in the inner movements, used freer forms for internal structure of movements, and generally made the symphony a vehicle for expression rather than a formal design. In a number of instances composers added chorus and solo voices to the orchestra (Beethoven, Berlioz, Liszt, Mahler, and others). The programmatic symphony was an important Romantic development.

Concerto

The piano and violin were the chief solo instruments employed in the concerto. Generally it was a brilliant show piece for the virtuoso soloist. The Romantic concerto retained the Classical three–movement plan.

Tone Poem

A new orchestral form, called *tone poem* or *symphonic poem*, was introduced by Franz Liszt around the middle of the century. It is a one–movement programmatic work with descriptive title, based on a literary work or legend. Some well–known tone poems are *Les Preludes* by Liszt, *The Moldau* (the second of six tone poems collectively entitled *Má Vlast*) by Bedřich Smetana (1824–1884), *Night on Bald Mountain* by Modest Mussorgsky, *The Sorcerer's Apprentice* by Paul Dukas (1865–1935), *Danse macabre* by Camille Saint–Saëns (1835–1921), *On the Steppes of Central Asia* by Alexander Borodin (1833–1887), *Finlandia* by Jean Sibelius (1865–1957), *Isle of the Dead* by Sergei Rachmaninoff, and *Till Eulenspiegel* by Richard Strauss.

Concert Overtures

Single–movement works, called *concert overtures*, were usually in sonata form but were not orchestral introductions to operas. To some extent they were programmatic and often had descriptive titles. Examples are Mendelssohn's *Fingal's Cave Overture*, Brahms's *Academic Festival Overture*, and the *1812 Overture* by Peter Illich Tchaikovsky (1840–1893).

Orchestral Variations

Relatively few orchestral works were in variation form. Some notable examples are Johannes Brahms's *Variations on a Theme of Haydn*, César Franck's *Symphonic Variations* for piano solo and orchestra, *Istar Variations* by Vincent d'Indy (1851–1931), and the *Enigma Variations* by Edward Elgar (1857–1934).

Symphonic Suites

Symphonic suites are programmatic works in several movements that do not follow symphonic form. In this category are originally composed fantasies, such as Nicholas Rimsky–Korsakov's *Scheherazade*; arrangements of ballet music such as Tchaikovsky's *Nutcracker Suite*; and incidental music to plays, such as Mendelssohn's *A Midsummer Night's Dream* and the *Peer Gynt Suite* by Edvard Grieg.

Dances

Semipopular orchestral music in dance forms includes the Johann Strauss (1825–1899) waltzes and other dances by a number of composers.

Composers

Germans were most important in the development of orchestral literature in the nineteenth century. As nationalism became a strong current after about 1850, more composers in other countries contributed to the literature.

Beethoven (1770–1827)

Ludwig van Beethoven's nine symphonies are the beginning of the expansion of orchestral form and medium. His sixth symphony (the "Pastoral" symphony) in five movements was an early program symphony. The finale of his ninth symphony contains the first use of solo voices and chorus in a symphony.

Schubert (1797–1828)

Franz Schubert wrote eight symphonies in Classical orchestral medium and form. Romantic elements in his music are the lyrical, transcendent melodies and ingenious harmonies. Best known are the "Unfinished" symphony in b minor and the c minor symphony.

Mendelssohn (1809–1847)

The best of Felix Mendelssohn's five symphonies are the last three, popularly known as the "Scotch", "Italian", and "Reformation." They are in Classical four–movement form with refined romantic materials. Other orchestral works are the incidental music to Shakespeare's *A Midsummer Night's Dream*, which contains the famous "Overture," "Scherzo," and "Wedding March," two piano concertos, the violin concerto in e minor, and the concert overtures *Fingal's Cave* (also called the *Hebrides Overture*), *Calm Sea and Prosperous Voyage*, and *Melusine*.

Schumann (1810–1856)

Robert Schumann's orchestral music is less programmatic than Mendelssohn's. He composed four symphonies, a piano concerto, violin concerto, and cello concerto.

Berlioz (1803–1869)

The most programmatic orchestral music in the first half of the century and the greatest advances in Romantic orchestration are attributed to Hector Berlioz. He wrote the first treatise on orchestration. He employed *cyclical form* (the recurrence of one or more themes in successive movements). His best–known orchestral work is the five–movement programmatic *Symphonie fantastique*, which contains an *idée fixe* (an orchestral motive that represents a character). Other symphonies are *Harold en Italie*, commissioned by the great virtuoso Niccolò Paganini (1782–1840), and *Roméo et Juliette*, after Berlioz's beloved Shakespeare, for orchestra, solo voices, and chorus.

Liszt (1811–1886)

Franz Liszt's main contributions are thirteen tone poems, two program symphonies (*Faust Symphony* in three movements, the finale of which employs a male chorus, and the *Dante Symphony* in two movements), and three brilliant virtuoso piano concertos.

Brahms (1833–1897)

Johannes Brahms's four symphonies are thoroughly Romantic in style but are not programmatic. They follow expanded classical form. Other orchestral works include two piano concertos, one violin concerto, a double concerto for violin and cello, two serenades, *Variations on a Theme of Haydn*, *Academic Festival Overture*, and *Tragic Overture*.

Bruckner (1824–1896)

Anton Bruckner's nine symphonies (the last incomplete) are notable for their great length and large orchestras. They are all in four movements with no overt programmatic elements. He composed no concertos or other orchestral works.

Mahler (1860–1911)

Gustav Mahler wrote ten symphonies, the last uncompleted. His second, third, fourth, and eighth symphonies make use of voices. The eighth symphony, appropriately known as the *Symphony of a Thousand*, represents the ultimate in large–scale form and medium. It calls for an enormous orchestra, a band, two mixed choruses, a boys' choir, and seven solo voices. Mahler's symphony/song cycle *Das Lied von der Erde* (*The Song of the Earth*) is for two solo voices and orchestra.

Tchaikovsky (1840–1893)

The last three of Peter Illich Tchaikovsky's six symphonies are the best known. Other orchestral works are the tone poems *Romeo and Juliet* (called an "Overture Fantasy") and *Francesca da Rimini*, the *1812 Overture*, three piano concertos, a violin concerto, and a *Serenade in C* for string orchestra.

Smetana (1824–1884)

Bedřich Smetana was a Czech nationalist known chiefly for his six "musical landscapes" entitled *Má Vlast* (*My Fatherland*).

Dvořák (1841–1904)

One of the most prolific orchestral composers in the late nineteenth century was Antonin Dvořák. The most famous of his nine symphonies is the *Symphony from the New World*, written during a three–year stay in the United States. He composed orchestral variations, six concert overtures, five tone poems, three *Slavonic Rhapsodies*, a violin concerto, a piano concerto, and two cello concertos.

Franck (1822–1890)

The French school of Romantic orchestral music began with César Franck. He composed one symphony, in d minor, *Symphonic Variations* with

piano solo, and the tone poems *Les Éolides*, *Le Chausseur maudit*, *Les Djinns* for piano and orchestra, and *Psyché* for chorus and orchestra.

Saint–Saëns (1835–1921)

Camille Saint–Saëns wrote symphonies (the third with organ and piano four hands), concertos, and the ever–popular tone poem *Danse macabre*.

D'Indy (1851–1931)

Vincent D'Indy wrote three symphonies, the best known of which is the *Symphony on a French Mountain Air* for piano and orchestra, and the *Istar Variations*.

Strauss (1864–1949)

Richard Strauss composed most of his tone poems in the 1890s. His orchestration and other aspects of style foreshadow modern techniques, though his music remains essentially Romantic. His principal tone poems are *Aus Italian*, *Tod und Verklärung* (*Death and Transfiguration*), *Till Eulenspiegel*, *Also Sprach Zarathustra*, *Don Quixote*, and *Ein Heldenleben* (*A Hero's Life*). Two program symphonies are *Sinfonia Domestica*, and *An Alpine Symphony*.

Sibelius (1865–1957)

Though he lived past the middle of the twentieth century, Jean Sibelius belongs mainly to the Romantic tradition. He was Finland's greatest composer. His field was principally orchestral music. He composed seven symphonies and several tone poems, the best known of which are *Finlandia*, *En Saga*, *Swan of Tuonela*, *Tapiola*, and *Pohjola's Daughter*. His *Karelia Suite*, like his tone poems, is based on Finnish legends.

Rachmaninoff (1893–1943)

Like Sibelius, Sergei Rachmaninoff belongs to the Romantic period, though he lived until 1943. His orchestral works include two symphonies, four piano concertos, the tone poem *Isle of the Dead*, and orchestral varations for piano and orchestra entitled *Rhapsody on a Theme of Paganini*.

CHAMBER MUSIC

Chamber music was one of the least favored media among nineteenth–century composers, mainly because it lacks the intimacy of the piano on the

one hand or the massive, colorful, and emotional qualities of the orchestra on the other. Almost no program music was written for chamber ensembles.

Media

The string quartet continued to be the most favored chamber medium. There was an appreciable increase in the number of chamber works employing the piano in trios, quartets, and quintets. Solo sonatas for violin and other instruments were relatively few.

Composers

After Beethoven and Schubert, among the foremost contributions to chamber music were those of Johannes Brahms and Antonín Dvořák. Composers who contributed most to chamber music literature were mainly those who had classical leanings.

Beethoven (1770–1827)

Nineteenth–century chamber music, like piano and orchestral music, began with Beethoven. His output in chamber music included sixteen string quartets, four string trios, six piano trios, ten violin sonatas, five cello sonatas, a horn sonata, and a quintet for piano and wind instruments.

Schubert (1797–1828)

Among Schubert's fifteen string quartets, the best known is the quartet in d minor, called the *Death and the Maiden Quartet* because the *andantino* movement is a set of variations on Schubert's song "Der Tod und das Mädchen." Another well–known work is the *Trout Quintet*, which includes a set of variations for the slow movement on Schubert's song "Die Forelle."

Mendelssohn (1809–1847)

Felix Mendelssohn's chamber music includes six string quartets, two quintets, an octet, a sextet for piano and strings, two piano trios, one violin sonata, and two cello sonatas.

Schumann (1810–1856)

Robert Schumann composed three string quartets, three piano trios, a piano quartet, a piano quintet, solo sonatas, and other works for various combinations of instruments.

Brahms (1833–1897)

Brahms, the "Romantic classicist," composed some twenty–four works in this category, including string quartets, quintets, sextets, a clarinet quintet, a piano quintet, piano quartets, piano trios, a trio for clarinet, cello, and piano, the famous *Horn Trio* for violin, piano, and French horn, and sonatas for piano and various solo instruments.

Dvořák (1841–1904)

Antonin Dvořák was one of the most important chamber music composers at the end of the century. His works include thirteen string quartets, two string quintets, one sextet, two piano quartets, four piano trios, one string trio, and one piano quintet.

Franck (1822–1890)

César Franck wrote a string quartet, a piano quintet, four piano trios, and the violin sonata in A Major, his most popular chamber work.

Fauré (1845–1924)

Gabriel Fauré's chamber music includes two piano quartets, two piano quintets, a piano trio, a string quartet, two violin sonatas, and two cello sonatas.

Scores and Recordings

Some of these examples are excerpts from larger works.

Piano Music

Field: NAWM 125

Chopin: NAWM 126; NSII 7 and 8

Robert Schumann: NSII 9

Liszt: NAWM 127 and 128; NSII 12

Clara Schumann: NSII 15

Chamber Music

Brahms: NAWM 132

Orchestral Music.

Schubert: NSII 2

Mendelssohn: NAWM 130; NSII 5 and 6

Berlioz: NAWM 129; NSII 3 and 4

Robert Schumann: NSII 11

Smetana: NSII 16

Brahms: NSII 19

Tchaikovsky: NSII 21

Mahler: NSII 23

Richard Strauss: NSII 25

MacDowell: NAWM 131

26

Summary of Major Nineteenth–Century Composers

The following summary lists the foremost masters of nineteenth–century music according to nationality, and points out the major fields of each composer.

GERMANY AND AUSTRIA

Germany and Austria were dominant countries in nineteenth–century Romantic music, with several important composers. Ludwig van Beethoven (1770–1827): transition from Classical to Romantic styles; symphony, concerto, piano sonatas and variations, chamber music. Carl Maria von Weber (1786–1826): German Romantic opera. Franz Schubert (1797–1828): Viennese composer of songs, symphonies, piano sonatas, chamber music. Felix Mendelssohn–Bartholdy (1809–1847), more commonly known as Mendelssohn: composer, conductor; especially important in choral music and oratorio; also song, symphony, symphonic suite, concert overture, chamber music, piano and organ music. Robert Schumann (1810–1856): composer, pianist, critic, author, and editor of the *Neue Zeitschrift für Musik* (*New Musical Journal*); song, piano music, symphony, chamber music, and concerto. Franz Liszt (1811–1886): Hungarian–born, the most famous virtuoso pianist–composer of the century; innovator of tone poem; piano music, programmatic orchestral works; also song, concerto, choral and organ music.

Richard Wagner (1813–1883): music drama (opera), author of treatises on opera theory. Anton Bruckner (1824–1896): Austrian composer; symphony, religious choral music. Johannes Brahms (1833–1897): leading Classicist among Romantic composers; nonprogrammatic instrumental works; religious and secular choral music, song, symphony, chamber and piano music. Hugo Wolf (1860–1903): solo song. Gustav Mahler (1860–1911): late–Romantic Austrian composer of large orchestral works, symphonies, songs, and song cycles. Richard Strauss (1864–1949): post–Romantic composer of tone poems, operas, songs. Max Reger (1873–1916): organ, orchestral music, chamber music, choral music, piano works.

Other composers: Johann Rudolf Zumsteeg (1760–1802): solo song. E.T.A. Hoffmann (1776–1822): romantic opera. Johann Nepomuk Hummel (1778–1837): piano music. Ludwig Spohr (1784–1859): German romantic opera, oratorios. Friedrich Kalkbrenner (1785–1849): piano. Carl Czerny (1791–1857): piano. Heinrich Marschner (1795–1861): opera. Karl Loewe (1796–1869): solo song. Albert Lortzing (1801–1851): opera. Otto Nicolai (1810–1849): German romantic opera. Friedrich von Flotow (1812–1883): opera. Sigismond Thalberg (1812–1871): piano music. Adolf von Henselt (1814–1889): music for piano. Robert Franz (1815–1892): song. Peter Cornelius (1824–1874): solo song. Johann Strauss (1825–1899): orchestral dances. Englebert Humperdinck (1854–1921): fairy tale opera. Hans Pfitzner (1869–1949): opera.

ITALY

Italian music was almost entirely confined to opera; instrumental music and solo song outside of opera were virtually nonexistent. Important composers and their contributions include the following: Gioacchino Rossini (1792–1868): principally opera buffa. Gaetano Donizetti (1797–1848): Romantic serious operas. Vincenzo Bellini (1801–1835): operas; noted for elegance and lyric charm. Giuseppe Verdi (1813–1901): the culminating figure of nineteenth–century Italian Opera; Requiem mass.

Other composers: Johann Simon Mayr (1763–1845): operas. Ruggiero Leoncavallo (1857–1919): verismo opera. Giacomo Puccini (1858–1924): opera. Pietro Mascagni (1863–1945): verismo opera. Ferruccio Busoni (1866–1924): a transition figure to the twentieth century; piano and orchestral works.

FRANCE

Musical activity in France was principally in opéra comique and lyric opera. In the second half of the century there was a notable rise of interest in solo song and orchestral composition. Giocomo Meyerbeer (1791–1864): grand opera. Hector Berlioz (1803–1869): composer, critic, conductor, and writer of a theory of orchestration; opera, symphony, oratorio, song, concert overture. Frédéric Chopin (1810–1849): Polish–born composer of piano music. Charles Gounod (1818–1893): lyric opera, church music, song. César Franck (1822–1890): Belgian–born composer and organist; organ music, orchestral works, chamber music, choral music. Camille Saint–Saëns (1835–1921): symphony, opera, oratorio. Georges Bizet (1838–1875): opera, orchestral music. Gabriel Fauré (1845–1924): solo song, piano music, chamber music, requiem. Vincent d'Indy (1851–1931): teacher, composer; operas, orchestral works.

Other composers: François Boieldieu (1775–1834): opéra comique. Daniel Auber (1782–1871): opéra comique. Louis Ferdinand Hérold (1791–1833): opéra comique. Jacques Halevy (1799–1862): grand opera. Ambroise Thomas (1811–1896): lyric opera. Jacques Offenbach (1819–1880): lyric opera. Victor Massé (1822–1884): opéra comique. Édouard Lalo (1823–1892): lyric opera. Léo Delibes (1836–1891): lyric opera. Emmanuel Chabrier (1841–1894): orchestral works. Jules Massenet (1842–1912): lyric opera. Charles–Marie Widor (1844–1937): organ, opera. Henri Duparc (1848–1933): solo song. Ernest Chausson (1855–1899): solo song. Gustave Charpentier (1860–1956): lyric opera. Paul Dukas (1865–1935): concert overture, opera.

RUSSIA

Russia became one of the prominent musical nations in the second half of the nineteenth century, with music of a strongly national flavor. The first important composer was Mikhail Glinka (1804–1857), who wrote nationalist opera.

"The Five," an important group who championed Russian nationalism, included the following five composers. Modest Mussorgsky (1839–1881): orchestral works, opera, song. Alexander Borodin (1833–1887): orchestral works, string quartet, opera. Mily Balakirev (1837–1910): symphony, song,

piano music. César Cui (1835–1918): French–born, the least known among "The Five"; songs, piano music. Nicolas Rimsky–Korsakov (1844–1908): master of orchestration; opera, orchestral music.

The late romantic style in Russia was represented by Peter Illich Tchaikovsky (also, Chaikovsky, Tschaikowsky; 1840–1893): orchestral music, symphonies, concert overtures, opera, song; and by Sergei Rachmaninoff (1873–1943): the last of the great Romantic pianist–composers, who wrote orchestral works, concertos, piano music, songs.

Other composers: Dimitri Bortniansky (1751–1825): religious choral works for the Greek Orthodox Church. Alexander Dargomizsky (1813–1869): opera. Anton Rubinstein (1829–1894): piano music. Alexander Gretchaninov (1864–1956): songs. Reinhold Glière (1875–1956): songs.

NORWAY

Edvard Grieg (1843–1907): Norwegian nationalist; orchestra, piano, symphonic suite, and choral works.

FINLAND

Jean Sibelius (1865–1957): Finnish nationalist; symphonies and tone poems.

CZECHOSLOVAKIA

Czech national music was represented by two major composers. Bedřich Smetana (1824–1884): opera, orchestral and chamber works. Antonin Dvořák (1841–1904): symphony, chamber music. Leoš Janáček (1854–1928): opera, choral works.

POLAND

Stanislaw Moniuszko (1819–1872): Polish nationalist; operas.

SPAIN

The principal characteristic of Romantic Spanish music is a strongly national color. Isaac Albéniz (1860–1909): piano and orchestral music. Enrique Granados (1867–1916): piano music, operas, orchestral works.

GREAT BRITAIN

From the time of Handel until the end of the nineteenth century, few British composers exerted much influence on the Continent. Among the more important were the following. Muzio Clementi (1752–1832): Italian–born composer, publisher, teacher; piano music. Samuel Wesley (1766–1837): organ and church music. John Field (1782–1837): Irish–born composer of piano music who emigrated to Russia; influence on Chopin. Samuel Sebastian Wesley (1810–1876): son of Samuel Wesley; church music. William Sterndale Bennett (1816–1875): piano and orchestral works. John Stainer (1840–1901): cantatas, anthems. Arthur Sullivan (1842–1900): with poet–librettist William Gilbert, creator of operettas. Charles Hubert Parry (1848–1918): oratorios, anthems. Charles Stanford (1852–1924): Irish nationalist composer; church music, oratorio, opera, chamber music. Edward Elgar (1857–1934): first of the important twentieth–century English composers; orchestral works, oratorios, cantatas.

UNITED STATES

The United States enjoyed an extraordinarily rich musical life in the nineteenth–century. The greatest development occurred in popular music (see Chapter 32). The influence of American art–music composers was not great in Europe, although many of them had been trained there and generally wrote in the the German–Austrian style. Composers often worked in or near Boston, especially toward the end of the period. Among the important composers were the following: Anthony Philip Heinrich (1781–1861): eccentric Bohemian–born composer of piano and programmatic orchestral music. Lowell Mason (1792–1872): composer, conductor, educator; sacred choral music. William Henry Fry (1813–1864): critic and opera composer. George Bristow (1825–1898): opera. Louis Moreau Gottschalk (1829–1869): virtuoso pianist–composer. John Knowles Paine (1839–1906): composer and first American professor of music; symphonies, sacred music, piano and organ music. Dudley Buck (1839–1909): opera, cantata, organ. Arthur Foote (1853–1937): piano and chamber music. George Chadwick (1854–1931): opera, orchestral music, choral music, and chamber music. Edgar Stillman Kelley (1857–1944): chamber and orchestral music. Edward MacDowell (1860–1908): piano and orchestral music. Charles Loeffler (1861–1935): chamber and orchestral music. Horatio Parker (1863–1919): teacher; cantata, oratorio, opera. Amy Cheney Beach (1867–1944): orchestral and chamber music. Henry Gilbert (1868–1928): orchestral music, piano music. Henry Hadley (1871–1937): conductor; song, chamber music, opera. Frederick Converse (1871–1940): opera, orchestral and chamber music.

PART SEVEN

THE TWENTIETH CENTURY

27

Introduction to the Twentieth Century

1902 Debussy: *Pelléas et Mlisande*

1903 First successful airplane flight

1905 Julliard Conservatory of Music founded

1907 Scriabin: *Poem of Ecstasy*

1908 Bartók: String Quartet no. 1

1909 Vaughan William: *Fantasia on a Theme of Thomas Tallis*

1912 Schoenberg: *Pierrot lunaire*

1913 Stravinsky: *Le Sacre du printemps*

1913 Webern: Five Pieces for Orchestra, Op. 10

1914–1918 World War I

1915 Ives: *Concord Sonata*

1916 Einstein's theory of relativity

1917 Ravel: *Le Tombeau de Couperin*

1917 Satie: *Parade*

1918 Prokofiev: *Classical Symphony*

1923 Schoenberg: Five Piano Pieces, Op. 23

1924 Gershwin: *Rhapsody in Blue*

1925 Berg: *Wozzeck*

1926 Puccini: *Turandot*

1928 Webern: Symphony, Op. 21

1929 Worldwide depression starts

1931 Varèse: *Ionisation*

1931 Crawford: *String Quartet 1931*

1933 Roosevelt becomes president of the United States

1933 Hitler becomes chancellor of Germany

1933 Schoenberg leaves Vienna for the United States

1934 American Musicological Society founded

1936 Bartók: *Music for Strings, Percussion, and Celeste*

1937 Picasso's *Guernica*

1937 Shostakovich: Symphony no. 5

1939–1945 World War II

1941 Messiaen: *Quartet for the End of Time*

1944 Copland: *Appalachian Spring*

1945 Britten: *Peter Grimes*

1949 First piece of musique concrte

1951 Cage: *Music of Changes*

1953 Death of Stalin

1954 *Brown vs. Topeka*, Kansas outlaws racial discrimination in American education

1955 Boulez: *Le Marteau sans maître*

1956 Stockhausen: *Gesang der Jünlinge*

1957 Bernstein: *West Side Story*

1958 Varèse: *Poèm électronique*

1959 Stravinsky: *Movements*

1959 Schuller: *Seven Studies on Themes of Paul Klee*

1960 Penderecki: *Threnody: To the Victims of Hiroshima*

1962 Cuban missile crisis

1964 Babbitt: *Philomel*

1964 Riley: *In C*

1965 First performance of Ives's Symphony no. 4

1965–1973 American involvement in the Vietnam War

1967 Subotnick: *Silver Apples of the Moon*

1968 Berio: *Sinfonia*

1970 Sessions: *When Lilacs Last in the Dooryard Bloom'd*

1970 Crumb: *Ancient Voices of Children*

1974 Nixon resigns presidency

1975 Glass: *Einstein on the Beach*

1976 Reich: *Music for 18 Musicians*

1976 Del Tredici: *Final Alice*

1979 Lansky: *Six Fantasies on a Poem of Thomas Campion*

1979 Cage: *Roaratorio, an Irish Circus on Finnegans Wake*

1981 Zwilich: *Passages*

1983 Anderson: *United States*

1985 Babbitt: Concerto for Piano and Orchestra

1985 Dashow: *In Winter Shine*

1986 Adams: Nixon in China

1989 Norton Lectures (Harvard) delivered by Cage

*T*he *twentieth century has witnessed changes that in frequency and magnitude are unmatched in any previous musical history. The diversity of trends, styles, and techniques preclude the possibility of studying art music as one coordinated whole, as historians have generally tried to do with it before this century. Further, we lack the necessary distance from the events to analyze fully our understanding of twentieth–century musical history. Composers of art music out of the Western tradition are now to be found throughout the world, making discussion of the music against a backdrop of merely European history and society impossible.*

A high regard for originality has accelerated rates of change in musical style, as composers and audiences sought out the newest and most dynamic form of expression. Some styles have emerged and expired within a single decade. Whatever the difficulties of studying the music, the twentieth century has been blessed with an extraordinary amount of music making. In fact, because of the quantity of music composed since 1900, it is difficult to be familiar with more than a small fraction of the literature. Compounding the problem is the much greater complexity of melody, harmony, tonality, rhythm, texture, and form found in the music. These elements combine and virtually preclude the kind of systematic analysis that can be applied to the music of earlier periods.

At the risk of oversimplification there seem to be five main currents that make up the art music of the twentieth century. (1) Musical styles that rely on national or regional idioms. (2) The incorporation of new developments into

musical styles rooted in the past. (3) A reaction to the post–Wagnerian romantic idiom that attempted to transform it. (4) A return to audience–pleasing music fashioned from earlier styles. (5) A radical attempt at rejection of the Romantic past and its aesthetic. None of these is a discrete school of thought and expression, and there are countless cross–currents. Many composers found two or more of these courses attractive and treated them in their own personal, often highly idiosyncratic way. Cutting across all of them is a tendency to twist conventional musical forms, structures, and values and turn them toward new ends.

DISSEMINATION OF MUSIC

The means of musical dissemination have expanded enormously. In addition to vast resources for live concert performance, music is also transmitted to a large public by radio, television, videos, Muzak™, and, most importantly, compact discs, tapes, and LPs. Until the end of the nineteenth century, one would have heard only live music making, but for the occasional music box. The late twentieth century is fundamentally different in that we normally expect music not to be live. Today, we are constantly surrounded by musical sounds of all types and qualities, which sometimes makes attaining the distance necessary for critical judgment far more difficult.

SUPPORT OF ART MUSIC

Public performance and the recording industry provides support for art–music performers, generally those who specialize in music of the eighteenth and nineteenth centuries. Universities have become the primary patrons of contemporary composers. The university system's regard for application of the scientific method has led to widespread experimentation. Immunity from public disapproval has fostered the development of idiosyncratic styles, often with only a small, but deeply engaged, audience.

COMMERCIAL ASPECTS

Music became an important business in the twentieth century. Public concerts by professional artists and organizations (orchestras, opera companies, choruses, and chamber ensembles) are important commercial enterprises. Companies that manufacture musical instruments and high–fidelity playback equipment are an integral part of the musical scene. Publication of books, periodicals, musical scores, and the availability of video tapes has disseminated music and musical information to an extent unknown in the past. The music–recording companies have become among the largest of big businesses. They have made available a vast repertory of music of the past as well as the present, and produced an audience hungering for many types of music.

KNOWLEDGE OF MUSIC

More Western people have educated themselves in music in the twentieth century than in any other century. The twentieth century has seen the study of music become part of all liberal curriculums, from elementary to higher education. At the college level, many universities now have schools of music, which offer professional training ranging from music performance, composition, theory, history and literature, and musicology to teacher training, the business of music, and music technology. Furthermore, the study of music has become a popular liberal arts subject for nonprofessionals.

Musicology　　Scholarly research in all aspects of music, but especially in music history, has made tremendous strides since its inception in the nineteenth century. Manifestations of the growing interest in this discipline are (1) the number of scholarly periodicals and books on music; (2) the impressive number of anthologies and complete works of individual composers now published in modern score and available in libraries; (3) the fact that musicology is a universally recognized discipline in higher education; and (4) the increasing number of distinguished musicologists.

Ethnomusicology　　Ethnomusicology, concerned mainly with the study of non–Western art music, has become more important. There are now many books, periodicals, and commercial recordings that treat this music. Colleges and universities

routinely offer courses in ethnomusicology. The work of ethnomusicologists has enforced the understanding that the art music of Europe and the United States is only one vibrant music system among many others. As a result of their work, many composers have been influenced by non–Western music.

HISTORICAL CONTEXT

Events and developments in political, social, scientific, and cultural history have inevitably and profoundly influenced the course of music history since 1900.

Political Events

Two global wars in the first half of the century, both resulting from German attempts to attain European hegemony, had powerful impacts on world history: World War I (1914–1918) and World War II (1939–1945). Each conflict was followed by an effort to establish world government: the League of Nations (1920–1946) and the United Nations (established in 1946). The Bolshevik Revolution in 1917 marked the emergence of Communism and of the Soviet Union as a world power. After World War II Japan and China also became major world powers. Notable conflicts since mid–century were the Korean War (1950–1953), the Arab–Israeli conflicts, and the Vietnamese wars involving first France and later the United States. Political and ideological struggle between the Soviet Union and the United States and their allies since World War II was known as the Cold War, a period of nonmilitary activity, but one marked by a major armaments race. Revolutions and changes of government throughout Eastern Europe in 1989 changed dramatically the political and ideological makeup of Europe.

Social and Economic Developments

Of great significance has been the decline of colonialism and the rise of independent states, especially in Africa and India. Greater autonomy was granted to British Commonwealth countries, notably Canada, Australia, New Zealand, and South Africa. Mention should be made of the economic depression in the 1930s and the development of European economic and political ties since World War II. By century's end, one can speak of a global economy as a result of the interlocking of national and regional markets and economies.

Since about midcentury acute social and economic problems have come to concern the world: environmental pollution and its consequences; population growth; racial, ethnic, and religious discrimation; severe poverty and

food shortages in many parts of the world; energy shortages; increases in crime and violence; urban decay.

Technology

Tremendous advances in science and engineering and their application to industry have affected social, economic, and cultural history. Far–reaching developments have taken place in biology, chemistry, physics, astronomy, and computer science. Technology has made astounding progress in the fields of information processing, communication, transportation, and medicine.

Some specific innovations are radio, television, atomic energy in military and industrial uses, transistors, the laser beam, jet propulsion, digital computers, antibiotics, photo duplication, exploration of outer space, exploration of suboceanic areas, and, especially relevant to music, high–fidelity sound transmission.

The Arts

As in the past, the concerns of the epoque are reflected in the arts. General traits of the arts in the twentieth century are frequency and rapidity of change, experimentation with new forms and media, and mixed media. In the visual arts a general trend away from representationalism and toward abstract and nonobjective expression may be noted. A distinctly new visual media is the cinema. Art has taken so many new directions since 1900 that it is impossible to list them all here; some of the important trends and artists include expressionism (Kokoschka, Kandinsky, Klee), cubism (Picasso, Braque), surrealism (Dali, Chagall), dadaism (Duchamp), abstract expressionism (Pollock), geometric abstractionism (Stella), neoplasticism (Mondrian). Further developments are in mixed media, kinetic (moving) art, temporal (or momentary) art, pop art (commonplace realism), op art (optical illusion), minimal art, and conceptual art. Perhaps the most significant developments in architecture stem from the establishment of the Bauhaus.

Literature, poetry, theater, and cinema have kept apace with the fine arts. Social protest, existentialism, pessimism and despair, absurdity, intentional "shock value," and ironic humor are some of the more pronounced traits.

28

General Developments in Twentieth–Century Music

A number of general stylistic trends are evident in art music since 1900. They do not form a neat chronological sequence; rather, they are overlapping developments, some of longer duration than others, some more prominent and pervasive than others. Furthermore, they are neither distinctly nor consistently separate developments. More than one trend is often synthesized in the individual style of a single composer.

ROMANTICISM

While radical innovations were emerging in the early decades, romantic currents remained dominant. Subjectivity, emotionalism, programmatic bases, and large orchestras were some of the traits that persisted even in compositions that employed new harmonies, rhythms, timbres, and tonalities. Composers who belong to the post–Romantic tradition (most of whom have already been mentioned in preceding chapters on the Romantic period) are Charles Stanford (1852–1924) and Edward Elgar (1857–1934) in England; Gustav Mahler (1860–1911) and Richard Strauss (1864–1949) in Germany; Jean Sibelius (1865–1957) in Finland; Edvard Grieg (1843–1907) in Norway; Reinhold Glière (1875–1956), Alexander Glazunov (1865–1936), and Sergei Rachmaninoff (1873–1943) in Russia; Pietro Mascagni (1863–1945), Ruggiero Leoncavallo (1857–1919), and Giacomo Puccini (1858–1924) in Italy; Manuel de Falla (1876–1946) in Spain; Camille Saint–Saëns (1835–1921) and Gabriel Fauré (1845–1924) in France; Leoš

Janáček (1854–1928) in Czechoslovakia; and Edward MacDowell (1860–1908) in the United States.

Nationalism

An alliance was forged in the nineteenth century between Romantic and nationalist musics. True to the charter, many of the previously–named Romantic composers incorporated nationalist elements in their music. In the generations since, nationalism has waned somewhat, concurrently with Romanticism. Composers of Romantic inclinations became more eclectic and borrowed freely from the music of other nationalities and regions. Some examples of "internationalism" during the midcentury period are *El Salon Mexico* by Aaron Copland (1900–1990), *Saudades do Brazil* by Darius Milhaud (1892–1974), *Escales* by Jacques Ibert (1890–1962), *Tabuh-tabuhan* by Colin McPhee (1901–1964), *Concerto in slendro* by Lou Harrison (1917–), and the eclectic music of Alan Hovhaness (1911–).

The New Romanticism

This movement dates from the 1960s, when some composers turned away from the prevailing highly complex, esoteric language of the avant–garde and embraced aspects of nineteenth–century music. The music of the masters of earlier centuries (e.g., Gustav Mahler, Ludwig van Beethoven [1770–1827], Johann Pachelbel [1653–1706], etc.) has served as a model, while other composers have used the generalized language of the Romantics. Quotation is a frequently used technique. Some composers are quite literal in their borrowings, while others use only details of the Romantic style. Important composers in this style, representing a range of styles and generations, include George Rochberg (1918–), György Ligeti (1923–), George Crumb (1929–), Luciano Berio (1925–), Barbara Kolb (1939–), Joan Tower (1938–), William Bolcom (1938–), David del Tredici (1937–), and John Corigliano (1938–).

IMPRESSIONISM

The first important trend toward twentieth–century modernism in music was Impressionism. In the hands of Claude Debussy (1862–1918), it paralleled movements in French painting, sculpture, and poetry. Largely a reaction against German Romanticism, it developed new styles and techniques.

Style

Although impressionistic music was romantically subjective and programmatic, it departed from nineteenth–century practices in several ways. It generally demonstrated a high degree of refinement, delicacy, subtlety of

form, and a quality of luminosity. More specific characteristics are (1) neomodality (a return to the use of church modes); (2) open chords (fifths and octaves without thirds); (3) prominence of ninth chords and some new chord structures; (4) *parallelism*, which results when the harmonic intervals of succeeding chords remain constant, and other unconventional chord progressions; (5) use of the *whole–tone mode* (six whole–steps to the octave); (6) free rhythms and less prominence of bar–line regularity; and (7) wide spacing and extreme registers, especially in piano music.

Composers In addition to Claude Debussy, composers who employed impressionist techniques were Maurice Ravel (1875–1937) in France, Frederick Delius (1862–1934) in England, Manuel de Falla (1876–1946) in Spain, Ottorino Respighi (1879–1936) in Italy, Alexander Scriabin (1872–1915) in Russia, Selim Palmgren (1878–1951) in Finland, and Charles Loeffler (1861–1935) and Charles Griffes (1884–1920) in the United States.

EXPRESSIONISM

Expressionism, another term borrowed from the visual arts, was as significant a movement as Impressionism. Covering the period from about 1910 to 1930, it sought to express the innermost feelings of the subconscious, the psychology of which was being studied at that time by Sigmund Freud. Composers and artists were generally drawn to treat intense, often hysterical, states of mind and being, which often resulted from social conditions. Being emotionally oriented music, it retained a certain degree of Romanticism. The style is harshly dissonant and often without a stable sense of a tonal center, or *atonal*. Three names closely identified with Expressionism are Arnold Schoenberg (1874–1951; *Pierrot Lunaire*), Alban Berg (1885–1937; *Wozzeck* and *Lulu*), and Anton Webern (1883–1945; *Five Pieces for Orchestra*, Op. 10).

NEOCLASSICISM

Neoclassicism was an extensive and pervasive trend lasting from about 1920 to 1950. In a general sense it implies a return to earlier ideals of objectivity, balance, clarity of texture, and absolute music, but it was not confined just to eighteenth–century Classicism. Neoclassicism also involved the revival of contrapuntal textures and forms (fugue, passacaglia, toccata, madrigal) from the Renaissance and Baroque while employing twentieth–century harmonies, rhythms, melodies, and timbres.

Composers

Many composers, including all the important Expressionists, incorporated Neoclassical elements in their music. Undoubtedly the most important neoclassical composer was Igor Stravinsky (1882–1971; *Octet for Winds* and *Pulcinella*). Others were Sergei Prokofiev (1891–1953; *Classical Symphony*) and Paul Hindemith (1895–1963; *Ludus Tonalis*, and the fourth string quartet).

Gebrauchsmusik

Originating with Paul Hindemith in the 1920s, Gebrauchsmusik (freely translated as "functional music" or "everyday music") was an offshoot of Neoclassicism. It was music intended primarily for amateur performance, specified occasions, or informal gatherings. It avoided technical difficulties, and although in a contemporary idiom, was less extreme than much music of the time. Representative works in this category are Paul Hindemith's *Plöner Musiktag*, composed for an amateur music festival in Plöner, *Wir bauen eine Stadt* (*Let's Build a City*), and *Trauermusik* (*Funeral Music*), composed on the occasion of the death of King George V of England in 1936.

THE AVANT–GARDE

The avant–garde is the most important new musical development of the last half of the twentieth century. Important contributions toward the establishment of the avant–garde were made early in the century by Charles Ives (1874–1954), Erik Satie (1866–1925), Henry Cowell (1897–1965), and Edgard Varèse (1885–1965). The avant–garde is less a unified style than any of the trends mentioned above, and more a movement. At its most radical, it rejects fundamental premises on which art music has traditionally been based. It might (1) be without melody in any traditional sense; (2) not use

harmonies in ways explainable by the tonal system; (3) have no readily discernible meter; (4) eschew traditional forms and structures; and (5) be performed by newly created instruments, or by historical ones played in new ways. At the base of much of this music is experimentation with the materials of sounds; in fact, the most revolutionary general segment of the avant-garde is *experimental music*. That the avant-garde has a strong regard for the process of making music (and not just the result) is manifest in important subcategories: *serialism*, *aleatory music*, *improvisation*, *minimalism*.

Notation

Notation devised for music of the seventeenth, eighteenth, and nineteenth centuries (the *common practice period*) served, with only minor inconvenience, art music before the time of the avant-garde. The revolutionary nature of the avant-garde has affected notation as dramatically as it has most other aspects of music making. Frequently, composers of the avant-garde invent their own notations, which are often unique to the composition. A piece's "notation" may be nothing more (or less) than a set of detailed, written instructions. Some composers have been drawn to electronic music and improvisation because these types of music generally do not need notation. These composers sometimes hold that musical intuition is fundamentally restrained by the literacy requirements of notation.

Scores and Recordings

Impressionism
 Debussy: NAWM 144; NSII 24
 Ravel: NAWM 145
 Scriabin: NAWM 151
New Romanticism
 Bernstein: NSII 44
 Crumb: NSII 48; NAWM 154
 Picker: NSII 49
Expressionism
 Schoenberg: NAWM 148 and 152; NSII 28
 Webern: NAWM 149; NSII 33
 Berg: NAWM 160; NSII 34
Neoclassicism
 Hindemith: NAWM 161
Avant–Garde
 Carter: NSII 40
 Cage: NSII 41
 Lutoslawski: NSII 42
 Babbitt: NSII 43
 Reich: NAWM 156

29

Specific Styles and Techniques

Music of the twentieth century has undergone startling changes in compositional styles and techniques. The conventional materials of music (meter, rhythm, melody, harmony, tonality, texture, and form) have continued to receive the attention of composers, while others have developed new techniques and styles that reflect a fundamentally different way of structuring sounds.

It must be emphasized that not every piece of twentieth-century music is a manifestation of radical change in all respects. Any single composition may be "modern" in only one or two respects and not necessarily extreme even in these. The literature rages from ultraconservative to experimental. Most compositions lie somewhere between.

THE CONVENTIONAL MATERIALS OF MUSIC

In one way or another all of the twentieth-century techniques developed for manipulating the conventional materials of art music follow from an awareness of musical history. It may be that composers are embracing the past, or attempting consciously to build upon it. And if they are denying it, they generally do so by extension of the system they reject.

Meter and Rhythm

During the common practice period relatively few evolutionary changes took place in the concepts of meter and rhythm. In general, rhythm plays a much more prominent role in twentieth-century music, where it has greater

vitality, complexity, variety, and flexibility than in the common practice era. Jazz and popular music have been primary influences in this development. Composers, seeking new rhythmic and metric effects, have overthrown "the tyranny of the bar line" by means of several devices.

New Time Signatures

Unusual time signatures, such as $\frac{5}{8}$ and $\frac{7}{8}$, are commonly found in modern scores.

Asymmetrical Grouping

New rhythmic effects are produced by asymmetrical grouping of beats or notes within a measure. For example, in $\frac{8}{8}$ meter such beat patterns as 3–2–2 (rumba) and 3–2–3 produce interesting rhythms. An example is the scherzo movement of the Fifth String Quartet by Béla Bartók's (1881–1945), which has a time signature indicated as $\frac{4+2+3}{8}$ ($\frac{9}{8}$ meter), and a trio section in $\frac{3+2+2+3}{8}$ ($\frac{10}{8}$) meter.

Nonmetric Music

Striving for nonmetric flexibility, a few composers have omitted the bar line altogether. In conventional media this device is necessarily limited to solo pieces (e.g., the *Concord Sonata* by Charles Ives [1874–1954]). Most tape and electronic music is nonmetric.

Polymetric Music

Polymetric music is that in which two or more meters are used simultaneously. For example, in the Piano Trio by Maurice Ravel (1875–1937), $\frac{3}{4}$ appears against $\frac{4}{2}$. In *Petrouchka* by Igor Stravinsky (1882–1971) there are passages of $\frac{5}{8}$ against $\frac{2}{4}$, and $\frac{7}{8}$ against $\frac{3}{4}$.

Multimetric Music

This term applies to music with a fairly common characteristic: frequent changes of time signature every measure or so. Examples of multimetric writing are found in Igor Stravinsky's *L'Histoire du soldat* (*The Soldier's Tale*), the second movement of *Jeremiah Symphony* by Leonard Bernstein (1918–1990), and Cantata, Op. 29 by Anton Webern (1883–1945).

Displaced Bar Line

Several devices used with conventional meters produce the effect of shifting or displacing the bar line in the score. Accents may be placed in recurring patterns in conflict with the normal accents of the measure (Exam-

ple 29.1a). Similar results can be produced by note grouping (Example 29.1b), by tying notes across the bar line in prolonged syncopations (Example 29.1c), or by means of melodic or rhythmic ostinatos at variance with the meter (Example 29.1d).

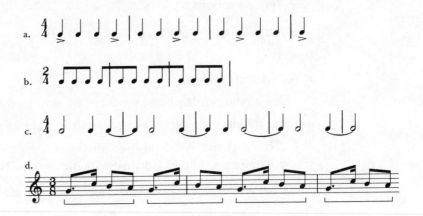

Example 29.1. Devices Producing Displaced Bar Lines

Polyrhythmic Music

In a sense all polyphonic music and even some homophonic music is polyrhythmic because different rhythmic patterns occurs simultaneously. But twentieth–century music often exaggerates conflicting rhythms (called *cross rhythms*). An example of polyrhythmic writing is the movement entitled "Dance" in *Music for the Theatre* by Aaron Copland (1900–1990), in which as many as five different rhythmic patterns, all in $\frac{5}{8}$ meter, oppose one another.

Combined Effects

It is apparent that all the above rhythmic and metric devices may be used in various combinations to produce an infinite variety of rhythmic–metric organization.

Melody

Departures from common practice period melodic concepts involve developments in three areas: (1) melodic style, (2) new mode bases, and (3) the role of melody in the total musical context.

Style

Although an appreciable portion of melodic material today is structured along common practice lines, some new and distinctly twentieth–century characteristics have emerged. More extreme melodic styles feature disjunct progressions (wide leaps from one note to the next), angularity (alternating

upward and downward direction), dissonant skips, and fragmentation (small groups of notes separated by rests and widely separated registers).

Mode Bases

Adoption of non–common practice modes have contributed to new styles in melody and harmony. Composers have borrowed from the old church modes in neomodal settings. For example, *Gymnopédie no. 2* by Erik Satie (1866–1925) is based on the mixolydian mode. The whole–tone mode is used in *Voiles* by Claude Debussy (1862–1918) and other impressionist compositions. Examples of other new systems are Béla Bartók's *Mikrokosmos no. 10*, which is based on a mode derived from a scale starting on D with an A♭, and *Mikrokosmos no. 25*, based on a scale starting on B with a C#. Modes using intervals less than a semitone (microtones) have been borrowed from Oriental music. Some composers have experimented with modes derived from non–equally tempered tunings. Composers who have written microtonal music are Charles Ives, Julián Carrillo (1875–1965), Hans Barth (1897–1956; *Concerto for Quarter–tone Piano and Strings*), Harry Partch (1901–1974), Ben Johnston (1926– ; *String Quartet no. 5*), Krzysztof Penderecki (1933–), John Cage (1912–), and others. Composers interested in experimenting with new modes, or none at all, have generally ignored conventional instruments (which are usually designed for playing in certain predetermined modes).

The Role of Melody

Until the twentieth century, melody was consistently a dominant element in music. By midcentury its role was variable. It retains its supremacy in contrapuntal textures, but it is usually subordinate in music in which rhythm, harmony, and timbre are the prominent elements. In some of these cases, pitch itself is not important, hence making melody, in any conventional sense, impossible. Examples of melodic subordination are *Pacific 231* by Arthur Honegger (1892–1955), *Ionisation* by Edgard Varèse (1885–1965), and *Toccata for Percussion* by Carlos Chávez (1899–1978).

Harmony

No element of music has been treated more radically by the twentieth century than harmony. New harmonic concepts involve four aspects: (1) chord construction; (2) chord progression; (3) dissonance; and, in extreme instances, (4) elimination of harmony altogether.

Chord Construction

During the common practice period, chords were built on a *tertial basis* (thirds stacked on top of one another). Chord vocabulary was expanded in the twentieth century by the further addition of thirds (to make up eleventh and thirteenth chords), *quartal harmony* (stacked fourths, as in Alexander Scriabin's [1872–1915] "mystic chord," containing the tones *C–F#–B♭–E–*

A–D, as in Charles Ives's "The Cage"), and other intervallic bases such as fifths (again, "The Cage"), sevenths, seconds (*tone clusters*, first utilized systematically by Henry Cowell), and others. Still further, all intervallic systems were abandoned in favor of tone combinations of heterogeneous intervals. Also, mixed chords (or *polychords*) of two or more different roots have been used (for example, superimposing the triad *C–E–G* and *F#–A#–C#*, as in Igor Stravinsky's "Petroushka chord").

Chord Progression

Conventional common practice root progressions have often been abandoned in favor of freely invented progressions, sometimes involving chords with roots foreign to the key, such as E♭ or G# triads in the key of C Major. New and original harmonic effects can be achieved solely by means of unconventional progressions of even simple triadic chords, as in parallelism. Two or more parallel progressions moving independently at the same time are called *chord streams*.

Dissonance

A distinct characteristic of twentieth–century harmony is the extent and degree to which dissonance is employed. Dissonance no longer requires resolution to consonance, and a composition may consist only of varying degrees of dissonance.

Nonharmonic Music

Much avant–garde music has struggled against the dominance of the harmonic idiom in Western music. Some composers have tried to remove all vertical arrangements of sound that connote harmonies and their function within a harmonic system. The use of *white noise*, which is a sound that contains all sounds (radio static is an example), has been employed precisely because it avoids the issue of harmonic (or melodic) function altogether.

Tonality

The system of tonality began to show signs of weakening during the nineteenth century. Chromatic harmony and prolonged modulations increasingly obscured the tonal center as composers stretched the bonds of the system. The twentieth century has departed still further from conventional tonal concepts, ultimately eliminating tonality altogether.

Harmonic Aspects

Some harmonic innovations that contributed to the lessened importance of the tonal center were neomodality, microtonality, new modes, and more intense and prolonged use of dissonance.

Polytonality

This simultaneous use of two or more keys is a twentieth–century innovation. It was first used extensively in the 1920s and has since been

absorbed into other techniques. Notable early proponents of polytonality were Darius Milhaud (1892–1974) and Arthur Honegger. Examples are Sergei Prokofiev's (1891–1953) *Sarcasms*, Op. 17, no. 3 (b♭ minor in the left hand, f# minor in the right hand), and the third of Milhaud's *Cinq Symphonies*, which opens in the keys of E Major (clarinet), D Major (bassoon), and E♭ Major (strings).

Atonality

Experimentation with the tonal system led, perhaps inevitably, to atonality, the absence of any key center or key feeling. Although twentieth–century art music ranges from completely tonal to completely atonal, the larger portion today probably eschews tonality.

Texture

Although homophonic textures are not uncommon in twentieth–century art music, contrapuntal textures dominate. An attribute of Neoclassicism is the renewed interest in contrapuntal forms of the Baroque such as fugue, canon, and passacaglia. Many composers are drawn to counterpoint because of a perceived purity of sound abstraction. An important avant–garde contrapuntal texture that features abstract "moments" of isolated sounds is *pointillism*. An example of pointillism may be found in Anton Webern's *Concerto for Nine Instruments*.

Form

Although contrapuntal forms have played a significant role in Neoclassicism, and Classical sectional structures (e.g., sonata cycle, variations, rondos) have by no means been abandoned, twentieth–century composers have generally avoided conventional forms or have greatly modified them. Several traits of modern form may be mentioned. *Nonperiodicity*, defined as the avoidance of conventional cadences and other indications of sectional division, is a significant structural characteristic. Related to nonperiodic structure is the concept of perpetual variation in which exact sectional repetition is studiously avoided and the musical materials undergo continual modification. Asymmetrical structures also are typical.

STYLES AND TECHNIQUES OF THE AVANT–GARDE

Since 1920, and certainly the case since 1950, important groups of composers have been interested in breaking with past traditions. Many new techniques and methods have been devised to accomplish this end.

Twelve–Tone Music

The adjectives *twelve–tone* and *dodecaphonic* refer to music based on serial manipulation of the twelve chromantic pitches. This system was defined first by Arnold Schoenberg (1874–1951) in the 1920s. The basic musical unit is a *tone row*. It contains all twelve tones of the chromatic octave arranged in such an order that any implication of tonic or key center is avoided. Melody, harmony, and themes are derived from the tone row, which replaces the mode as the basis of composition. The original row (*O*) of a composition may be treated in any of the following ways: through transposition (*T*), through octave transposition (*OT*) of any tones in the row, through retrogradation (*R*) of the row as a whole or in part, through inversion (*I*) of the row, and through combinations of these such as retrograde inversion (*RI*). The row and its basic manipulations are illustrated in Example 29.3.

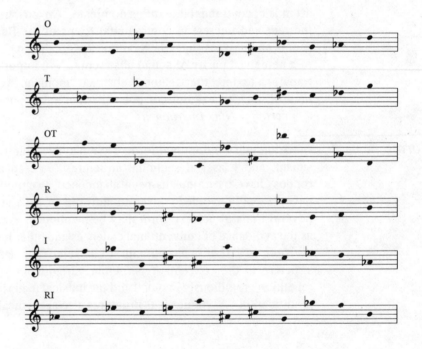

Example 29.3. Manipulations of the Tone Row.

Multiple Serialism

Twelve–tone music is a form of *serialism*, in which only the pitches of the tone row and its derivations are treated recurrently in series. Anton Webern added to pitch serialization the serialization of rhythm. Here a row of rhythmic values is constructed and subjected to manipulations, much like those of pitch. Composers have since expanded elements eligible for serialization to include dynamics, timbre, densities, sonorities, forms, even seri-

alism itself. In *total serialization* all elements are serialized. The most complex serial music is that in which two or more series are not synchronized within a given time span. Example 29.4 is a simple illustration of such serial organization. Series 1 is a tone row; series 2 is a recurrent rhythmic pattern of four beats (in $\frac{3}{4}$ meter); series 3 is a simple crescendo/decrescendo dynamic pattern lasting seven beats; and series 4 is a cycle of three timbres in a series approximately four bars long. Longer patterns, manipulations of the rows, and the addition of harmonic series, density series, and so on could be employed toward a more complex multiple serialism.

Example 29.4. Multiple Serialization

Composers

Since 1950 a large number of composers have employed various serial techniques. Among these are Olivier Messiaen (1908–) and Pierre Boulez (1925–) in France; Henri Pousseur (1929–) in Belgium; Karlheinz Stockhausen (1928–) and Wolfgang Fortner (1907–) in Germany; Luigi Dallapiccola (1904–1975), Luciano Berio (1925–), Luigi Nono (1924–), and Bruno Maderna (1920–1974) in Italy; and Wallingford Riegger (1885–1961), Ernst Krenek (1900–), Adolph Weiss (1891–1971), Stefan Wolpe (1902–1972), and Milton Babbitt (1916–) in the United States.

Indeterminacy

Indeterminacy (also *chance music* or *aleatory music*) is one of the most radical trends of the century. It is to some extent a reaction against the rigid determinism of serialism, but perhaps even more a philosophical challenge to the whole notion of how the musical past shapes and controls the musical present. This is a concept based on chance selection of musical materials by the composer, the performer(s), or both. As it often happens, the composer employs some method to ensure a chance selection of basic musical materials or ideas: e.g., by throwing dice, employing the ancient Chinese book the *I Ching*, or using a computer "random generator." This music attempts to escape the orthodoxy of Western art music practice by freeing sound to be itself. It promises the listener an opportunity to make of a listening experi-

ence what he or she will, unhindered by any prior expectations or experiences.

Cage (1912–)

John Cage is the most important figure in the development of aleatory music. His *Music of Changes* from 1951 is a forty–three–minute work for piano in which every note and aspect of the music was determined by coin tosses. The following year he conceived *4'33"*, which is the length of time that a listener should concentrate on the aural environment, hearing what free sounds there are to experience.

Other Composers

Other examples of chance music in the United States are the early works of Morton Feldman (1926–1987), such as his *Projection II* for flute, trumpet, violin, and cello (only registers of "high," "middle," and "low" as time values and dynamics are indicated), and in pieces by composers Earle Brown (1926–), Christian Wolff (1934–), Nam June Paik (1932–), Barney Childs (1926–), Lukas Foss (1922–), Larry Austin (1930–), Philip Corner (1933–), Robert Ashley (1930–), and many others.

European composers have also been influenced by aleatory music, but generally use chance techniques to provide a framework for improvisation. Karlheinz Stockhausen's *Klavierstücke XI* consists of nineteen fragments for piano, which can be played in any order, at any of six tempos and dynamic levels, and with various degrees of staccato or legato. His *Zyklus* for one percussion player is a score in circular form that can be read clockwise, counterclockwise, or upside down. *ST/10, 080262*, and *Strategie* by Yannis Xenakis (1922–) are pieces based on mathematical laws of chance and computer indeterminacy, an approach that he calls *stochastic music*. Other European composers who use or used chance techniques include: Sylvano Bussotti (1931–), Roman Haubenstock–Ramati (1919–), Mauricio Kagel (1931–), Folke Rabe (1935–), Cornelius Cardew (1936–1981), and many others.

Electronic Music

At least as important as any development in art music since World War II is electronic music. There have been three important stages in its development: (1) tape music, (2) analog–synthesizer, and (3) digital–synthesizer.

Tape Music

Magnetic audio tape was developed by the Germans during the war. In the late 1940s, composers and technicians in Paris began experimenting with the medium, opening radically new vistas in music. The first step was the recording of live (concrète) sounds: conventional music, natural or contrived sounds such as traffic noise, bird calls, breaking glass, and squeaky doors. These sounds were then abstracted through four basic procedures:

(1) changing the speed of the tape, (2) reversing its direction, (3) cutting and splicing the tape into new combinations, and (4) combinations of these. Separate sound tracks could then be mixed onto one track. The resulting music was called *musique concrète*. By the early 1950s, centers for experimentation in tape music had developed in other countries, especially the United States.

Besides the purely aural experience, the greatest importance of this music was that the role of the performer was greatly diminished or eliminated altogether, for the music was created directly on magnetic tape by the composer and heard through loudspeakers. It is a feature of much of this music that conventional melody and harmony are absent. Rhythm, however, was often important.

Composers of tape music are: Pierre Schaeffer (1910–), Pierre Henry (1927–), and Pierre Boulez in France; Karlheinz Stockhausen (*Gesang der Jünglinge*) in Germany; Luciano Berio in Italy; Edgard Varèse, Otto Luening (1900–), Mel Powell (1923–), Vladimir Ussachevsky (1911– ; *A Piece for Tape Recorder*), John Cage (*Imaginary Landscape no. 5*), and Mario Davidovsky (1934– , *Study no. II*) in the United States.

Analog–Synthesizer

By the early 1950s experiments had led to the development of electronic devices capable of generating and altering sounds. This technology could produce and control the four properties of sounds: frequency (pitch), amplitude (dynamics), duration (rhythm), and timbre (tone quality). Since sound is composed of soundwaves and these waves could now be produced electronically, it was theoretically possible to manufacture any sound at all. This could be achieved by activating an oscillator, which produced the simple, basic electronic soundwave, modifying that wave (which at this stage is merely electrical voltage) by combining (modulating) it with the output of other oscillators, and polishing and shaping it by diverting that collective result through various electronic filters. The soundwave might then be stored directly on magnetic tape, perhaps to be manipulated further through cutting and splicing. The complex electronic instrument that contained the oscillators and filters under a single control system was called an *analog synthesizer*. The first of these was the RCA Electronic Music Synthesizer, completed in 1955. The Columbia–Princeton Electronic Music Studio in New York became home to some of the most sophisticated experimentation with synthesizers. In the 1960s and 1970s the Moog, Buchla, and ARP Synthesizers brought down the cost and size of these instruments, creating opportunities for many composers to work with the medium.

Many composers active first in tape music moved naturally to synthesized music. Among many others, these were Milton Babbitt (whose *Composition for Synthesizer* of 1961 was the first largescale synthesized work),

Morton Subotnik (1933–), Charles Wuorinen (1938–), Wendy Carlos (1939–), and John Eaton (1935–).

Digital–Synthesizer

The digital computer has made possible the next evolutionary step in electronic music. Sound can be converted to digital information through a process called *sampling*. Here a soundwave is analyzed by an *analog–to–digital converter* that, as the name implies, converts an analog sound into discrete digits. This information can then be transfered to a computer's memory and manipulated (edited) by the composer. A digital–to–analog converter can then turn the numbers back into a soundwave, to be played through any playback system. Once the digital properties of sounds are known they can be produced in digital form, bypassing the initial step.

There are three advantages that a sophisticated computer music instrument (like the Synclavier II, the Fairlight, or the Yamaha DX–7) has over tape and synthesizer music. (1) Audio quality is extremely high. Practically no noise (distortion) is introduced into the sound material—the "sound" is but patterns of 0s and 1s—allowing for many generations of sound editing with no deterioration of quality. (2) The music is heard in *real time*. The composer can store the piece digitally as it is made, and can play it back at any instant. In tape music, once the materials were generated, the composer then had to cut and splice and hope the result was satisfactory, a cumbersome process at best. An analog–synthesizer could only generate the sound sources for a composition, not the piece itself. (3) Editing is infinitely and easily possible. This advantage follows from the digital nature of the material, which can be manipulated as easily as issuing an instruction to the computer to change the digital configuration. For example, a musical event can be heard higher, lower, louder, softer, faster, slower, shortened, lengthened, inverted, mirrored, sequenced, segmented, repeated, incremented, compressed, and so on, by a simple line of computer code. The interface—often a traditional keyboard—between a user and a computer program is now so "friendly" that the composer need not know any programming. Many composers report that the ease and the immediacy of real–time editing allow them to work more intimately with the actual sound material than in any other medium. Composing tape music and synthesizer music was, on the other hand, slow and awkward work.

Legions of composers have worked and are working with this technology. Lejaren Hiller (1924–) might have been the first when he used the University of Illinois computer to produce his *Illiac Suite for String Quartet* in 1957. Other early experimenters were Max Matthews (1926–), James Tenney (1934–), J. K. Randall (1929–), John Chowning (1934–), John Cage, and Yannis Xenakis. The 1970s and 1980s heard important work by Salvatore Martirano (1927–), David Behrman (1937–), James Dashow

(1944–), Charles Dodge (1942–), Jon Appleton (1939–), Paul Lansky (1944–), and Jean–Claude Risset (1938–).

Computer music technology has generated enormous interest among all strata of the musical world: professional, amateur, popular music, art music, commercial music, academic music. The computer might well be the dominant musical instrument of the 1990s.

Performance of Electronic Music

Much of this music was composed for the traditional concert stage and has been "performed" there with great success. Many, though, have found sitting quietly and staring at loudspeakers a less than satisfactory experience. Accordingly, even by the 1950s composers were "softening" tape music by combining it with live performance, which used conventional performance media and traditional timbres. *Rimes* by Henri Pousseur combines common practice instruments with electronic sounds. *Kontakte II* by Karlheinz Stockhausen is entirely electronic, but it simulates some conventional timbres. In his *Synchronisms* Mario Davidovsky uses solo instruments and all prerecorded electronic sounds. Luciano Berio employed nontextual tape-recorded vocal sounds combined with electronic sounds in *Visage*. *Philomel* by Milton Babbitt is for a soprano and tape, on which the soprano's voice is heard among other more abstract sounds. Otto Luening's *Gargoyles* was composed for violin solo (undistorted) and synthesized sound. *HPSCHD* (1968) by Lejaren Hiller and John Cage is for seven harpsichords, tapes, dancers, and, in the LP version, listener/performer. *Animus II* by Jacob Druckman (1928–) is for female voice, two percussionists, and tape.

Improvisation

Improvisation is more a force in the twentieth century than in any period since the Middle Ages. This is largely because of the influence of jazz and rock, and a general awareness of other non-Western musical cultures, many of which feature improvisation. Beyond that, improvisation had been perceived by some composers as a way to inject a fundamentally human aspect into their music. It might also be a way for the composer to relinguish some control over the product and free the performer for more natural, innately creative expression, an ideal that follows from indeterminacy. Except for music based on serialist concepts, improvisation is some part of all important trends in the avant–garde movement.

Highly proficient improvisation ensembles arose in the 1960s and 1970s. They included the New Music Ensemble, the Sonic Arts Group, the Musica Elettronica Viva, and several ensembles at the University of Illinois.

Composers

Composers who wrote music with improvisation in mind were Robert Ashley, Luciano Berio, John Cage, Stuart Dempster (1936–), Robert Erick-

son (1917–), Lukas Foss, Pauline Oliveros (1932–), Roger Reynolds (1934–), Gunther Schuller (1925–), and Karlheinz Stockhausen.

Minimalism

As the word implies, minimalism (also known as *process music* and *phase music*) is created from limited materials. Melodies may be extremely simple, harmonies uncomplicated and static, and ostinatos may be featured, as might drones. The overriding characteristic is repetition. Typically the music changes slowly, almost imperceptibly. When change does occur it is often a greatly exciting moment, snapping the listener out of a hypnotic, trancelike state.

The history of minimalism could be said to extend back to the Baroque. Many of J. S. Bach's works use extremely limited material and change only slowly. The Prelude in C Major from the *Well–Tempered Clavier*, Book I is such a piece. Many minimalist composers point to Erik Satie as the germinal figure of the movement. Much of his music used simple, almost clichéd material that was repeated at length over ostinato patterns. His *Vexations* is an exaggerated example of this characteristic. It is a one–minute composition in *AA* form that is repeated 840 times, affording the listener a chance to hear the same music 1680 times over about fourteen hours! John Cage, who has been strongly influenced by Satie, has contributed to this movement. His *4'33"* is about as "minimal" as one can imagine. Morton Feldman wrote music that was to be played so softly as to be almost inaudible, forcing the listener to pay close attention.

La Monte Young (1935–) has been involved in making music that uses drones, one of which he maintained continuously from 1979 to 1985. A listener would, given enough time, come to appreciate the subtleties of overtones and intonations. In 1964 Terry Riley (1935–) wrote his *In C*, a ninety–minute piece with fifty–two segments repeated in an overlapping fashion. Philip Glass (1937–), who performs with his own virtuoso ensemble, has adapted idioms from rock music, such as repetitive, predictable harmonies and a thundering bass line, for his music. He has written several well–received full–length operas in this style. Steve Reich (1936–) has been particularly interested in *phasing*, in which performers play the same pattern but gradually fall out of phase with one another. John Adams (1947–) has used formal techniques of electronic music to give his music a driving, pulsating harmonic quality. Meredith Monk (1943–) has developed a strictly vocal form of minimalism, which she combines with dance.

Performance Art

This is a form of highly theatricized music making, generally solo, that came about in the 1970s and 1980s. It had its foundation in the Dadaist movement of the early century, with its theater–for–its–own–sake philosophy. Also important to the formation of this style was Harry Partch, with his theatrical instruments and manners of playing them.

Performance art borrows freely from other avant–garde styles, such as *conceptual art* (in which the concept is more important than the product), nonnarrative theater, minimalism, and electronic music, and from rock music. Certainly the best–known composer of this form is Laurie Anderson (1947–), who is typically also a performer. Her performances feature a stage full of electronic devices, invented instruments (such as her electronic tape–bow which she draws across violin strings), lighting effects and visual images, and her own arresting and theatrical persona. Like most performance art, her music assumes an engaged and vitally interested audience, not always the case in much other avant–garde music. Perhaps her most impressive composition to date is the two–evening *United States*. Philip Glass's operas have also been important in the development of performance art.

Scores and Recordings	Stravinsky: NAWM 147; NSII 32
	Ives: NSII 29
	Twelve–tone
	Schoenberg: NAWM 148
	Minimalism
	Reich: NAWM 156

30

Musical Media

The distinctive sounds of twentieth–century music are due in large part to developments in media, some of which represent radical innovations. Generally, composers have chosen to use media traditional to the nineteenth century, and performed in conventional ways, or invented or utilized new media, or devised new performing techniques for old media. The period since World War II has seen far more of the development of new media.

CONVENTIONAL MEDIA

The changes in conventional media have not been as revolutionary as those in the forms and techniques they employ.

Orchestral Music

The orchestra remains a most important medium. Orchestral compositions are often scored for smaller orchestras than in the late nineteenth century, in part because of the greater expense of rehearsing and performing with a large ensemble. The piano and a few other instruments have been added to the percussion section. Instruments in the woodwind, brass, and string choirs have not changed.

The most prominent traits in modern orchestration are (1) more variety of color combinations, (2) greater frequency of change in timbres, and (3) thinner scoring.

A few works have explored the possibilities of vocal elements without text: *Sirenes* by Claude Debussy (1862–1918) and the last movement of *The Planets* by Gustav Holst (1874–1934). Several orchestral works have used a speaking part for narrator: *Lincoln Portrait* by Aaron Copland (1900–1990), *Peter and the Wolf* by Sergei Prokofiev (1891–1953), *Survivor from*

Warsaw by Arnold Schoenberg (1874–1951), *Testament of Freedom* by Virgil Thomson (1896–1989), and *A Parable of Death* by Lukas Foss (1922–).

Music for the cinema has not contributed substantially to orchestral literature, but a few successful works derived from movie sound tracks are Aaron Copland's *Our Town*, Virgil Thomson's *The Plow that Broke the Plains*, Sergei Prokofiev's *Lieutenant Kije Suite* and *Alexander Nevsky*, and *Antarctic Symphony* by Ralph Vaughan Williams (1872–1958).

Chamber Music

A revival of interest in chamber music is one manifestation of Neoclassicism. As the medium best suited to conveying clear sonorities and contrapuntal textures, it is compatible with classical objectivity. Although the string quartet remains a favorite ensemble, various combinations of wind instruments have also attracted composers. A combination of instruments favored among performing groups and composers is the wind quintet consisting of flute, clarinet, oboe, bassoon, and horn, examples of which are *La Cheminée du Roi René* (*The Hearth of King René*) by Darius Milhaud (1892–1974), *Trois pièces brèves* by Jacques Ibert (1890–1962), *Zeitmesse* by Karlheinz Stockhausen (1928–), and *Quintet in the Form of a Choro* by Heitor Villa–Lobos (1887–1959).

Chamber orchestras and string orchestras also reflect the Neoclassical trend in such works as Ralph Vaughan Williams's *Fantasy on a Theme of Thomas Tallis*, *Apollon Musagète* by Igor Stravinsky (1882–1971), Aaron Copland's *Quiet City*, and *Adagio for Strings* by Samuel Barber (1910–1981). Other prominent composers of chamber music are Charles Ives (1874–1954), Béla Bartók (1881–1945), Paul Hindemith (1895–1963), Arnold Schoenberg, Dmitri Shostakovich (1906–1975), Walter Piston (1894–1976), Quincy Porter (1897–1966), David Diamond (1915–), Leon Kirchner (1919–), Donald Martino (1931–), Elliott Carter (1908–), and Milton Babbitt (1916–).

New Combinations

Chamber music instrumentation has always enjoyed some degree of flexibility, and twentieth–century composers have explored this feature. A few examples are *Concerto for Celesta and Harpsichord* (without orchestra) by Daniel Pinkham (1923–); Arnold Schoenberg's *Serenade* for baritone voice, clarinet, bass clarinet, mandolin, guitar, violin, viola, and cello; Heitor Villa Lobos's *Bachianas Brasilerias no. 1* for eight cellos; Béla Bartók's *Music for Strings, Percussion, and Celesta*; *Toccata for Percussion* by Carlos Chávez (1899–1978); and *Quatuor pour la fin du temps* (*Quartet for the End of Time*) by Olivier Messiaen (1908–).

Concert Band

The concert band (also known as *symphonic band* and *symphonic wind ensemble*), as distinct from military, marching, and jazz bands, began to

receive attention from composers in the twentieth century. The nineteenth century saw band music grow in importance to the point that it became a type of popular music. Patrick Sarsfield Gilmore (1829–1892) directed an American band during the Civil War period, and after that established new standards of ensemble playing in this country. John Philip Sousa (1854–1932), at the end of the century, first conducted his most famous of the professional touring bands, which played for millions of American and Europeans over several decades. He was also the composer of dozens of rousing marches (e.g., "Stars and Stripes Forever," "Washington Post") that are still featured at band concerts. Sousa's band, which rarely marched, was in instrumentation more–or–less equivalent to an orchestra, with woodwinds taking the place of strings. Band programs, which earlier had consisted almost entirely of marches, popular arrangements, and transcriptions of orchestral music, began to program more complex music freshly written for the sophisticated new medium.

Examples of more recent symphonic band music by major composers are Paul Hindemith's *Symphony in B♭* , Darius Milhaud's *Suite Française* and *West Point Suite*, Samuel Barber's *Commando March, Chorale and Alleluia* by Howard Hanson (1896–1981), Ralph Vaughan Williams's *Toccata filarziale, Divertimento for Band* by Vincent Persichetti (1915–), Virgil Thomson's *A Solemn Music*, Arnold Schoenberg's *Theme and Variations for Band, Lincolnshire Posy* by Percy Grainger (1882–1961), *Fantasy on a Theme by Haydn* by Norman Dello Joio (1913–), *Music for Prague* by Karel Husa (1921–), and *Pittsburgh Overture* by Krzysztof Penderecki (1933–).

Choral Music

Relatively fewer composers of the twentieth century have explored large–scale choral forms than did those in the seventeenth or eighteenth centuries. The ones who have include Igor Stravinsky (*Symphony of Psalms, Threni*), Arthur Honegger (1892–1955; *King David, Jeanne d'Arc au Bucher*), William Walton (1902–1983; *Belshazzar's Feast*), Carl Orff (1895–1982; *Carmina Burana*), Walter Piston (*Carnival Song*), Howard Hanson (*Lament for Beowulf*), Luigi Dallapiccola (1904–1975; *Job*), Francis Poulenc (1899–1963; *Gloria, Mass*), Benjamin Britten (1913–1976; *Festival Te Deum, War Requiem*), Anton Webern (1883–1945; two cantatas), Krzysztof Penderecki (*St. Luke Passion*), and Arvo Pärt (1935– ; *Jubilio*).

The twentieth–century has seen the development of an extraordinary number of high–quality choirs, primarily in the United States and in connection with music programs at high schools, colleges, and universities. Many composers have provided them with short works, generally in a conservative style. Among the more important are Randall Thompson (1899–1984), Ernst Toch (1887–1964), Jean Berger (1909–), Paul Creston (1906–), Samuel Barber, Gian Carlo Menotti (1911–), and Ned Rorem (1923–). Composers of the avant–garde have also written for choral ensembles. Among them are

Earle Brown (1926–), Salvatore Martirano (1927–), Kenneth Gaburo (1926–), Richard Felciano (1930–), Roger Reynolds (1934–), Olly Wilson (1937–), William Brooks (1943–), and Neely Bruce (1944–).

Piano Music

Although the piano is important in ensemble media, music for piano solo does not hold the prominent place it did in nineteenth–century music. Some noteworthy examples of twentieth century piano literature are *Sonatine* and *Le Tombeau de Couperin* by Maurice Ravel (1875–1937), Claude Debussy's *Preludes and Etudes*, Arnold Schoenberg's *Drei Klavierstücke*, Op. 11, Béla Bartók's *Mikrokosmos*, Darius Milhaud's *Saudades do Brazil*, Olivier Messiaen's *Vingt regard sur l'enfant Jésus*, Dmitri Shostakovich's *Twenty–four Preludes and Fugues*, Paul Hindemith's *Ludus Tonalis*, *Makrokosmos I & II* (for amplified piano) by George Crumb (1929–), Karlheinz Stockhausen's set of *Klavierstücke*, and *The People United Will Never be Defeated* by Frederic Rzewski (1938–), a set of driving variations on a Chilean popular song.

Art Song

Probably more art songs have been written in the twentieth century than in any other. Some important song cycles are Claude Debussy's *Chansons de Bilitis*, Paul Hindemith's *Marienleben*, *Gitanjali* by John Alden Carpenter (1876–1951), Samuel Barber's *Hermit Songs*, Ned Rorem's *Poems of Love and the Rain*, and *The Children* by Theodore Chanler (1902–1961). Charles Ives made particularly important contributions to the genre early in the century without writing a song cycle. Composers in somewhat less conservative styles have also been drawn to the art song. They include: Arnold Schoenberg, Anton Webern, Milton Babbitt, Ruth Crawford (1901–1953), Wallingford Riegger (1885–1961), Ernst Krenek (1900–), George Rochberg (1918–), George Perle (1915–), Dominick Argento (1927–), and John Cage (1912–).

Opera

Although the repertory of major opera companies still draws predominantly from the nineteenth century, an impressive number of operas in twentieth–century styles has been produced, among the first of which was Claude Debussy's impressionist opera *Pelléas et Mélisande*, written in 1902.

Notable operas from the first half of the century are Maurice Ravel's *L'Heure Espagnole*; Paul Hindemith's *Mathis der Maler*; Benjamin Britten's *Peter Grimes*; Alban Berg's *Wozzeck* and *Lulu*; Gian Carlo Menotti's *The Medium*, *The Consul*, and *The Telephone*, Arnold Schoenberg's *Moses and Aaron*; Ernst Krenek's *Jonny Spielt Auf*; Carl Orff's *Die Kluge*; Virgil Thomson's *Four Saints in Three Acts* and *The Mother of Us All*; *The Devil and Daniel Webster* by Douglas Moore (1893–1969); Dmitri Shostakovich's *Lady Macbeth of Mtzensk* and *The Nose*; *Down in the Valley* by Kurt Weill (1900–1950); and *Porgy and Bess* by George Gershwin (1898–1937).

The composition of operas has enjoyed something of a resurgence since 1950, often as a result of high–quality opera programs in conservatories and schools of music, and these schools' willingness to premiere new works. With only a few important exceptions, these operas have not made their way into the repertories of major opera houses. Some important operas produced since 1950 are Gian Carlo Menotti's *The Saint of Bleeker Street*, *Amahl and the Night Visitors* (composed for television), and *The Last Savage*; Igor Stravinsky's *The Rake's Progress*; Benjamin Britten's *Billy Budd*; *Don Rodrigo* and *Bomarzo* by Alberto Ginastera (1916–1983); Francis Poulenc's *Les Dialogues des Carmélites* and *La Voix humaine* (*The Human Voice*, a tragic telephone monologue); Douglas Moore's *Giants in the Earth* and *The Ballad of Baby Doe*; *Susannah* and *Of Mice and Men* by Carlisle Floyd (1927–); *Boulevard Solitude* and *The Stag King* by Hans Werner Henze (1926–); Samuel Barber's *Vanessa* and *Anthony and Cleopatra*; Krzysztof Penderecki's *The Devils of Loudun*; *Trouble in Tahiti* by Leonard Bernstein (1918–1990); *The Crucible* by Robert Ward (1917–); Dominick Argento's *Casanova's Homecoming*; *Atalanta* by Robert Ashley (1930–); Lukas Foss's *The Jumping Frog of Calaveras County*; the trilogy on historial figures by Philip Glass (1937–): *Einstein on the Beach*, *Satyagraha* (on Gandhi's early life), and *Akhnaten*, and *1000 Airplanes on the Roof*; *Mary, Queen of Scots* by Thea Musgrave (1928–); *The Postman Always Rings Twice* by Stephen Paulus (1949–); *The Cry of Clytaemnestra* by John Eaton (1935–); *The Visitation* by Gunther Schuller (1925–); *Nixon in China* by John Adams (1947–); and *The Ghost of Versailles* by John Corigliano (1938–).

Operetta

The vogue of operettas and musical comedies, which began with the Gilbert and Sullivan operettas, continued in the twentieth century with works by many important composers. They came to be called *musical comedies* and achieved the status of popular music. They are discussed further in Chapter 33.

Ballet and Modern Dance

Dance as a dramatic form independent of opera has enjoyed a popularity unknown since seventeenth–century French court ballets. The revival began in the late nineteenth century with Russian ballet and music by Peter Illich Tchaikovsky (1840–1893; *Swan Lake*, *Sleeping Beauty*, and *The Nutcracker*). Modern ballet, which contributes an important literature to orchestral concerts, began with the choreography of Sergei Diaghilev (1872–1929) and the music of Igor Stravinsky: *The Firebird*, *Petrouchka*, *Le Sacre du printemps* (*The Rite of Spring*). Other important dance music includes Stravinsky's *L'Histoire du soldat* (*Soldier's Tale*), *Pulcinella*, *Jeu de cartes* (*Card Game*), *Les Noces*, *Apollon Musagete*, and *Agon*; Maurice Ravel's *Daphnis et Chloe*; *Gayne* by Aram Khatchaturian (1903–1978); Darius Milhaud's *Le Boeuf sur le toit* (*Bull on the Roof*); Paul Hindemith's

Nobilissima Visione from the ballet *St. Francis*; Aaron Copland's *Appalachian Spring*, *Billy the Kid*, and *Rodeo*; Thomson's *Filling Station*; Walter Piston's *Incredible Flutist*; *Judith* and *Undertow* by William Schuman (1910–); and *Fancy Free* by Leonard Bernstein (1918–1990). Since the 1950s, composers and dancers have worked together perhaps more closely than ever before. A list of composers who have written music for dance might include most of those active. Two important composers, though, are John Cage, who has worked with Merce Cunningham for five decades, and Meredith Monk (1943–) who has established herself as composer, choreographer, and vocalist.

MEDIA OF THE AVANT–GARDE

Experimentation in media is as significant a trait in music as it is in painting or sculpture. Not only have composers sought new effects with conventional instruments but they have invented, or contributed to the development of, entirely new means of producing sounds.

Unusual Uses of Conventional Instruments

The urge to create new kinds of sounds led to exploring the possibilities of using conventional instruments in unusual ways. For example, Igor Stravinsky opened his *Le Sacre du printemps* with a bassoon solo in the extremely high register. Bartók produced new string effects by combining pizzicato, sul ponticello, col legno, glissando, and harmonics in his third, fourth, and fifth string quartets. Krzysztof Penderecki composed *Threnody for the Victims of Hiroshima* for string orchestra, making use of extremely high registers and "bands" of adjacent tones played simultaneously.

The piano has received special unconventional treatment. Henry Cowell (1897–1965) produced unusual sounds from a piano in *Banshee* and *Aeolian Harp* by instructing the performer to pluck the strings or to run a fingernail along the length of a piano string. Alan Hovhaness (1911–) has used a plectrum and tympani sticks on piano strings while simultaneously using the keyboard in conventional manner (*Pastorale, Orbit no. 2, Jhala*). Conlon Nancarrow (1912–) composes for player pianos, sometimes more than one, punching the notes into the piano rolls directly. This method of composing and performance allows for rhythmic complexity far beyond the capabilities of even the most facile pianist. John Cage developed the *prepared piano* in the 1940s by systematically experimenting with materials (screws, rubber,

glass, wood, metal, plastics, cellophane) on and between the piano strings. His *Sonatas and Interludes* are among the best examples of this style.

Unconventional Instruments

Unusual sound–producing objects have been introduced in amazing profusion. An early example is Richard Strauss's (1864–1949) use of a wind machine in *Don Quixote*. Edgard Varèse (1885–1965) calls for a siren in *Ionisation*. Harry Partch (1901–1974) has invented a variety of instruments largely out of a need to perform his music, which is based on a mode with forty–three pitches per octave. Among them are bamboo marimbas, cloud chamber bowls, surrogate kitharas, mazda marimbas, and the boo. Nearly all his music, for example, *Petals Fell in Petaluma* and *Delusion of the Fury*, was composed for his unique orchestra. Since mid–century composers have been inspired by artists who incorporated *objets trouvé* (found objects) into their artwork. Water–buffalo bells and brake drums, among other instruments, are used in John Cage's *Double Music*.

Electronic Instruments

This category includes instruments that depend partly or entirely on electricity for sound production, but it excludes more advanced electronic media developed since 1950. (See the section on Electronic Music, Chapter 29.) Several instruments that generate tones electronically were invented during the first half of the century. These include the Telharmonium, Novachord, and Vibraharp. The Theremin was another and achieved some success, with compositions for it by Edgard Varèse, Percy Grainger, and others. The Ondes Martinot was used by Darius Milhaud, André Jolivet (1905–1974), Jacques Ibert, Arthur Honegger, and Olivier Messiaen. The Hammond Organ, invented in 1933, has been a great commercial success, but only a few composers, Karlheinz Stockhausen and Mauricio Kagel (1931–) primary among them, have written concert music for it. Electronic amplification has been applied to conventional instruments, especially the guitar, and has had a tremendous impact, especially on popular music.

Multimedia

Already in the 1950s composers were combining media into larger and more theatrical events. Two early examples serve to define the genre. (1) John Cage, pianist David Tudor, painter Robert Rauschenberg, and dancer Merce Cunningham teamed to produce the first multimedia *happening* in 1952, with its collage of music, lectures, dances, and visual images. (2) Edgard Varèse's *Poème électronique* (1958) is a 480–second tape composition, with both synthesized and musique concrète elements, that was heard in a pavilion designed by architect Le Corbusier, and accompanied by multiple projected images.

Countless multimedia avant–garde performances have taken place since. The ONCE group (which included composers Robert Ashley, Gordon Mumma, and Roger Reynolds, among other actors, dancers, and artists) was a primary focus for multimedia activities during the late 1950s and 1960s.

Other important composers in the style were Morton Subotnick (1933–), Peter Maxwell Davies (1934–), Boguslaw Schäffer (1929–), George Crumb, Salvatore Martirano (*L's GA*), and Nam June Paik (1932–). Rock groups (e.g., Pink Floyd and Kiss) have been influenced by multimedia techniques; performers like Michael Jackson (1958– ; *Thriller*) have applied them to video production.

Mixed Media

Mixed media is closely related. Where multimedia is generally eclectic and disjunctive, mixed media is intended to be more unified and focused. Barton McLean's (1938–) *Identity* compositions serve as an example. These pieces deal with an audience's relationship with, perception of, and control over the immediate environment. The audience, through its physical movements, actually controls the sounds heard. Other composers include Karlheinz Stockhausen, Mauricio Kagel, Salvatore Martirano, Robert Moran (1937–), and Stuart Dempster (1936–).

Intermedia

Intermedia attempts to erase distinctions between conventional categories of art. The Fluxus group was germinal in this movement, and was a loose coalition of visual artists, poets, performers, and musicians. La Monte Young (1935–), George Brecht (1926–), and Yoko Ono (1933–) were important figures.

Scores and Recordings

Orchestral Music
 Debussy: NAWM 144; NSII 24
 Ravel: NAWM 145; NSII 30
 Richard Strauss: NAWM 146; NSII 25
 Vaughan Williams: NSII 27
 Ives: NSII 29
 Stravinsky: NAWM 147; NSII 32
 Schoenberg: NAWM 148
 Webern: NAWM 149; NSII 33
 Bartók: NSII 31
 Copland: NAWM 150; NSII 38
 Lutoslawski: NSII 42
 Ligeti: NSII 46
 Picker: NSII 49

Chamber Music
 Schoenberg: NAWM 152
 Bartók: NAWM 153
 Carter: NSII 40
 Crumb: NAWM 154; NSII 48
 Messiaen: NAWM 155; NSII 39
 Cage: NSII 41
 Babbitt: NSII 43
 Reich: NAWM 156

Art Song
 Ives: NAWM 159

Opera
 Berg: NAWM 160; NSII 34
 Prokofiev: NSII 35
 Hindemith: NAWM 161
 Britten: NAWM 162
 Stravinsky: NAWM 163
 Musgrave: NSII 47

31

Summary of Principal Twentieth–Century Composers

This chapter names twenty–three countries especially prominent in twentieth–century art music. Under each is a listing of composers who have attained special eminence. In some cases the list is extensive, reflecting the extraordinary level of musical activity in the twentieth century.

THE UNITED STATES

The United States has become the prominent musical nation, having achieved excellence in music education, performance, technology, scholarship, and composition. Its culture is heterogeneous and so is its music, with many different styles being practiced. In the nineteenth century and early decades of the twentieth century, the American art music culture was largely indebted to Europe for the training of its musicians and composers. From this predominantly European heritage, though, American composers emerged as individualists with strongly eclectic tastes. Since World War II, the United States has assumed leadership among the avant–garde, largely because of university support. Public concert stages and opera houses have generally supported more conservative styles.

The Traditionalists Several turn–of–the–century American composers who belong mainly to romantic European traditions were treated in Chapter 26. Among them

were Arthur Foote, George Chadwick, Edgar Stillman Kelley, Edward MacDowell, Charles Loeffler, Horatio Parker, Amy Cheney Beach, Henry Gilbert, Henry Hadley, Frederick Converse. Members of the next, related generation are Edward Burlingame Hill (1872–1960), Daniel Gregory Mason (1873–1953), John Alden Carpenter (1876–1951), and Charles T. Griffes (1884–1920). Arthur Farwell (1872–1952) was one of the first to incorporate references to American Indian music into many of his compositions.

Ives (1874–1954)

Charles Ives is generally considered to be the United States's first great art music composer. His pioneering experiments led to early developments in polytonality, atonality, nontertial harmonies, nonmetric music, and chance music. Still his musical reference is almost always to conventional forms, genres, and media. He made significant contributions to the literature of the art song, string quartet, symphony, and piano sonata. He was also a lively critic and aesthetician.

Cowell (1897–1965)

Henry Cowell was a Californian who studied the traditional music of the western Pacific and incorporated elements of that music into his eclectic style. He experimented with alternative sound sources and with unconventional manners of playing conventional instruments.

Thomson (1896–1989)

Although he usually employed conventional media and frequently traditional genres (operas, especially), Virgil Thomson was thoroughly anti–Romantic in his music. He strove for a plain, repetitive style that disarmed and charmed through its simplicity.

Gershwin (1898–1937)

George Gershwin's music was animated by the rhythms of popular music and jazz. He wrote in conventional genres such as song, concerto, rhapsody, tone poem, and opera.

Copland (1900–1990)

Aaron Copland's ballets have been his most successful compositions, being rhythmically animated and frequently based in American folk idioms. He wrote in a conventional vein for many genres and idioms.

Carter (1908–)

Many of Elliott Carter's major works are large in scale and highly inventive. In an important way, his musical language is traditional, in that it relies on conventions of rhythm and harmony. The result, in his wide range

of compositions, is a dissonant style that does not fit easily into the categories usually assigned to art music in the twentieth century.

Bernstein (1918–1990)

Leonard Bernstein composed, lectured, wrote, and conducted widely. He composed for conventional media in a generally traditional manner. His musical comedies, *West Side Story* and *Our Town*, have been especially popular.

Other Composers

Other important American composers who have developed or explored conventional styles, techniques, or media include Dominick Argento (1927-), Samuel Barber (1910–1981), John Becker (1880–1961), Arthur Berger (1912–), Jean Berger (1909–), William Bergsma (1921–), Marc Blitzstein (1905–1964), Ernest Bloch (1880–1959), William Bolcom (1938–), Theodore Chanler (1902–1961), Chou Wen–chung (1923–), John Corigliano (1938–), Ruth Crawford (1901–1953), Paul Creston (1906–), Ingolf Dahl (1912–1970), Norman Dello Joio (1913–), David Del Tredici (1937–), David Diamond (1915–), Halim El–Dabh (1921–), Irving Fine (1914–1962), Ross Lee Finney (1906–), Carlisle Floyd (1927–), Peggy Glanville–Hicks (1912–), Percy Grainger (1882–1961), Ferde Grofé (1892–1972), Howard Hanson (1896–1981), Roy Harris (1898–1979), Alan Hovhaness (1911–), Andrew Imbrie (1921–), Ulysses Kay (1917–), Leon Kirchner (1919–), Barbara Kolb (1939–), Peter Mennin (1923–1983), Gian Carlo Menotti (1911–), Douglas Moore (1893–1969), Stephen Paulus (1949–), Vincent Persichetti (1915–), Tobias Picker (1954–), Daniel Pinkham (1923–), Walter Piston (1894–1976), Quincy Porter (1897–1966), George Rochberg (1918–), Ned Rorem (1923–), Carl Ruggles (1876–1971), William Schuman (1910–), Harold Shapero (1920–), Seymour Shifrin (1926–1979), Elie Siegmeister (1909–), John Philip Sousa (1854–1932), William Grant Still (1895–1978), Randall Thompson (1899–1984), Ernst Toch (1887–1964), Joan Tower (1938–), Robert Ward (1917–), Hugo Weisgall (1912–), and Adolph Weiss (1891–1971).

The Avant–Garde

Varèse (1885–1965)

From the 1910s Edgard Varèse was experimenting with new musical resources. His Ionisation of 1931 for forty–three percussion instruments was a landmark. He had been interested in electronic instruments since working with a Theremin in the 1930s. His Poème electronique (1958) is one of the early masterpieces of electronic music and multimedia.

Sessions (1896–1985)

Roger Sessions's music is intensive, concentrated, usually highly dissonant, and, after about 1950, twelve–tone. He wrote nine symphonies and four operas, among other pieces in traditional forms.

Partch (1901–1974)

Harry Partch is one of the most inventive and eccentric composers of the century. He reasoned a new modality that led him to compose music for instruments that he had to invent and build. To perform this rich, exotic–sounding, ritualistic music, he had to train his own group of performers.

Cage (1912–)

No composer has been more influential since mid–century than John Cage. He is the acknowledged leader of the avant–garde. He is primarily responsible for the concept of indeterminacy, which he named. Fundamental to that development is a philosophy, influenced by Zen and other forms of Eastern thought, contending that sound should be liberated from the rigid control typical of conventional compositional techniques. His works have spanned available media and genres.

Other Composers

Important American composers involved in the avant–garde movement include John Adams (1947–), Laurie Anderson (1947–), George Antheil (1900–1959), Jon Appleton (1939–), Robert Ashley (1930–), Larry Austin (1930–), Milton Babbitt (1916–), Hans Barth (1897–1956), David Behrman (1937–), Henry Brant (1913–), George Brecht (1926–), William Brooks (1943–), Earle Brown (1926–), Neely Bruce (1944–), Wendy Carlos (1939–), Barney Childs (1926–), John Chowning (1934–), Philip Corner (1933–), George Crumb (1929–), James Dashow (1944–), Mario Davidovsky (1934–), Stuart Dempster (1936–), Charles Dodge (1942–), Jacob Druckman (1928–), William Duckworth (1943–), John Eaton (1935–), Donald Erb (1927–), Robert Erickson (1917–), Richard Felciano (1930–), Morton Feldman (1926–1987), Lukas Foss (1922–), Kenneth Gaburo (1926–), Philip Glass (1937–), Lou Harrison (1917–), Lejaren Hiller (1924–), Karel Husa (1921–), Ben Johnston (1926–), Alison Knowles (1933–), Ernst Krenek (1900–), Ezra Laderman (1924–), Paul Lansky (1944–), Daniel Lentz (1942–), Alvin Lucier (1931–), Otto Luening (1900–), Stanley Lunetta (1937–), Barton McLean (1938–), Donald Martino (1931–), Salvatore Martirano (1927–), Max Matthews (1926–), Meredith Monk (1943–), Robert Moran (1937–), Gordon Mumma (1935–), Conlon Nancarrow (1912–), Pauline Oliveros (1932–), Yoko Ono (1933–), Nam June Paik (1932–), George Perle (1915–), Mel Powell (1923–), J. K. Randall (1929–), Steve Reich (1936–), Roger Reynolds (1934–), Wallingford Riegger (1885–1961), Terry Riley (1935–), Frederic Rzewski (1938–), Gunther Schuller (1925–), Ralph Shapey (1921–), Morton Subotnik (1933–), James Tenney (1934–), Vladimir Ussachevsky (1911–), Adolph Weiss (1891–1971), Olly Wilson (1937–), Christian Wolff (1934–), Stefan Wolpe (1902–1972), Charles Wuorinen (1938–), and La Monte Young (1935–).

SOVIET UNION

Russia came significantly into the European musical scene in the nineteenth century. In the twentieth century the Soviet Union has been mostly outside the mainstream avant–garde developments because of government pressure to avoid alienating the people by *formalist* (i.e., avant–garde) techniques. Nevertheless, it has produced great musicians, performing artists, conductors, and composers during the period.

**Stravinsky
(1882–1971)**

Despite its general conservatism it was Russia that produced probably the most eminent composer of the twentieth century. Igor Stravinsky, who emigrated to Paris in 1910 and to the United States in 1939, can justly be called an international composer. Although he was a versatile composer in all media, it was in ballet music that his fame was first established. Although his style changed repeatedly, there are certain traits that have remained constant: strong and often complex rhythm, ostinato, brilliant orchestration, and pungent harmonies. Stylistic trends can be noted: (1) the Russian period, in which he was strongly influenced by Rimsky–Korsakov (*Firebird*); (2) the so–called dynamistic (or, alternately, primitivist) period of *Le Sacre du printemps* and *Petrouchka*; (3) the Neoclassical period of the Octet for Winds, *L'Histoire du soldat*, *Pulcinella*, *Symphony of Psalms*, and *Apollon Musagete*; (4) the jazz–influenced music of *Ragtime*, *Ebony Concerto*, and *Dumbarton Oaks*; and (5) the use of serial technique in such works as *Agon* and *Threni*.

**Prokofiev
(1891–1953)**

Like Stravinsky, Sergei Prokofiev emigrated and lived in the United States and Paris between 1918 and 1934, but he returned to the Soviet Union to become one of its most distinguished composers. Among his most popular compositions are *Lieutenant Kijé*, *Peter and the Wolf*, the "Classical" Symphony, and the opera *The Love for Three Oranges*.

**Shostakovich
(1906–1975)**

Dmitri Shostakovich's music has had a varied reception in the Soviet Union, ranging from enthusiastic acclaim to denouncement and back again. On the whole, he was able to infuse his music with moderately progressive styles while retaining popular appeal.

**Other
Composers**

Among other important Soviet composers are Mikhail Ippolitov–Ivanov (1859–1935), Alexander Gretchaninov (1864–1956), Alexander Glazunov (1865–1936), Alexander Scriabin (1872–1915), Sergei Vasilenko (1872–1956), Nicholas Tcherepnin (1873–1945), Reinhold Glière (1875–1956), Nicolai Miaskovsky (1881–1950), Aram Khatchaturian (1903–1978), and Dmitri Kabalevsky (1904–1987). More recent Soviet composers, some of

whom employ electronic and aleatory techniques, are Tikhon Khrennikov (1913–), Edison Denisov (1929–), Sergei Slonimsky (1932–), Andrei Volkonsky (1933–), Alfred Chnitke (1934–), Arvo Pärt (1935–) an important young Estonian composer, Leonid Grabovsky (1935–), and Valentin Silvestrov (1937–).

FRANCE

France has been in the front ranks of music making in the twentieth century. French composers were the first to turn from the dominance of German Romanticism to new modes of musical thought, and they have been in the forefront of important developments in electronic music.

The Traditionalists

As in the United States, there is a generally clear division between composers of the period before World War II and those since.

Debussy (1862–1918)

Claude Debussy, the foremost Impressionist composer, stood on the threshold of modernism much in the same way that Beethoven represented the transition from Classical to Romantic music. His innovations, revolutionary in their day, opened the door to many twentieth–century developments. Debussy's principal media for composition were the piano and the orchestra, in which he introduced new harmonies and sonorities. His best-known orchestral works are the tone poem *Prélude à l' après–midi d' un faune* (*Prelude to the Afternoon of a Faun*) and the orchestral suites *La Mer* and *Nocturnes*.

Satie (1866–1925)

Erik Satie purposefully wrote music in an anti–Romantic vein. He turned often toward popular music idioms to accomplish this. His influence on the avant–garde has been considerable.

Ravel (1875–1937)

Maurice Ravel's style transcends Impressionism, to which he added Neoclassical clarity, colorful orchestration, and considerable use of Spanish elements.

Les Six

In the 1920s a group of six composers initiated an anti–Impressionist movement of a neoclassical nature. "The Six" were Darius Milhaud, Arthur

Honegger (1892–1955), Francis Poulenc (1899–1963), Germaine Tailleferre (1892–1983), Georges Auric (1899–1983), and Louis Durey (1888–1979).

Milhaud (1892–1974)

Darius Milhaud was the most eminent, versatile, and prolific composer among Les Six. He composed music in all media and in many twentieth–century styles. He was a proponent of polytonality in the 1920s. Though consistently Gallic in spirit, he was an eclectic cosmopolite who absorbed idioms from Brazil, jazz, and other indigenous elements, including those of his native Provence.

Other Composers

Composers whose creative lives belong mostly to the twentieth century but who stylistically belong more to the nineteenth century were Gustave Charpentier (1860–1956), Joseph Guy Ropartz (1864–1955), Paul Dukas (1865–1935), Charles Koechlin (1867–1950), Henri Rabaud (1873–1949), Jean Roger–Ducasse (1873–1954), Jacques Ibert (1890–1962), and Henri Duparc (1848–1943). Special mention should be made of Albert Roussel (1860–1937), Florent Schmitt (1870–1958), Henri Sauguet (1901–), Maurice Duruflé (1902–), André Jolivet (1905–1974), and Jean Françaix (1912–). Nadia Boulanger (1887–1979), also a composer, was one of the most influential teachers of composition in the twentieth century.

The Avant–Garde

Messiaen (1908–)

Olivier Messiaen embraced modern idioms early in his career. His music is thoroughly eclectic, borrowing from Catholic church music, Indian music, birdsongs, and serialist techniques. He has been an important teacher of composition.

Boulez (1925–)

A student of Messiaen, Pierre Boulez continued his teacher's development of the concept of total serialism. Boulez's works are rigorously structured but feature delicate sonorities.

Composers of Electronic Music

Pierre Schaeffer (1910–) and Pierre Henry (1927–) were the first to experiment with musique concrète. The French have continued to be involved in important developments in electronic music, lately resulting from outstanding facilities at the Institut de Recherche et de Coordination Acoustique/Musique (IRCAM). Among the important composers in the medium are Luc Ferrari (1929–) and Jean–Claude Risset (1938–).

AUSTRIA

Austria maintained its position as one of the leading musical countries of Europe through the middle of the century.

**Schoenberg
(1874–1951)**

One of the most influential composers of the century, Arnold Schoenberg began with post–Wagnerian music (*Verklärte Nacht*), moved toward atonality and into Expressionism in the second decade, and established the twelve–tone system in the early 1920s. He initiated a vocal style called *sprechstimme* or *sprechgesang* (half–spoken, half–sung text), which he employed first in *Pierrot lunaire*, and later in *Survivor from Warsaw*, for narrator, chorus, and orchestra. He moved to the United States in 1933.

**Berg
(1885–1935)**

A pupil of Schoenberg, Alban Berg employed the tone–row system loosely, and his music is generally more Romantic and more tonal than Schoenberg's. His most famous works are the two operas *Wozzeck* and *Lulu*.

**Webern
(1883–1945)**

Also a pupil of Arnold Schoenberg, Anton Webern composed in a more stringent style, employed dissonant counterpoint, disjunct melodic lines, severely economical means, and pointillistic texture. He was not a prolific composer, but his music has had a profound influence on composers since 1945.

**Other
Composers**

Other important composers are Alexander von Zemlinsky (1871–1942), Franz Schreker (1878–1934), Josef Hauer (1883–1959), and Gottfried von Einem (1918–). Ernst Toch and Ernst Krenek moved to the United States in the 1930s.

Leaders in the new music movement in Austria include Friedrich Cerha (1926–), the Hungarian György Ligeti, and the Polish Roman Haubenstock–Ramati.

GERMANY

The musical importance of German–speaking nations, including Austria, has been noted from the time of the minnesingers to the present.

**Hindemith
(1895–1963)**

Following the domination of Richard Strauss in the early decades, Paul Hindemith stood as the most eminent representative of German music in the first half of the century.

**Stockhausen
(1928–)**

Since midcentury Karlheinz Stockhausen has been the most influential German composer. His thought and music were fundamentally altered as a result of a meeting with John Cage in 1950. Since then, his ideas have been central to many of the important developments of the European avant–garde.

**Other
Composers**

Among important German composers of the first half of the century are Paul Dessau (1894–1979), Carl Orff (1895–1982), Hanns Eisler (1898–1962), Kurt Weill (1900–1950), Werner Egk (1901–1983), Boris Blacher (1903–1975), Karl Hartman (1905–1963), and Wolfgang Fortner (1907–).

Composers who have been prominent since World War II include: Giselher Klebe (1925–), Hans Werner Henze (1926–), and Dieter Schnebel (1930–).

ITALY

For the most part, Italy was musically conservative in the first decades of the twentieth century. Toward midcentury, Italian composers moved into the main current of contemporary developments.

**The
Traditionalists**

Busoni (1866–1924)

Ferruccio Busoni was one of the few early twentieth–century Italians interested in new musical idioms, generally those being developed in Germany and Austria. Influential as composer, pianist, editor, critic, and teacher, he pointed the way to new musical thought in Italy.

Respighi (1879–1936)

Ottorino Respighi was Italy's first important instrumental composer in the twentieth century, although he was conservative even in terms of then current practices. His best–known works are the two tone poems (each in four continuous movements) *The Pines of Rome* and *The Fountains of Rome.*

Malipiero (1882–1973)

Francesco Malipiero was an eminent musicologist who made scholarly studies and editions of Italian Baroque composers (Monteverdi, Vivaldi, and others). The studies influenced the Neoclassicism of his own compositions, which include operas, symphonies, large choral works, and chamber music.

Other Composers

Other significant Italian composers are Ermanno Wolf–Ferrari (1876–1948), Ildebrando Pizzetti (1880–1968), Alfredo Casella (1883–1947), and Goffredo Petrassi (1904–). Gian Carlo Menotti has studied, resided, and produced most of his operas in the United States.

The Avant–Garde

Berio (1925–)

Luciano Berio was interested early in electronic music. With Maderna he set up the first electronic music studio in Italy. His music since has drawn on a wide range of contemporary and conventional idioms, but is always structured with great care and is inherently dramatic.

Other Composers

Among important Italian avant–garde composers, mainly of serial or electronic compositions, are Luigi Dallapiccola (1904–1975), Bruno Maderna (1920–1974), Luigi Nono (1924–), Franco Donatoni (1927–), Sylvano Bussotti (1931–), Niccolò Castiglioni (1932–), and Salvatore Sciarrino (1947–).

GREAT BRITAIN

Great Britain's high position in music, which had declined after the Renaissance, has been restored in the twentieth century.

Vaughan Williams (1872–1958)

Generally considered the most eminent English composer in the first half of the century, Ralph Vaughan Williams composed moderately conservative, Romantic, and consistently tonal music. English folk–song idioms are evident in much of his music. He excelled in symphonic and choral media.

Walton (1902–1983)

William Walton assimilated a number of modern techniques in his generally conservative, highly personal style. Among his many successful works are *Façade* for chamber orchestra, with recited poems by Edith

Sitwell, the oratorio *Belshazzar's Feast*, the opera *Troilus and Cressida*, and music for the films *Henry V* and *Romeo and Juliet*.

Britten
(1913–1976)

Benjamin Britten is widely recognized as a major composer who has produced a number of excellent large–scale works. His operas have become part of the standard repertory.

Other
Composers

The Traditionalists

Important composers mentioned in Chapter 26 who represented the transition from the nineteenth to the twentieth centuries were Charles Parry, Charles Stanford, and Edward Elgar. British composers who worked in a more–or–less conventional vein include Frederick Delius (1862–1934), Granville Bantock (1868–1946), Gustav Holst (1874–1934), Arnold Bax (1883–1953), Lord Berners (1883–1950), Arthur Bliss (1891–1975), Philip Heseltine (1894–1930; known as Peter Warlock), Alan Bush (1900–), Edmund Rubbra (1901–), Lennox Berkeley (1903–), Michael Tippett (1905–), Mátyás Seiber (1905–1960), Alan Rawsthorne (1905–1971), Elisabeth Lutyens (1906–1983), Humphrey Searle (1915–1982), Richard Arnell (1917–), Peter Racine Fricker (1920–), Malcolm Arnold (1921–), Anthony Milner (1925–), Malcolm Williamson (1931–), and Richard Rodney Bennett (1936–).

The Avant–Garde

Important among the avant–garde movement in England are Andrzej Panufnik (1914–), Iain Hamilton (1922–), Alexander Goehr (1932–), Peter Maxwell Davies (1934–), Cornelius Cardew (1936–1981), and John Tilbury (1936–). Thea Musgrave (1928–) is Scottish, and a composer of dramatic works.

HUNGARY

Hungary has produced some distinguished composers in the twentieth century.

Bartók
(1881–1945)

A top–rank pianist, scholar of Balkan folk music, teacher, and composer, Béla Bartók is one of the giants of modern music. He was never a "systems" composer, conforming rigidly to styles or techniques. His music taken as a whole encompasses many modern developments in melody, harmony, rhythm, tonality, and textures. Among his works are *Mikrokosmos* (153 graded pieces for piano), six string quartets, and the *Music for Strings, Percussion, and Celesta*.

**Kodály
(1882–1967)**

Zoltán Kodály followed in Bartók's footsteps as a modern Hungarian nationalist, though somewhat more conservative. He formulated a pedagogic method for teaching music to children that is still in wide use. His principal works are the opera *Háry János*, *Psalmus Hungaricus*, and *Dances of Galanta*.

**Other
Composers**

Other Hungarian composers are Ernst von Dohnányi (1877–1960), Leo Weiner (1885–1960), Tibor Serly (1901–1978), and Pál Kadosa (1903–1983). Among the active avant–garde, one must include György Ligeti (1923–), who left Hungary in 1956, György Kurtág (1926–), Istváan Láng (1933–), Zsolt Durkó (1934–), Attila Bozay (1939–), László Sáry (1940–), and Zoltán Jeney (1943–).

SPAIN

Spanish music of the twentieth century is generally conservative and nationalist in style.

**De Falla
(1876–1946)**

The most outstanding Spanish composer in the first half of the century was Manuel de Falla. His principal works are the opera *La Vida breve* (*Life Is Short*), the ballets *El Sombrero de tres picos* (*The Three–Cornered Hat*) and *Noches en los jardines de España* (*Nights in the Gardens of Spain*).

**Surinach
(1915–)**

Carlos Surinach, who emigrated to the United States in 1951, is probably the Spanish composer best known since midcentury. His music combines a nationalist approach with progressive but not extreme techniques.

**Other
Composers**

Among other important Spanish composers are Joaquín Turina (1882–1949), Oscar Esplá (1886–1976), Roberto Gerhard (1896–1970), Rodolfo Halffter (1900–), Julian Bautista (1901–1961), Joaquín Rodrigo (1901–), and Ernesto Halffter (1905–).

Among the avant–garde include Joaquín Homs (1906–), Luis de Pablo (1930–), and Critóbal Halffter (1930–).

ARGENTINA

An abundance of folksong material, mostly of Gaucho origin, provides a rich source of native materials used by many Argentine composers.

The Traditionalists

Composers active in the early part of the century include Alberto Williams (1862–1952), Juan Castro (1895–1968), Juan Carlos Paz (1897–1972), Roberto Morillo (1911–), and Carlos Guastavino (1912–).

The Avant–Garde

Argentina enjoys a particularly active avant–garde.

Ginastera (1916–1983)

Alberto Ginastera blended native color with moderately dissonant but tonal harmonies in his early works. His operas, *Don Rodrigo* and *Bomarzo* utilized avant–garde techniques.

Kagel (1931–)

Mauricio Kagel, who left Argentina for Germany in 1957, has been at the fore of developments in European experimental music. His complex, highly theatrical creations draw upon aleatory techniques, multiple–serialism, and multimedia.

Other Composers

Other composers include Alcides Lanza (1929–), Antonio Tauriello (1931–), Gerardo Gandini (1932–), and Armando Krieger (1940–). Mario Davidovsky left Argentina for the United States in 1958.

BELGIUM

Prominent composers active in the first half of the century were Paul Gilson (1865–1942), Joseph Jongen (1873–1953), Paul de Maleingreau (1887–1956), Jean Absil (1893–1974), and Marcel Poot (1901–). Among the avant–garde, Henri Pousseur's (1929–) work with electronics and with the applications of aleatory technniques places him at the forefront. Other figures important in new music include Karl Goeyvaerts (1923–), Lucien Goethals (1931–), Philippe Boesmans (1936–), and Pierre Bartholomée (1937–).

BRAZIL

Brazilian music is a mixture of African, native Indian, Portuguese, and cosmopolitan European cultures.

Villa–Lobos
(1887–1959)

The most illustrious among Brazilian composers, Heitor Villa–Lobos was a conservative nationalist, drawing from the various ethnic sources of his country. Among his highly individualistic works were fourteen compositions called *Choros*, and nine compositions entitled *Bachianas Brasileiras*, loosely based on forms or techniques used by Bach.

Other
Composers

Other composers are Francisco Mignone (1897–), Camargo Guarnieri (1907–), Claudio Santoro (1919–), Gilberto Mendes (1922–), and Marlos Nobre (1939–).

CANADA

The leading names among Canadian composers are Healey Willan (1880–1968), Claude Champagne (1891–1965), Colin McPhee (1901–1964), Barbara Pentland (1912–), John Weinzweig (1913–), Alexander Brott (1915–), and Jean Papineau–Couture (1916–). Pierre Mercure (1927–1966) was a leader of the Canadian avant–garde before his early death. Others of that school include Udo Kasemets (1919–), István Anhalt (1919–), Harry Freedman (1922–), John Beckwith (1927–), and R. Murray Schafer (1933–).

CZECHOSLOVAKIA

Czech music has remained predominantly conservative, romantic, and strongly nationalistic in the twentieth century. Leoš Janáček is the important transitional figure to the twentieth century.

Martinů *(1890–1959)*	Influenced by Impressionism and somewhat by Igor Stravinsky, Bohuslav Martinů made use of native folk idioms in his operas (*Comedy on a Bridge*), symphonies, ballets, and chamber works.
Other *Composers*	Other composers include Josef Suk (1874–1935), Alois Hába (1893–1973), who was a microtonalist, Jaromir Weinberger (1896–1967), who is known for his opera *Schwanda the Bagpiper*, Miloslav Kabeláč (1908–1979), Eugen Suchon (1908–), Karel Reiner (1910–1979), and Ján Cikker (1911–). Among the younger generation of composers are Ladislav Burlas (1927–), Roman Berger (1930–), Ilja Zeljenka (1932–), Dusan Martinček (1936–), Ladislav Kupkovič (1936–), Petr Kolman (1937–), and Juraj Hatrík (1941–). Karel Husa has lived in the United States since 1954.

DENMARK

Nielsen *(1865–1931)*	Carl Nielsen was touched by the neoclassical style, especially toward the end of his career. He is often mentioned with Sibelius, but unlike the Finnish master he skillfully explored new idioms while still working in conventional forms and genres. An example of this trait is his use of the snare drum as a solo instrument in his Symphony no. 5. His symphonies have come to enjoy special attention in the twentieth century.

FINLAND

Palmgren *(1878–1951)*	Selim Palmgren was the most important Finnish master of the early twentieth century after the long–lived but basically Romantic Sibelius. Palmgren employed Finnish folk idioms in an Impressionist style. Following him were Yrjö Kilpinen (1892–1959) and Aarre Merikanto (1893–1958).
Other *Composers*	Other composers include Erik Bergman (1911–), Einar Englund (1916–), Bengt Johansson (1914–), and Joonas Kokkonen (1921–), the last two of whom are aligned with the avant–garde.

GREECE

Some names in early twentieth–century Greek art music are George Lambelet (1875–1945), Manolis Kalomiris (1883–1962), Mario Varvoglis (1885–1967), Nikos Skalkottas (1904–1949), and Manos Hadzidakis (1925–).

Xenakis (1922–)

Yannis Xenakis is the leading Greek composer of the avant–garde. His music, which is usually for conventional media, is derived from mathematical and philosophical principles he developed. His rigorous structures, based on probability theory, however, include an element of indeterminacy.

Other Composers

Others of the avant–garde include: Anestis Logothetis (1921–), Nikos Mamangakis (1929–), Yannis Ioannidis (1930–), George Psouyopoulos (1930–), and Stephanos Gazouleas (1931–).

HOLLAND

Important names in the twentieth century, are Henrik Andriessen (1892–1981), Willem Pijper (1894–1947), and Jurriaan Andriessen (1925–).

Composers of the avant–garde in Holland include Kees van Baaren (1906–1970), Henk Badings (1907–), Rudolf Escher (1912–1980), Ton de Leeuw (1926–), Jan Vriend (1938–), and Louis Andriessen (1939–).

JAPAN

Since World War II, Japan has shown an affinity for all kinds of Western music, including art music. Japan has produced important performing artists, conductors, and composers. Among the latter are Yoritsune Matsudaira (1907–), Shin–elchi Matsushita (1922–), Toshiro Mayuzumi (1929–), Joji Yuasa (1929–), Toru Takemitsu (1930–), Yori–Aki Matsudaira (1931–),

Toshi Ichiyangi (1933–), and Yuji Takahashi (1938–). Except for Yoritsune Matsudaira, all are involved in some aspect of the avant–garde.

MEXICO

Mexican music, like that of other Latin American countries, manifests a strong nationalist strain that blends indigenous elements with Spanish and conservatively modern styles.

Chávez (1899–1978)

Carlos Chávez was Mexico's foremost musician, educator, organizer, conductor, and composer. His music was nationalistic and neoclassical and in a variety of media.

Revueltas (1899–1940)

Mexican folklore and idiom are essential ingredients in Silvestre Revueltas's music. His most famous works are *Cuauhnahuac* and *Sensemaya*, both for orchestra.

Other Composers

Other important Mexican composers include Julián Carrillo (1875–1965), known for his microtonal music, Manuel Ponce (1882–1948), Daniel Ayala (1906–1975), Miguel Jimenez (1910–1956), Blas Galindo (1910–), and Pablo Moncayo (1912–1958). Leaders among the avant–garde are Manuel Enríquez (1926–), Mário Kuri–Aldana (1931–), and Hector Quintanar (1936–). Conlon Nancarrow immigrated to Mexico from the United States in 1940, eventually to become a Mexican citizen.

POLAND

Important names in early twentieth–century Polish music are Karol Szymanowski (1882–1937), Karol Rathaus (1895–1954), and Alexander Tansman (1897–). Poland has enjoyed a particularly vital avant–garde movement. An early leader was Witold Lutosawski (1913–), followed by Roman Haubenstock–Ramati (1919–), who emigrated to Austria in 1957, Tadeusz Baird (1928–1981), Boguslaw Schäffer (1929–), and H. M. Górecki (1933–). Krzysztof Penderecki (1933–) has gained wide attention with his

music featuring large banks of dissonant tone clusters. Andrzej Panufnik emigrated to England in 1954.

SWEDEN

Composers who worked within an early twentieth–century idiom include Natanaël Berg (1879–1957), Kurt Atterberg (1887–1974), Oskar Lindberg (1887–1955), and Lars–Erik Larsson (1908–).

Composers active since the 1940s include Karl–Birger Blomdahl (1916–1968), Hans Holewa (1905–), Sven–Eric Johanson (1919–), Bengt Hambraeus (1928–), Folke Rabe (1935–), and Bo Nilsson (1937–).

SWITZERLAND

Martin (1890–1974)

Frank Martin was the most important Swiss composer of the century (excluding expatriots such as Honegger, Bloch, and others). He employed a modified twelve–tone technique in a personalized manner.

Liebermann (1910–)

Rolf Liebermann's style is based mainly on a twelve–tone technique combined with Classic and Romantic elements and a strong rhythmic sense. His most famous work is the *Concerto for Jazz Band and Symphony Orchestra*.

Other Composers

Other important Swiss composers are Wladimir Vogel (1896–1984), a Russian–born serialist composer living in Switzerland, Willy Burkhard (1900–1955), Conrad Beck (1901–), and Heinrich Sutermeister (1910–). Active members of the avant–garde include Jacques Wildberger (1922–), Klaus Huber (1924–), Rudolf Kelterborn (1931–), and Jacques Guyonnet (1933–).

PART EIGHT

POPULAR MUSIC, JAZZ, AND ROCK

32

Introduction to Popular Music, Jazz, and Rock

1728 Gay: *The Beggar's Opera*

1768 James Hook: *A Collection of Songs Sung at Vauxhall and Marylebone Gardens*

1808 First issue of Thomas Moore's *Irish Melodies*

1823 "Home, Sweet Home" (Bishop–Paine) premiered

1840 Henry Russell: "The Old Arm Chair"

1843 First minstrel show

1843 Hutchinson Family Singers meet success in New York City

1843 First song by Stephen Foster

1851 Foster: "Old Folks at Home"

1857 "Jingle Bells" by J. S. Pierpont

1859 Dan Emmett: "Dixie"

1864 Death of Foster

1866 *The Black Crook* premiered

1873 Harrigan–Hart: *The Mulligan Guard*

1875 James Bland: "Carry Me Back to Old Virginny"

1876 Henry Clay Work: "Grandfather's Clock"

1885 Gilbert–Sullivan: *The Mikado*

1892 Charles K. Harris: "After the Ball"

1896 Maud Nugent: "Sweet Rosie O'Grady"

1897 Paul Dresser: "On the Banks of the Wabash"

1899 Scott Joplin: "Maple Leaf Rag"

1905 "In the Shade of the Old Apple Tree" (Williams–Van Alstyne)

1906 George M. Cohan: *Forty–Five Minutes from Broadway*

1911 Irving Berlin: "Alexander's Ragtime Band"

1912 Publication of first country blues

1917 First recording of jazz by the Original Dixieland Jazz Band

1917 Storyville, in New Orleans, closed

1923 Bessie Smith makes her first blues recordings

1925 Louis Armstrong makes first recordings with his Hot Five

1927 Jerome Kern's *Showboat*

1927 *The Jazz Singer* (movie)

1930 Gershwin: "Embraceable You"

1933 Kern: "Smoke Gets in Your Eyes"

1934 Cole Porter: *Anything Goes*

1934 Benny Goodman's Band formed on model of Fletcher Henderson's Band

1939 Harold Arlen: music to *The Wizard of Oz*

1940 Duke Ellington and His Orchestra make string of extraordinary recordings

1942 Irving Berlin: "White Christmas"

1943 *Oklahoma!* by Rodgers and Hammerstein

1945 Charlie Parker and Dizzy Gillespie make classic bebop recordings

1953 Death of Hank Williams

1954 Newport Jazz Festival founded

1954 Elvis Presley cuts his first recording

1955 Death of Charlie Parker

1955 "Rock Around the Clock" rises to number one

1955 Chuck Berry: "Maybellene"

1956 Presley's "Heartbreak Hotel"

1956 Presley on *The Ed Sullivan Show*

1956 Charlie Mingus: *Pithecanthropus erectus*

1957 *West Side Story*

1958 Presley drafted into the Army

1959 Buddy Holly killed in plane crash

1959 Dave Brubeck: "Take Five"

1960 Ornette Coleman: *Free Jazz*

1963 Bob Dylan: "Blowin' in the Wind"

1964 The Beatles on *The Ed Sullivan Show*

1965 The Beatles: *Help!* (film)

1966 Last public appearance by the Beatles

1966 Summer of Love (San Francisco)

1967 Beatles: *Sgt. Pepper's Lonely Hearts Club Band*

1968 Rolling Stones: "Sympathy for the Devil"

1969 Miles Davis: *Bitches Brew*

1969 Woodstock rock festival

1970 The Beatles disband

1970 Deaths of Janis Joplin and Jimi Hendrix

1971 Carole King: *Tapestry*

1973 Stephen Sondheim's *A Little Night Music*

1977 Death of Elvis Presley

1978 The Bee Gees: *Saturday Night Fever*

1980 The Clash: *London Calling*

1981 Laurie Anderson: "O Superman"

1982 Michael Jackson: *Thriller*

1984 Bruce Springsteen: *Born in the USA*

1985 Live Aid concerts

1986 Paul Simon: *Graceland*

1987 U2: *Joshua Tree*

*W*estern music other than art music has existed during all periods. *Generally this music is referrred to as the music of the vernacular, or the common culture. Often this has been music that exists in oral tradition, performed from memory and passed on orally. Such music is often called folk music. Many different types of folk music have coexisted in any given frame. Some have been developed in urban situations, but the genre flourished most in a rural, agrarian society. By its very nature it is difficult to document these traditions; hence folk music does not typically figure significantly in any*

comprehensive written history of music. Implicit in a musical system that embraces both notated music and an oral tradition is social standing and class. Before and during the Middle Ages, the Roman Catholic Church was generally the only social institution that had a place for literacy. That today we know most about church music from that period is not surprising since the Church kept the records. Music of those outside the written tradition, usually the working people, was of little interest to church clerics and remained undocumented except in incidental ways.

Popular music, rock, and jazz have in common the facts that they all grew out of music for the common people, that the vernacular tradition was at least initially important, and that the music was conceived in reaction to the prevailing musical idiom. Thus, the histories of these musics are bound to the histories of other musics, perhaps primarily art music. Many of the concepts needed to understand popular music, rock, and jazz are ones already introduced.

The definition of popular music is elusive. There is about it a quality of entertainment, of lightness in opposition to the serious intent of art music or even folk music, which often has a rather obvious didactic intention. Popular music is literally music for the people ("populus" in Latin means "the people"). From early it has meant the music preferred by the masses rather than by the elites, whether defined by wealth, power, or intellect. By the nineteenth century it was music that was quantifiably popular. That is, printed popular music sold more units (e.g., sheet music) of music than did nonpopular music (generally art music). This distinction holds well into the twentieth century. Rock is also a form of popular music, but it is stylistically so disinct from popular music before its development that convention calls popular music and rock by different names. Jazz has never been a form of truly popular music. Even if one were to limit the audience to African–Americans, blues, gospel, or rhythm and blues would be more popular at a given time. Although it has features characteristic of music for the elite, jazz has much more in common with forms of popular music than not. In addition, it has exerted considerable influence on both popular music and rock, and has been influenced in turn. In the twentieth century, popular music, jazz, and rock are bound by their common treatment of rhythm. All share a rhythmic quality that is historically new and different in the West. The essence of this dynamic new regard for rhythm is syncopation.

33

Popular Music

Popular music is usually in the form of a song with accompaniment (often piano). Its primary intention is to provide entertainment and diversion. Composed and published to make a profit, it is only secondarily a form of self–expression. Only after the Industrial Revolution generated a large middle class with disposable income did popular music become a powerful force. The most important developments in this music took place in England in the eighteenth century and in the United States in the nineteenth and twentieth centuries. By the mid–nineteenth century there was much greater involvement with popular music by people in English–speaking nations than with art music. The twentieth century has seen this trend accelerate. Since the mid–1950s rock has become the most important form of popular music. Rock (see Chapter 35) is different from the subject of this chapter in several important ways and is not a part of this discussion.

EARLY HISTORY

Folk–Songs, musical works of a narrative nature that exist in oral tradition, are the sources for early popular music. Hundreds of these were known to working–class people in England, Scotland, and Ireland before the eighteenth century, and were brought to America by immigrants. Some folk–songs go back at least to the time of the Middle Ages. Others were more–or–less contemporary songs published and sold in the form of the *penny ballad* or *broadside* (a single–sheet printed impression that uses only one side of the paper). Favorite songs of this sort often became part of the oral tradition. Broadside ballads (a *ballad* is, in this context, a narrative song) had a text that commented on some current event (i.e., it was *topical*) and

was set musically to a well–known tune. If there was an accompaniment to the solo voice or a harmonic setting of the melody, it was improvised.

The broadside ballad already meets the basic requirements for a popular song: (1) that it be simple and attractive to its intended audience; (2) that its melody be the primary musical feature; (3) that the text be immediately meaningful to its intended audience; (4) that it be capable of performance by an amateur; and (5) that profit be a motive behind its creation and dissemination.

Composers in eighteenth–century England first started writing songs somewhat like the broadside ballads, but with a notated accompaniment and a text that was less politics–oriented and more entertainment–oriented. These songs were featured at *pleasure gardens*, large private parklike settings outside major cities where one might enjoy nature while eating, drinking, talking, flirting, or listening to music. Middle–class amateur musicians bought these songs, took them home, and performed them for friends and family in the home. The songs were published in the form of *sheet music*, on large, heavy, sheets of paper that, unlike the broadsides, might be printed on both sides. By the end of the century there were thousands of these songs and dozens of composers. Two representative composers are Thomas Arne (1710–1778) and James Hook (1746–1827).

Americans of the eighteenth century also had pleasures gardens to attend, but almost all of the popular music heard there was imported from England. The few popular songs composed in the colonies were of the same general style as those in England. They were generally written by immigrant musicians from England.

The period at the turn of the nineteenth century found the English and the Americans fascinated with Scottish and Irish songs, both of which featured exotic–sounding melodies (often because they were pentatonic) and romantic texts. The songs of Robert Burns (1759–1796; "Auld Lang Syne," "Comin' Thro the Rye," "John Anderson My Jo") and of Thomas Moore (1779–1852; "Believe Me if all Those Endearing Young Charms," "Oft, in the Stilly Night," " 'Tis the Last Rose of Summer") were especially important. The latter issued his songs in an eight–volume collection called the *Irish Melodies*. It was also at this time that art music became increasingly esoteric, and therefore less capable of meeting the musical needs of a burgeoning European and American middle–class population. Popular music benefited significantly from this trend.

NINETEENTH–CENTURY POPULAR MUSIC

The first great success by an American songwriter was "The Minstrel's Return'd from the War" (1825) by John Hill Hewitt (1801–1890). This song referred to an experience shared by many Americans (death on the battlefield in defense of one's country), and reinforced the notion that home, family, and love of country are essential values. Musically, it is exemplary among nineteenth–century American popular song. (1) It is a simple song, easy to play and sing, designed to appeal to modest talents. (2) The eight–measure piano introduction sets the mood of the piece, and is followed by the principal melody in the voice. (3) The melody is diatonic and conjunct, of graceful contour with climactic high notes toward the end; the phrases are of the same length. (4) There is enough repetition to make the melody memorable, but not so much that it becomes tedious. (5) Harmonies are limited to the tonic, subdominant, and dominant.

Russell (1812–1900)

Henry Russell was the dominant force in American popular music during the 1830s. He was one of the first to realize the didactic possibilities of popular music. He used his songs to speak on topical social issues of the day, like the ill treatment of Indians ("The Indian Hunter"), insane asylums ("The Maniac"), and temperance ("The 'Total Society"). Above all his music reaffirmed American middle–class social values. Two characteristics distinguish his songs from earlier ones: an accompaniment that exhibits the influence of Italian opera, then enjoying a vogue, and an implicit sense of drama. Russell, an able performer as well as a composer, was also among the first to make performance of popular music a profitable, public event.

The Singing Families

The Hutchinson Family Singers, a quartet of three brothers and a sister, the most notable of hundreds of such groups, extended Henry Russell's innovations through the 1840s and 1850s. They, too, used popular music to comment on a wide range of social issues, including advocating the abolition of slavery. Their songs were like *glees*, simple songs for three or four parts. They performed them with (1) a *chorus* at the end of each verse, where everyone sang together the most memorable and melodic music; (2) a close, "sweet" blend of voices; (3) much attention to the "natural," easy vocal sound, with perfect intonation; (4) clearly articulated words; (5) a stage manner that was casual, comfortable, and informal; and (6) song topics that ranged over items of direct concern to their audience. Their enormous popularity as performers established these characteristics as standards for the next one hundred years of popular music.

The Minstrel Shows

The first minstrel show took place in New York City in February 1843. Four white performers, who called themselves the Virginia Minstrels, dressed themselves to portray African–Americans, applied *blackface* makeup, and sang, danced, played instruments, made jokes, and mounted skits and humorous speeches. This was racially based entertainment that parodied and ridiculed southern slaves and northern freedmen, and appealed to a white working–class American audience. Individual blackface entertainers had been seen in theaters since the 1820s. Two songs from that early period were "Jump Jim Crow" and "Zip Coon." Like much early minstrel show music, these songs were extremely simple melodically and harmonically, with spirited rhythms. The texts were disjunctive rather than narrative. Minstrels arrayed themselves in a semicircle, with comics on either ends (the *endmen*) who generally played the bones (Mr. Bones), a castanetlike clapper, and the tambourine (Mr. Tambo), respectively. The entertainer in the middle was called the *interlocutor* and was the butt of the jokes. Other musicians played banjos, fiddles, and concertinas. Early troupes include Christy's Minstrels, Buckley's New Orleans Serenaders, White's Minstrels, the Harmoneons, and the Ethiopian Serenaders.

The structure of an early minstrel show was two–part. The first was a parody of the northern, urban black, who was generally depicted as a tasteless dandy. The second part was set on a southern plantation, and portrayed slaves as grotesque, ridiculous, fun–loving, musical, and amorous. After the 1850s a middle section was often added, which consisted of a variety of songs and gags, often having little or nothing to do with blacks. It was called the *olio*. Soon the first section came to be dedicated to *genteel* (or *parlor*) songs, and were sometimes even performed without blackface. The final section then became the focus of racial stereotyping. It featured a rousing finale called the *walkabout* or *walkaround*, with highly rhythmic music and extravagant group dancing. The most famous of these songs was by Dan Emmett (1815–1904), and entitled "I Wish I Was in Dixie's Land," or, today, just "Dixie."

The minstrel shows became the period's most popular form of musical theater. They were especially popular in the north, where people wished to cast those exploited by slavery as unworthy of their attention. Within six months of the first minstrel show in the United States, London was enraptured with the genre. From there it spread throughout the world, becoming the first form of American popular culture to have a worldwide impact. Although the shows changed and adapted somewhat, they lasted into the mid–twentieth century.

Foster (1826–1864)

Stephen Collins Foster was the greatest composer for the minstrel show. Many of his songs for it are still known today: "Oh Susanna," "Old Folks at Home" (or "Swanee River"), "My Old Kentucky Home," "Old Black Joe,"

and "Camptown Races," among others. His early minstrel show songs were typical of the genre. Black speech patterns were represented in an exaggerated way and the caricatures were grotesque. Musically, the songs were nicely crafted with symmetrical phrases, singable melodic contours of limited range, appropriate, simple harmonies, and a chorus that was the most important part of the song. The rhythm is often the most original aspect, with some syncopation. By 1854 Foster had considerably softened racial stereotyping in minstrel shows and was instead portraying his subjects as warm, caring, loving, and more human. He did this by overlaying characteristic themes of nonminstrel popular music, such as nostalgia for home, parental love, and sadness at the death of a loved one.

Songs for the minstrel shows were not the whole of Stephen Foster's output; in fact, they number only about thirty of the total two hundred. Most of the others are of a general type called *parlor songs*, composed to be performed in the middle–class home, and part of a general social movement sometimes called the *genteel tradition*. An important influence here was the body of Irish songs by Thomas Moore. Examples of the sort include "Sweetly She Sleeps, my Alice Fair," "Comrades, Fill No Glass for Me," "Gentle Annie," and "Jeanie with the Light Brown Hair." The lyrics are elegiac, melancholy, often bittersweet; nostalgia for a lost, past happy time is frequent. The melodies are often pentatonic. Several of Foster's songs were influenced by the vogue for Italian opera. "Wilt Thou Be Gone, Love?," a setting of the balcony scene from *Romeo and Juliet*, is one of these, as are "Come Where My Love Lies Dreaming" and "Beautiful Dreamer."

The best of Stephen Foster's songs are synthesized from styles and materials available to him, but more than that they have about them a distinctly American sound. No one before, and perhaps no one since, has so successfully merged disparate musical elements together to produce an individual style. Commercially, Foster was also greatly successful. He became the first American composer to support himself on royalties generated by the sale of his songs.

Songs of the Civil War

Popular songs of unusually high quality expressed the tragedy of the Civil War (1861–1865). Several song categories can be identified.

Soldiering Songs

Songs were sung by soldiers in great number. They sang of grief, discomfort (bad food, primarily), and longings for home; they sang humorous songs, folk–songs, and freshly composed popular songs. They sang to themselves, with their comrades–in–arms, and, in a particularly strong image that defined the peculiar nature of this war, with the enemy.

Patriotic Songs

This category contains two of the best–known songs from the period: "The Battle Hymn of the Republic," which became an anthem for Unionists, and "Dixie," a rallying cry for Confederates. Julia Ward Howe's famous poem gave the song its title and much of its urgency. Like many songs of the period, the text was set to a preexistent tune. "Dixie" was borrowed from the minstrel show stage. There is no crusade in this song; rather it is all celebration of the south and of being a southerner. Dozens of other patriotic songs were published, but none matched these two for popularity.

Home Songs

Generally, songs of the Civil War were for parlor consumption, as the family tried to understand and fix the emotions of victory, defeat, glory, death, horror, and comic relief. A representative sample includes "Tramp! Tramp! Tramp!, or the Prisoner's Hope" by George F. Root (1820–1895), "Tenting on the Old Camp Ground" by Walter Kittredge (1832–1905), "All Quiet Along the Potomac Tonight" by John Hill Hewitt, "The Drummer Boy of Shiloh" by Will S. Hays (1837–1907), "Weeping, Sad and Lonely, or When This Cruel War is Over" by Henry Tucker (1826–1882), and finally, the moment war–weary American dreamed of, "When Johnny Comes Marching Home" by Patrick Sarsfield Gilmore (1829–1892).

Popular Music of the Post–Bellum Period

American popular song was standardized after the war. Almost all songs of this period (1) began with a piano introduction of regular length (four or eight measures), which usually introduced the song's melody; (2) had a verse for solo voice of sixteen measures, divided into four equal phrases, typically in the melodic pattern *AABC*, *ABAC*, *AABA*, or *ABCB*, with two to four verses, which built a narrative with a moral; (3) climaxed in the chorus, which was often arranged for four voices and related musically to the verse; (4) generally concluded with an instrumental postlude melodically related to the *A* phrase of the verse.

Popular music in the period 1865–1880 was largely composed for three institutions: the minstrel show, the home, and the musical stage.

The Minstrel Show

After the Civil War, racial stereotyping in the minstrel shows became even more repugnant, suggesting that consciences had been cleared by emancipation. Songs by Will S. Hays ("The Little Old Cabin in the Lane") and Bostonian C. A. White (1829–1892); ("The Old Home Ain't What It Used to Be"), among many others, tried to suggest that the black man in America looked fondly backward to the days of slavery. The first great black song composer James Bland (1854–1911) mouthed a similar message in his "Carry Me Back to Old Virginny," "In the Evening by the Moonlight," and

others. Black popular stage entertainers of that time were trapped by circumstances into reinforcing the stereotypes.

The Home

The American family continued to buy and perform songs that represented middle–class values. A master of the genre was Henry Clay Work (1832–1884). During the war he wrote songs that drew hope, rejoicing, and victory from tragedy. Afterward, his "Grandfather's Clock," perhaps the most popular song of the period, told of respect for a work ethic, of parents, and of materialism. Other important parlor songs of the period fit into comfortable and familiar categories. "I'll Take You Home Again, Kathleen" by Thomas P. Westendorf (1848–1923) is a nostalgic regard for home and romantic love. Henry Tucker's "Sweet Genevieve" is an intensely sentimental ballad to a lost young love, while "Silver Threads Among the Gold" by H. P. Danks (1834–1903) celebrates a mature romantic love.

TIN PAN ALLEY

Although many millions of copies of sheet music were sold before 1890, it was not until this time that there developed a specialized industry to produce, manage, disseminate, and profit from only popular song. Before, a music publisher issued a full range of music, from oratorios and symphonies to popular songs. The new industry was gathered around 28th Street in New York City, an area that came to be called *Tin Pan Alley* after the incessant racket produced by dozens of pianos sounding at once. The efficient publishers of Tin Pan Alley hired professional lyricists to work with their house composers, who might rush their newest song down to the demonstration room where company singers and pianists would perform it for potential buyers.

Early Years: 1890–1920

Popular music changed with the business. Most prominently, harmonies became much more venturesome, embracing chromatic alterations and key modulations. The use of *secondary dominance* was a favorite device. (*Barbershop quartets* today keep the style alive; "Sweet Adeline" was composed in 1903.) The chorus also became more important. Typically there were only two verses and a long, thirty–two measure chorus. Stephen Foster, by comparison, might have four verses and a sixteen–, or even eight–measure chorus. The verses of a typical Tin Pan Alley song functioned much like recitative in opera: they told the story in graphic, dramatic terms, but

contained music of relatively little interest. The chorus was where one heard the main, memorable melody. "After the Ball" by Charles K. Harris (1867–1930), claimed to have sold five million copies, is such a song. Rhythmically, there was a decided preference for a waltzlike triple meter during the period, perhaps more the case in 1890 than in 1920.

Socially, the songs of the period symbolized a break with the generation formed by the Civil War. Slang became a part of the language of popular music. "How'd you like to spoon with me?," "She's your tootsie–wootsie in the good old summertime," and other such lines suggest a loosening of social mores that an older generation found regretable.

Composers

Among the many excellent composers of this music were: Paul Dresser (1857–1906; "Banks of the Wabash," "My Gal Sal"), Charles K. Harris, Harry Von Tilzer (1872–1946; "A Bird in a Gilded Cage"), Ernest R. Ball (1878–1927; "When Irish Eyes are Smiling," "Will You Love Me in December As You Do in May?"), and Joseph E. Howard (1878–1961; "Good Bye, My Lady Love").

Years of Maturity, 1920–1955

Formally, the songs of Tin Pan Alley were virtually static. The chorus was so important that in some songs the verse was omitted altogether. Nearly all had thirty–two choruses, lending the form a name: *thirty–two–bar form*. Most choruses were in an *AABA* melodic structure, with each section eight measures in length. The *B* section was called the *release*, for its contrasting quality. Another popular form was *AA* or *AA'* (the prime stroke means that it is a closely related variant). Occasionally songs were in unusual forms such as *ABCA*, *ABAC*, or even *ABCD*.

The lyrics of these songs covered a range of subject matter. Family, nostalgia, the exotic and foreign, novelty (i.e., fads and crazes), patriotism, and, in the 1930s, the depression were all treated. Most were about romantic love, though.

Composers

The composer who perhaps best defined the period was Irving Berlin (1888–1990), who had hits in each decade; among his many popular songs were "Alexander's Ragtime Band," "Oh How I Hate to Get Up in the Morning," "Always," "Blue Skies," "A Pretty Girl is Like a Melody," "How Deep is the Ocean," "Easter Parade," "Dancin' Cheek to Cheek," "God Bless America," "White Christmas," "Anything You Can Do," and "There's No Business Like Show Business." Other important composers were Jerome Kern (1885–1945), who brought a more complex harmonic language to popular music, Cole Porter (1893–1964), with his sophisticated texts and harmonies, George Gershwin (1898–1937), whose music revealed the influ-

ence of jazz rhythms, Harold Arlen (1905–1986), Vincent Youmans (1898–1946), Walter Donaldson (1893–1947), and Richard Rodgers (1902–1979).

Dissemination Until the 1920s, the pattern of dissemination of successful popular songs had remained the same for nearly a century. (1) A composer wrote a song. (2) A publisher published it. (3) A professional entertainer performed it widely. (4) Members of the audience liked it, purchased a copy from their music store, and played it at home. Sometimes points two and three would be reversed; rarely was point three bypassed altogether. An important aspect of this pattern was that music was being heard and enjoyed in live performance. The technological revolution of the 1920s changed the way music was first exposed to the public and, therefore, consumed.

Recordings

Commercial recordings of music had been available from before the turn of the century. In the 1920s, though, sales of them achieved a level that was not reached again until the 1950s. Popular songs fit conveniently the three–to–five–minute limit of most disk recordings. As a result, composers did not appreciably change their style of writing to accommodate the new medium.

Radio

The first commercial radio station in the United States broadcast in 1919. Programmers quickly realized the potential of music. By the end of the 1920s almost all American homes had radio receivers. The playing of one new song could insure its commercial success. This was the first decade in which songs were made or broken by radio audience response; such is still the case today.

Many radio shows up until about 1945 featured *big bands*. Some of these, like Guy Lombardo and His Orchestra, played straightforward (*sweet*) arrangements of popular songs. Others, though, played in a style more appropriate for the faster, livelier dancing then popular. These bands were influenced by developments in jazz, particularly in their use of driving, syncopated, "swinging" rhythms—hence the term *swing band* (see also Chapter 34). Some of the most important white swing bands were led by Benny Goodman (1909–1986), Tommy Dorsey (1905–1956), Glenn Miller (1904–1944), and Artie Shaw (1910–). They tended to play with more restraint than the black swing bands, some of whom were headed by Bennie Moten (1894–1935), Count Basie (1904–1984), Fletcher Henderson (1897–1952), Duke Ellington (1899–1974), among others, who transfused the genre with the intensity of jazz and blues. Big bands generally played popular songs, which encouraged composers to write songs suitable for swinging. The vocalists with the bands often sang in a half–voiced, breathy, relaxed style, called *crooning*, that took advantage of the increased sensitivity of

radio microphones. Rudy Vallee (1901–1983), Bing Crosby (1904–1977), and Frank Sinatra (1915–) were some of the better–known crooners.

Film

Popular song was first heard on the sound track to *The Jazz Singer* (1927). Almost immediately composers began writing songs for the medium. Irving Berlin's "Puttin' on the Ritz" was written for the movie of the same title in 1929. The 1930s and 1940s made up a golden era for movie musicals, with scores of them produced and filmed.

MUSICAL THEATER

The history of the musical theater is closely connected to that of popular music. The minstrel shows were partly responsible for the relationship. Many songs written for the popular stage worked their way into the home, and parlor songs made their way onto the stage.

The Black Crook, staged in 1866, is an important production in the development of popular musical theater. It combined an intriguing story with dance, popular music, romance, and extraordinary special effects. The Harrigan and Hart shows of the 1870s developed on the notion of the unified stage production. These were basically whiteface minstrel shows, but with an urban ethnic basis instead of a rural racial one. Set in New York City, there were characterizations of Scottish, Irish, Italian, Chinese, African–American, German, and Jewish, mixed in with urban conflicts, political intrigues, ethnic humor, slapstick, special stage effects (waterfalls, fires, storms), and songs. *A Trip to Chinatown* (1891) shared many qualities in common with the Harrigan and Hart shows. It was the most successful musical of its day, largely because of the music, which in later productions included "After the Ball."

The productions of George M. Cohan (1878–1942) of the 1900s, especially *Little Johnny Jones* (1904) and *Forty–five Minutes from Broadway* (1906) were the breakthroughs to *musical comedy*. They had a tight plot, were American in tone, spirit, and theme, and featured the infectious songs of Cohan. Jerome Kern, in the 1910s, expanded upon the genres by tightening the plot further and writing more sophisticated music. He learned from the cohesive structure of operetta, a tradition that had been kept alive in the work of Victor Herbert (1859–1924), Reginald de Koven (1859–1920), and Rudolf Friml (1879–1972). Kern's *Show Boat* (1927) was a watershed for its high–quality music, text, and production, and for the seriousness of its

subject (racism). Other important musical comedies were Cole Porter's *Anything Goes* (1934), Richard Rodgers's *Oklahoma!* (1943), *Guys and Dolls* (1950) by Arthur Loesser (1894–1969), *The Music Man* (1957) by Meredith Willson (1902–1984), and *West Side Story* (1957) by Leonard Bernstein (1918–1990). The tradition has continued into the present, with the work of Stephen Sondheim (1930–), Andrew Lloyd Webber (1948–), and others.

Vaudeville and Revues

Vaudeville flourished in the last third of the nineteenth century. Derived in part from the minstrel show, it was a mix of a dozen or more individual acts, featuring popular entertainers (singers, dancers, comics, animal trainers, jugglers, magicians, etc.). At its height in the early twentieth century, more than ten thousand vaudeville theaters were open in the United States. The *revue* was only slightly more organized, with its set of unrelated skits, usually with music, an expensive production, and a chorus line of attractive, scantily clad female dancers. The annual revues of Florenz Ziegfeld (1867–1932), which he called his *Follies*, premiered some of the best-known popular songs of the era.

Recordings

Moore's Irish Melodies (Nonesuch 79059)

An Evening with Henry Russell (Nonesuch H71338)

Popular Music in Jacksonian America (Musical Heritage Society MHS 834561)

Songs by Stephen Foster (Nonesuch H71268)

Songs by Henry Clay Work (Nonesuch H71317)

After the Ball: A Treasury of Turn–of–the–Century Popular Songs (Nonesuch H71304)

Vaudeville: Songs of the Great Ladies of the Musical Stage (Nonesuch H71330)

The Great American Composers: Irving Berlin (CBS C21/2 7929); *George and Ira Gershwin* (CBS C21/2 7925); *Cole Porter* (CBS C21/2 7926); *Rodgers and Hart* (CBS C21/2 7971)

American Popular Song: Six Decades of Songwriters and Singers (Smithsonian R031 P7 17983)

Time–Life Music: Your Hit Parade [a series of recordings of hit songs of the 1940s and 1950s]

The Smithsonian Collection of American Musical Theater: Shows, Songs, and Stars (Smithsonian RD 036 A4 20483)

34

Jazz

Jazz has no standard definition. It does, however, always involve lively, syncopated rhythms and instrumental improvisation. The style was developed around the turn of the twentieth century by African–Americans. An urban music, it had a close connection to New Orleans. Several different kinds of music came together to shape early jazz, including black spirituals, the cakewalk, work songs, and white hymns, popular songs, band marches, and popular piano pieces. Its development has since gone through fairly well defined stylistic periods. Jazz has come to exert considerable influence on other styles of music.

THE COMPONENTS OF JAZZ

Swing

Swing is a rhythmic phenomenon. It may be the most important ingredient in jazz, for it is found in all periods and styles. Jazz musicians will always deliberately and in a highly controlled way deviate ever so slightly from notated rhythmic values. A swing musician will never play straight eighth notes or sixteenth notes, but will minutely add or subtract values in such way as to enliven the phrase. Generally this is done so subtly that conventional notation is unable to capture it.

Improvisation

Improvisation is spontaneous composition. Far from unstructured, though, improvisation happens generally within formal bounds understood beforehand by the performers and, usually, the audience. The most frequent structure is a kind of theme and variations. For example, when a performer improvises on the chorus of a popular song ("I Got Rhythm" by George Gershwin [1898–1937] is a particularly popular one) he or she usually

maintains the length of the original chorus, its form, and its harmonic framework. This allows other performers and the audience to maintain a point of reference. The shape of the melody may be followed loosely as might the rhythm, but one or both will undergo substantial alteration. The performer may also suspend the structure momentarily by adding an improvised interlude, called a *break*. When the performer is said to play another *chorus*, further improvisation (or variation) on the main statement (the "theme," usually the chorus of a popular song) takes place. Often improvisation takes the form of *call and response*, in which soloist and ensemble "speak" back and forth.

Preexistent Musical Styles

New Orleans was a city where black and white, African and American, urban and rural met. Musics associated with these and other groups became part of the mixture that led to jazz.

Blues

Blues developed among rural southern blacks after their emancipation from slavery. It gave expression to the hard lot of these impoverished, exploited people. The blues might have originally been sung a capella, but came generally to be accompanied by a guitar. The style, as well as the genre itself, was deeply rooted in African traditions. The blues singer sang with a variety of groans, scoops, "bent" notes, and other qualities not usually heard in Western music. He (in the early years; "she" only later) sang notes that did not fit into Western intonation systems. Three favorite ones, called *blue notes*, were pitched slightly under Western tunings of the third, fifth, and seventh of the major scale. Rhythms were gently syncopated. Accompaniments often featured *riffs*, short melodic ostinatos of two to four measures. Form in this early style, which is called *country blues*, was variable. About 1910, a standardized form, known as *twelve–bar blues*, gained acceptance. It consists of three four–measure phrases that follow a uniform harmonic progression and textual format.

measure:	1	2	3	4
harmony:	I	I	I	I

text: *A* (example: "Been down to New Orleans, had a look around")

measure:	5	6	7	8
harmony:	IV	IV	I	I

text: *A* (example: "Oh, been down to New Orleans, had a look–a–see")

measure:	9	10	11	12
harmony:	V	V (or IV)	I	I

text: *B* (example: "Found plenty women, I think it's the place for me")

This framework then serves for additional choruses in which the narrative is developed and new melodies are improvised. By the 1920s an urban blues style had matured that featured star singers, small instrumental ensembles, and the twelve–bar blues form. Some of the best–known blues singers were female, such as "Ma" Rainey (1886–1939), Bessie Smith (1894–1937), and Alberta Hunter (1895–1984). Among later blues singers, B. B. King (1925–) is probably the best known.

Ragtime

Ragtime developed in the St. Louis and Kansas City area in the early 1890s and enjoyed popularity through the first decade of the twentieth century. It was originally piano music, although small bands eventually played it as well. It required a degree of musical literacy. Ragtime pieces (called *rags*) are not improvised, nor are performers expected to swing the rhythms. In the left hand a strict rhythm, usually in $\frac{2}{4}$ meter and at a moderate march tempo, is maintained while the right hand plays a syncopated melody. The forms were derived from marches and dances; the standard form is *AABBACCDD*. Ragtime's biggest contribution to jazz was its heavily stressed syncopated rhythmic style. A classic example is "Maple Leaf Rag" (1899) by Scott Joplin (1868–1917).

Bands

The nineteenth century was a golden era for both the brass band and the wind band. Many villages and towns had their own bands. In some parts of the United States, blacks were encouraged to form their own bands, a tradition that goes back at least to the 1820s and the famous band of Frank Johnson (1792–1844). New Orleans had a vital black marching band tradition by the turn of the century. These groups provided the training for the musicians who determined the early history of jazz.

STYLISTIC PERIODS OF JAZZ

In New Orleans, a fusion of the above–mentioned styles and African musical traditions led to jazz. West Africa had a vibrant musical life, and parts of it came to the New World with the slaves. Especially significant to West African music were the rhythms, which were much more complex than those found in the West. Layers of rhythms (*polyrhythms*), repetitious but with improvised changes over time, produced a rich sound of extraordinary

rhythmic subtlety and sophistication. Western musical culture provided the harmonies, the instruments, and some of the forms for jazz; African music breathed life into it through its rhythms and regard for spontaneity.

Dixieland Jazz

Dixieland (also *New Orleans style*) was an instrumental music. A typical New Orleans dixieland band had from five to eight performers, who played clarinet, trumpet, trombone, drums, string bass, banjo, guitar, and piano. The first three were the main melodic instruments (the *front line*), and the others formed the *rhythm section*. The texture was contrapuntal, with several instruments improvising a countermelody to the main one. Dixieland was group–oriented; individuals were important, but only as they fit into the group. Blues, rags, hymns, and band pieces all served as material for improvisation. Important early figures were King Oliver (1885–1938), Jelly Roll Morton (1890–1941), and Sidney Bechet (1897–1959).

Armstrong (1900–1971)

By the late 1910s jazz was being heard in New York, Chicago, Kansas City, Memphis, and other cities, in addition to New Orleans. Chicago became especially important in the 1920s as important musicians migrated there from New Orleans. Louis Armstrong was one of these, and he was responsible for important developments in the Chicago hot style, which came to be called *hot jazz*. A virtuoso trumpeter and the developer of *scat–singing* (nontexted vocalisations in a jazz idiom), Armstrong took the basic New Orleans band and introduced the featured soloist—often himself. The soloist was less bound by what the supporting players might do, and therefore freer to let the improvisations range afield. The resulting brassy sound and jolting rhythms gave the form its name. By the end of the decade, the bands had grown in size to perhaps ten players. Bix Beiderbecke (1903–1931), one of several white jazz musicians of this time, benefited from Louis Armstrong's innovations.

Piano Styles

The period also witnessed developments in piano style. *Boogie–woogie* was a percussive kind of playing that favored a "walking," eighth–note ostinato pattern in the left hand over a blues harmonic progression. This style enjoyed a vogue in the 1930s, but its greatest influence came later in rhythm and blues (see Chapter 35). *Stride piano* emphasized (1) left–hand accents on beats two and four in a $\frac{4}{4}$ measure; (2) melodic improvisation in the right hand, much in the manner of a solo instrument; and (3) expansion of the harmonic language to include complex chords, dissonances, and ninth and eleventh chords. The primary developer of this style was Fats Waller (1904–1943).

Swing

Big bands that could play swing rhythms combined ensemble playing and the new solo improvisatory style around 1930, signaling the beginning of the *swing* period. The size of a typical swing band was twice that of a dixieland band. There were usually four reeds (saxophones and clarinets), and five brass (three trumpets and two trombones), plus the rhythm section. Increased numbers forced the notation of nonimprovisatory sections of a piece. These were called *charts*. One person, the arranger, took responsibility for laying out the charts, and came to function much like a composer does in art music traditions. Continuing a trend, the harmonic vocabulary became fuller during the period. Music available for "swinging" came to include popular songs.

Ellington (1899–1974)

Swing bands were identified by race. The white bands, such as those led by Benny Goodman (1909–1986), the Dorsey Brothers, and Artie Shaw (1910–), were more closely associated with popular music than the black swing bands, led by Bennie Moten (1894–1935), Fletcher Henderson (1897–1952), Count Basie (1904–1984), and others. Duke Ellington clearly stood apart. He was jazz history's greatest composer, and wrote standards like "Mood Indigo," "Sophisticated Lady," and "In a Sentimental Mood." Ellington was the first to write charts not based on preexistent songs, but freshly composed for the occasion. Among his many innovations was the recognition that timbre could be thematic in the way that melody and harmony had been traditionally—an idea he might have developed from his study of the French Impressionists. He also stretched the time frame of jazz composition. Some of his works were multimovement and took ten or more minutes to perform. Examples of this sort are *Diminuendo and Crescendo in Blue* and *Black, Brown and Beige*, virtually a tone poem intended to portray the history of African–Americans through their music.

Bebop

Bebop, also called *rebop* or, simply, *bop*, was a major stylistic development of the 1940s. It was characterized by a rebellious return to smaller ensembles (called *combos*) that allowed for more individualistic playing. Instead of a chart, pieces were learned by rote, as in the Dixieland style, then improvised around during performance. Unlike most swing band music, bebop is fast and driving, even aggressive or snarling at times. It was music for listening—not for dancing, as had generally been the case with swing.

The musical characteristics of bebop include a much more complex harmonic language. Performers often used the harmonies of a song as the foundation for improvisation, instead of the melodies, as before. Since performers changed the names of their pieces from the original song titles, most members of the audience were unaware of the source of improvisation. Most innovative, though, were the rhythms, which were woven into a dense

polyrhythmic fabric by the drummer. The ending of a phrase was often signaled by two punched fast notes, the vocalisation of which gave the style its name. Important in the development of this music were Dizzy Gillespie (1917–), Max Roach (1924–), Thelonious Monk (1917–1982), Miles Davis (1926–), and Art Tatum (1909–1956).

Parker (1920–55)

Charlie Parker may well be the greatest improviser produced by jazz. His musical invention was always fresh, original, and appropriate. Parker's idiomatic manner of playing—angular, intense, and nervous—influenced several subsequent generations. The alto saxophone was established as one of jazz's most characteristic timbres as a result of Parker's virtuosic control of it.

Cool Jazz

Also a reaction to the swing band style, cool jazz came about in the late 1940s. There is a quiet, but highly intense intellectualism about this music. Cool jazz is related to bebop but has none of the aggression. Many of the cool jazz musicians were conventionally trained, and their music demonstrated sophisticated harmonic language, counterpoint, and formal structures borrowed from art music. Drummers in this idiom used a brush on the cymbal instead of the fast hard stick characteristic of bebop. The Modern Jazz Quartet epitomizes the style. Other important musicians are Lester Young (1909–1959), Stan Getz (1927–), Lennie Tristano (1919–1978), Dave Brubeck (1920–), Gerry Mulligan (1927–), and, again, Miles Davis.

Jazz Since 1960

Jazz has splintered into several subgroups but, in the composite, enjoys great popularity. A style related to bebop (sometimes called *neo–bop* or *hard bop*) has remained arguably the most popular form of jazz at a professional level. It maintains the traditional idioms of jazz. The highly inventive Charles Mingus (1922–1979) was influential in this development. It is possible, however, to hear any historical style of jazz one wants. Among amateur players, especially at the high school and college level, the swing band style is probably most practiced. There are developments that are new, though, and that continue the dynamic development of jazz.

Free Jazz

Also called *new thing*, and *avant–garde jazz*, this style grew out of experimentation with harmonies in the 1950s by performers like Cecil Taylor (1933–), Ornette Coleman (1930–), John Coltrane (1926–1967), and Miles Davis. The former two stretched harmonies to the point that tonal centers were obscured or lost. The latter explored complex harmonies based in the church modes. By the 1960s certain principles could be applied to this music. (1) Improvisation is of paramount importance. The improvisor has complete freedom apart from the expectation that reference will be maintained loosely

to some theme, harmonic progression, or idea. (2) The materials available to free jazz include shouts, cries, outbursts, and other nonconventional sounds. (3) Improvisation avoids predictable order; surprise is critical to the aesthetic.

Third Stream

This was named by Gunther Schuller (1925–) in the late 1950s for a music in which jazz styles and traditions are consciously merged with styles and techniques associated with art music, to form a new current. Schuller himself and composer Ran Blake (1935–), both of whom have strong roots in both traditions, have been most successful at it. Beyond them, composers of art music have been influenced by the whole notion of synthesis to include jazz elements in their work. Third stream is part of a general post World War II tendency toward eclecticism and synthesis.

Fusion

Fusion (also, *jazz rock*) melded the rhythms and sounds of rock with the skilled improvisation of jazz. In fusion, traditional acoustic instruments are heard in combination with synthesizers and electric pianos, guitars, and basses. The rhythm section is enlarged and of greater importance. Miles Davis was an important early influence with his recording *Bitches Brew* (1969). Others include Larry Coryell (1943–), Herbie Hancock (1940–), Chick Corea (1941–), John McLaughlin (1942–), Pat Metheny (1954–), and the group Weather Report. This style achieved a popularity not reached in jazz since the swing band period. Groups closer to the rock end of the spectrum include Chicago, and Blood, Sweat, and Tears.

Recordings The Smithsonian Collection of Classic Jazz (Smithsonian RD 033 A5 19477)

35

Rock

Rock is a form of popular vocal music that has an energetic, syncopated rhythm and features electric guitar accompaniment and other amplified instruments. Its function as dance music was initially paramount and has continued to be important. In the years since its birth, substyles have come about that encourage close listening, utility as background music, or other purposes.

Rock comes closest to being a worldwide form, appreciated in almost all countries and played in countless local, regional, and national idioms. Yet rock was developed in the United States, and this country has always been at the forefront of the music's evolution.

Rock is the first music to be shaped by recording technology and to be disseminated mainly in recorded form. As a result, it had little need to develop any formal literacy and has continued essentially as an oral tradition. Performers learned their songs by rote or composed them themselves aurally. This music, which has extraordinary vibrancy, has thus produced the most passive of audiences, who expect others to produce the music for them. They are nonetheless passionately involved in listening to it and are deeply immersed in the culture that surrounds it.

THE EARLY YEARS OF ROCK

It is not clear who invented rock. The proper answer, as often happens in music with wide impact, is that many different musics and elements of music were synthesized to fashion a new style. In the case of rock, the two major ones were *rhythm and blues* and *country music*, both of which had

more in common with each other than with the prevailing white popular music styles.

Rhythm and Blues

Rhythm and blues (or *R & B*) was popular music for many African–Americans during the period when most white Americans were listening to Tin Pan Alley. (Jazz had become an elite form of black music–making by the 1930s.) As the name implies, one basis of this music was the blues. Like the blues, R & B has lyrics of an earthy nature, generally about relations between men and women, which were sung in an almost speechlike talking style, direct and straight at the audience. Also like the blues, this music is generally in the form of the twelve–bar blues. Heavily stressed rhythms are also important to the style. Characteristically, there is a heavy *backbeat* in which, in $\frac{4}{4}$ meter, beats two and four are punctuated; beat one receives less emphasis and beat three hardly any at all. A riff is often integral to the background texture. Instrumentation is typically a piano, drums, and guitars (one or two), and frequently a saxophone; the guitars are generally amplified to be heard over the noise of a dance hall. Some of the most important R & B performers were Chuck Willis (1928–1958; "C. C. Rider"), Joe Turner (1911–1985; "Shake, Rattle and Roll"), and Muddy Waters (1915–1983; "Hoochie Coochie Man"). While white popular music was sophisticated and urbane, rhythm and blues was guileless, direct, and spirited. These elements were critical to the acceptance of rhythm and blues by young white audiences in the 1950s, who were seeking an alternative to what they considered to be a stilted and overly self–conscious white popular music style.

Country Music

Some white audiences were not listening to Tin Pan Alley performed by swing bands. They were generally of the working classes, often from rural areas, and frequently from the south, which had not been integrated into the American mainstream after the Civil War. This social group practiced and enjoyed a music we now called *country music*; they called it *hillbilly music* and, later, *country and western*. Among the important sources for country music are (1) the folk ballad tradition, which had been preserved intact in many parts of the south, (2) instrumental dance pieces, often called *fiddle tunes*, also a vernacular tradition in the south, and (3) white gospel music, with its passion and fervor. Merging these styles produced an up tempo dance music, often dominated by the fiddle and guitar, with lyrics that dealt with real–life issues (death, loneliness, family). It was sung with a traditional nasal quality and no attempt was made to camouflage the "southernness" of the accent or the music. Further, many of the early stars, such as Jimmie Rodgers (1897–1933; "Blue Yodel No. 11") and Hank Williams (1923–1953; "Lovesick Blues") were familiar with black music and were influenced by it. Among other stars in country music of the 1930 and 1940s were the Carter Family ("Wildwood Flower"), Roy Acuff (1903– ; "Great Speckled Bird"),

Ernest Tubb (1914–1984; "Walking the Floor over You"), and Bob Wills (1905–1975; "Steel Guitar Rag").

Rock and Roll

Although there are many influences from country music, *rock and roll* is an extension of rhythm and blues. The primary difference is that rock and roll in its early years, was performed by white musicians. The prevailing attitudes toward race in the United States of the 1950s probably dictated that any new widely successful music would be white.

Haley (1925–1981)

Bill Haley was the first star of rock and roll. Haley had all the requisite social and musical credentials for national success: he was white, middle-class, but not from the south, was influenced strongly by rhythm and blues, and was experienced in performing country music styles. Like many of the early white rock and roll performers, Haley and his group (The Comets) recorded *covers* of successful rhythm and blues songs—that is, they took songs by black performers, generally toned down the racy language, and packaged them for adolescent white audiences. His "Shake, Rattle, and Roll" was such a song, taken from Joe Turner. Haley's version of the song entered the *Billboard* hit charts on 1 January 1955, and effectively dates the beginning of rock. Later that year, his "Rock Around the Clock" became a number–one hit, the first such rock and roll song to do so. The music featured a heavy backbeat, a twelve–bar blues structure, the instrumentation of rhythm and blues, and a text that encouraged adolescent rebelliousness, all characteristics of the style.

Presley (1935–1977)

The pivotal figure in the history of rock and roll, Elvis Presley brought the music to wide national attention. His music is exemplary of the synthesis of rhythm and blues and country music. In fact, a name often used to describe this music is itself a synthesis: *rockabilly*. Nearly all aspects of his style, dress, stage presence, and songs are traceable to one or the other of the genres. Presley went on to record an unprecedented string of hits over the next several years including number–one hits like "Heartbreak Hotel," "Hound Dog" (a cover of a Big Mama Thornton song), "Don't Be Cruel," and "Jailhouse Rock."

Other White Performers

Performers such as Buddy Holly (1938–1959), Jerry Lee Lewis (1935–), Carl Perkins (1932–), and the Drifters sang rock and roll songs about young romance and the concerns of the adolescent (cars, high school, clothes, peer status). Like country music, these songs were sincere, without any touch of irony. Members of the so–called baby boom generation thus had their own music, distinct from anything associated with their parents.

Black Performers

Once the way had been led by white musicians, black musicians started to enjoy success performing a generally toned–down version of rhythm and blues. Among these were Little Richard (1932– ; "Tutti Frutti"), Chuck Berry (1926– ; "Maybelline"), and Fats Domino (1928– ; "I'm Walkin'"). Each of these used the boogie–woogie ostinato bassline that had been heard first in 1920s jazz. It became a characteristic of many rock and roll songs.

THE YEARS 1958–1964

Rock and roll in its earliest years was most frequently produced in small recording studios and distributed locally or regionally, much like rhythm and blues. With the popularity of Elvis Presley, the commercial potential of the music became obvious. Accordingly, many large recording companies, which had been allied with Tin Pan Alley, attempted and managed to gain economic control. Their natural reaction was to alloy rock and roll with Tin Pan Alley styles.

Boone (1934–)

Pat Boone, a clean–cut singer who sang in a style close to crooning, was the first to be set up as an alternative to raucous rock and roll. His music was much less abrasive and the accompaniment sometimes included soft violins. The backbeat was still present, but muted. Among his hits were "Ain't That a Shame," a cover of a song by Fats Domino, and "Love Letters in the Sand," a song from the 1930s.

Other similar singers followed, including Frankie Avalon 1940–), Fabian (1943–), Paul Anka (1941–), and Ricky Nelson (1940–1985).

Novelty Rock

Within the same vein were the many hit novelty songs of the period, which featured unusual, exotic, bizarre, but essentially harmless, lyrics. Examples of the sort include "Witch Doctor," "Purple People Eater," "Yakety Yak," "Alley–Oop," "Ahab the Arab," and "Yellow Polka Dot Bikini."

Other Styles

Other number–one hits were Tin Pan Alley songs, such as "Smoke Gets in Your Eyes." Then there were performers like Bert Kaempfert (1923–) and Mitch Miller (1911–), who were not associated with rock and roll at all, and Connie Francis (1938–), who was popular with teenagers but whose singing had little to do with rock and roll. This development pointed up the

plurality of musical styles that existed during the time, and is evidence of efforts by the music business to tame rock and roll.

Vestiges of Rock and Roll

There were still elements of rhythm and blues to be found, generally among black performers. One style, out of Detroit, was called *motown*. It was smoother and more refined than R & B, with soft melodies and slick harmonies, but it retained the energy and drive. *Doo–wop* was essentially an unaccompanied, close–harmony black vocal style that can be traced back to the Ink Spots in the 1930s. With adolescent–specific lyrics and a softened rock beat, groups like Danny and the Juniors ("At the Hop") and the Belmonts ("A Teenager in Love") enjoyed a period of popularity. Dance crazes in the early 1960s produced songs glorifying the *twist*, first popularized by Chubby Checker (1941–), and other dances like the hucklebuck, the pony, the fly, the watusi, the mashed potato, pony, fish, and hully–gully. All of these were danced to the basic rock and roll beat. *Surf rock*, popularized by the Beach Boys, had much of the subject matter of rock and roll but with an innocence of tone and lyrics foreign to the genre.

Folk Rock

This style should also be mentioned. Initially, it was perceived as an alternative to rock and roll. The Kingston Trio sang songs in the late 1950s and early 1960s that were sometimes rooted in the oral tradition ("Tom Dooley," 1958). They took a style that went back through the Weavers and Woody Guthrie (1912–1967) to folk music and shaped it for urban tastes accustomed to a more genteel sound. They had many imitators, the best–known of whom were Peter, Paul, and Mary, whose first big hit was "Blowin' in the Wind" (1963). This song was composed by Bob Dylan (1941–), who wedded a rock beat to the urban folk style in 1965.

THE YEARS 1964–1972

During this period the primary influence of rhythm and blues waned somewhat. This is reflected in the use of the term *rock* (rather than rock and roll) to name the music. Rock headed off in several different directions as songwriters and performers explored the possibilities of the still–young style. Nonetheless, some general observations can be made. (1) The group became the primary performing unit. (2) During this time performers frequently served as their own songwriters. (3) Rock was internationalized as

England, primarily, contributed mightily to the development of the style. (4) It was a period of tremendous social change and the music reflected this. (5) The generation in its 'teens and early twenties during this time identified so strongly with the music that popular music enjoyed unprecedented acceptance.

The Beatles

This group's dramatic rise to prominence in 1963–1964 signaled the internationalization of rock, the ascension of the rock group, and the imminent domination of the genre by singer–songwriters. The Beatles were composed of a quartet of lower–middle–class Englishmen in their twenties, heavily influenced by American rock and roll dance music, who sang and played amplified guitars (one "lead" melody instrument, one rhythm guitar, and one bass guitar) and a trap drum set. Their early songs revealed their schooling in American rock and roll; "Can't Buy Me Love," for example, is a form of twelve–bar blues. Beginning in 1964, especially with the songs written by Paul McCartney (1942–) and John Lennon (1940–1980) for studio recording sessions (i.e., not for live performance in the dance hall), their style broadened to include the lyrical, humorous, even philosophical. By 1967, with their recording *Sgt. Pepper's Lonely Heart Club Band*, the Beatles were incorporating structures, ideas, and instrumentation from art music, but maintaining the essential rock beat. Their music was extraordinary in its breadth, ranging stylistically from country music to avant–garde art music, and socially and politically across the spectrum of issues concerning young people at that time. The Beatles have been the most influential group in the history of rock—an influence that continues to be felt decades after their disbanding in 1970. They might also be rock's most popular group. Perhaps the groups most closely related to the Beatles were the Kinks and Pink Floyd, both also English.

Other English Influences

The Rolling Stones are also an English group, but one more limited in style. They played music closer to the traditional core of rock and roll, specifically R & B and blues. "(I Can't Get No) Satisfaction" (1965), their first number–one hit, is characteristic in its blues–inflected singing, virtuosic, screaming guitar playing, and loud, hard–driving rhythms that together give sound to the notion of rebellion. Their image was more aggressive than that of the Beatles, personified by their lead "bad–boy" singer, Mick Jagger (1944–). *The Who* was a British group also influenced by traditional rock and roll. Eric Clapton (1945–), one of the finest guitarists in a genre filled with them, and his group Cream established a heavily blues–oriented style called *blues rock*.

West Coast Rock

American rock flourished during the period with many important performers and developments in style, although no group or performer equaled the popularity of the Beatles or the Rolling Stones. Several important groups

made their homes on the West Coast, including Jefferson Airplane, the blues–and jazz–influenced Grateful Dead, and the Doors. *Acid Rock* (also *psyche-delic rock*) was music that grew out of the drug culture around San Francisco at that time. The disjunctive lyrics of this heavily amplified music were supposedly reflective of the mind–altering, psychedelic drug experience. Much of this music included distortion of some kind; indeed instrumentalists sought out equipment that would produce this sound. The guitarist Jimi Hendrix (1943–1970) and the singer Janis Joplin (1943–1970) were masters at this. The "rock generation" interpreted this deliberate rejection of a musical convention as symbolic of their general rejection of social norms.

Folk Rock

Bob Dylan (1941–) is the pivotal figure in this genre. His use of amplified instruments in 1965 dates the beginning of the style. This music was text–oriented in a way other forms of rock were not. In many cases, the songs qualify as outstanding contemporary poetry. *The Byrds*, another West Coast group, were also early exponents of the style. Related to folk rock in instrumentation and in its emphasis on textual content is *soft rock*. Per-former–composers in this genre wed acoustic instruments to a tuneful me-lodic style reminiscent of Tin Pan Alley but with a rock beat. Among the best–known of these were Simon and Garfunkel, Joni Mitchell (1943–), James Taylor (1948–), and Joan Baez (1941–). The popularity of this genre is attested to by the success of the recording *Tapestry* by Carole King (1942–), which has been one of the best–selling recordings in the history of rock.

Soul

Generally, aforementioned rock styles were practiced by white musi-cians. American black performers and audiences were largely drawn to *soul*. The sources for this music were twofold: (1) motown and (2) gospel music. From motown the music got its instrumentation, its theatrical values, and its secularity. It got its "soul" from the black gospel music tradition, in which singers sang religious songs with intense, flaming, spontaneous passion. Part blues, part ecstatic singing, soul singers like Aretha Franklin (1942–), James Brown (1932–), and Otis Redding (1941–1968) returned rock close to its roots. Stevie Wonder (1950–) widened the genre by the force of his rich imagination. As a result of his work, soul came to have an elemental influence on music of the 1970s and 1980s.

ROCK SINCE 1972

Rock since 1972 has gone in many different directions. It is impossible to refer to a single style or group or performer as the most important. Instrumentation of the rock group expanded during this period to include not only electric guitars and drums, but also synthesizers and other electronic instruments. This period has seen the demise of American dominance of the genre; British, Australian, Swedish, and German groups now have international followings. Much of rock has become highly commercial, with profit as its reason for being.

Rock

This grouping includes important performers, groups, and styles that have not generated a special category. Several of these continued development from musics of the 1960s. Some performers and groups have remained close to rock and roll. Among these is *Bruce Springsteen* (1949–), who has been perhaps the most successful American rock singer–songwriter of the period in any genre. His intensity, conviction, the quality and range of his music, his backup group (the E Street Band), and the timeliness of his songs have preserved his popularity. Two others who have managed similarly are Tom Petty (1952–) and John Cougar Mellencamp (1951–). The influence of the Beatles, endemic throughout rock, is especially evident in the music of U2. Paul Simon (1941–) has continued to search out the folk roots of rock. His *Graceland* (1986), one of the most influential recordings of the 1980s, brought black South African music and musicians to the attention of the world.

Art Rock

Several groups of the late 1960s and 1970s were influenced by art music. Emerson, Lake, and Palmer played transcriptions of art music compositions in a rock style, most famously their "Pictures at an Exhibition" after Modest Mussorgsky. Others, like Genesis and Electric Light Orchestra, used some of the idioms more subtly. Frank Zappa (1940–), who admits to being influenced by Erik Satie, Edgard Varèse, and John Cage, produced a mixture of rock, jazz, and art music. Minimalist techniques have been applied to rock, which in structure is naturally sympathetic. This has been done by Brian Eno (1948–), the German groups Kraftwerk and Tangerine Dream, and the Talking Heads. For some performers, only convention determines their membership in the art music world or the rock music sphere. For example, Laurie Anderson (1947–), discussed earlier in Chapter 29, has regularly appeared on the rock music charts.

Heavy Metal

This music was derived from acid rock. Heavy metal is highly amplified, features electric guitars in extended virtuosic solos, electronic distortion of

sound often resulting from "power chords," and attention–grabbing stage acts, outrageous clothing, posturing, light shows, visual images, and the like. The lyrics often deal with sex, violence, and rebellion. This highly theatricized music appeals generally to white male teenagers. Among the most important of these groups are Led Zeppelin, Aerosmith, Black Sabbath, Iron Maiden, Kiss, and Van Halen.

Southern Rock

This form of rock was distinctive for its references to forms of country music, especially rockabilly. The Allman Brothers were generally considered the best exponents of this music. The Band, who backed Bob Dylan on many of his tours, was also of the genre, although only one member of the group was from the south.

Punk

Punk was initially an English music that sprang from the working–class neighborhoods of south London. There, poverty and lost hope promoted a youth revolt that led to rejection of the values, mores, and music of preceding generations. Groups like the Sex Pistols played loud, simplistic music, purposefully uncommercial, with antiestablishment, nihilistic lyrics; they also dressed in wildly unconventional ways and comported themselves violently. Their music was solidly grounded in traditional rock and roll and prompted renewed interest in the roots of the music. Punk gave way to *new wave*, which maintained the primitive energy but acknowledged changes in rock styles since the 1950s. The best English group of this sort was the Clash. English groups strongly influenced by new wave but closer to the mainstream were the Police, the Pretenders, Culture Club, and the Eurhythmics. In the United States the style was less well defined, but groups like Blondie, Devo, the Ramones, and the B52s were called "new wave."

Reggae

This music originated in Jamaica and grew from a 1950s style called *ska*. It achieved considerable popularity in England. Reggae is a melding of American and traditional African–Jamaican styles. Its most important feature is a rhythm with a heavy accent on beats two and four in a $\frac{4}{4}$ meter and avoidance of emphasis on beats one and three. Bob Marley and the Wailers was the best–known reggae group. Groups and performers as diverse as Eric Clapton, Stevie Wonder, Bob Dylan, the Clash, and Blondie have been influenced by the style.

Disco

Disco enjoyed great popularity in the late 1970s and early 1980s. It is fundamentally dance music, with a relentless $\frac{4}{4}$ beat and extended instrumental breaks that encourage freestyle dancing. Lyrics are generally of an amorous, if not erotic, quality. Soul is an important influence. Many of the recordings featured synthesizers. Donna Summer (1948–), Chic, and The

Bee Gees gave the style definition. By the early 1980s, disco had been overexposed and lost popularity. *Funk* superseded it, with its sparser, more relaxed sound. It is characterized by extended repetitions over one or two chords and by heavy syncopation. Instrumentation features a prominent bass guitar, conga drums, and whistles. Some important performers of funk include Kool and the Gang and the jazz–influenced Herbie Hancock (1940–).

Rap

This is a style of black music in which rhymes are improvised to a highly rhythmic, dance–based accompaniment. It is a part of the general movement of black popular music from melody–based to rhythm–based. Rap emerged in the mid–1970s but has become especially important since the mid–1980s. Its lyrics have ranged from exhortations to dance to social commentary on the lot of urban blacks. Initially, the rhythmic background was producing by *scratching*, in which an LP was moved by hand on a turntable to produce a rhythm. Later, electronic "drum machines" were aids in producing the characteristic thumping bass line. Funk was an early source for the music. Among the best–known rap groups are M. C. Hammer, Run–DMC, and Public Enemy.

The Video

In 1982, television network MTV began twenty–four–hour broadcasting of popular music. Like the single on many radio stations, highly theatricized videos of hit songs became the staple of programming. Some performers have been more adept than others at combining mainstream rock with the dramatic potential of the medium. Madonna (1959– ; "Material Girl"), Michael Jackson (1958– ; "Thriller"), and Prince (1960– ; "Purple Rain") have become immensely popular and influential for their work in this new dimension.

Recordings

It is a simple matter to find examples of this music at almost any record store. Among collections that are especially useful are these:

Atlantic Rhythm and Blues: 1947–1974 (Atlantic 781620–1)

Country Music: The Smithsonian Collection of Classic Country Music (Smithsonian R025 P815640)

Time–Life Music issues several outstanding series useful for documenting the music discussed in this chapter. They are: *The Rock 'n' Roll Era*, *Classic Rock* [primarily dedicated to the 1960s], and *Sounds of the Seventies*.

Selected Bibliography

This bibliography is designed as a guide to English–language sources of information related to music history. It excludes books that are biographical and most that are genre– or region–based. Information on these sorts of subjects can be gathered from the references listed below.

Five sources should be singled out as especially useful and important:

(1) Sadie, Stanley, ed. *The New Grove Dictionary of Music and Musicians.* 20 vols., London: Macmillan, 1980. This monumental work of music history should be the first choice of any student for any kind of additional information on music. The bibliographies are also generally excellent, although some are becoming outdated.

(2) Hitchcock, H. Wiley, and Stanley Sadie, eds. *The New Grove Dictionary of American Music.* 4 vols., London: Macmillan, 1986. Equally important in the more specialized fields of American music.

(3) Grout, Donald Jay, and Claude V. Palisca. *A History of Western Music*, 4th ed. New York: W. W. Norton, 1988. One of the most widely accepted surveys of Western music history. The bibliographies at the end of nearly every chapter are accurate, well–chosen, up–to–date, and extremely useful.

(4) Duckles, Vincent, and Michael A. Keller. *Music Reference and Research Materials: An Annotated Bibliography*, 4th ed. New York: Schirmer, 1988. This book offers additional bibliographic assistance to the inquiring student.

(5) Library Catalogs and Databases. Obvious, perhaps, but a primary reference source for locally available materials, books, scores, and recordings. It should be consulted for important subject headings, name entries authors, composers, performers, and titles.

Music Dictionaries and Encyclopedias

In addition to essential information about subjects or persons, most of the following reference works provide bibliographies of books and articles.

Apel, Willi. *Harvard Dictionary of Music*, 2d ed. Cambridge: Harvard University Press, 1969. A comprehensive dictionary of terms; significant historical information about musical subjects. There are no biographical entries.

Scholes, Percy A. *The Oxford Companion to Music*, 10th ed., edited by John Owen Ward. London: Oxford University Press, 1970. Extensive cross references and many illustrations.

Slonimsky, Nicholas. *Baker's Biographical Dictionary of Musicians*, 7th ed. New York: Schirmer, 1984. A fairly comprehensive and accurate one–volume dictionary of names and dates.

Sadie, Stanley, and Alison Latham, eds. *The Norton/Grove Concise Encyclopedia of Music*. New York: W. W. Norton, 1988.

Comprehensive Histories of Music

The New Oxford History of Music. 10 vols. London: Oxford University Press, 1954. This is basically a treatment of Western art music.

The History of Music in Sound, a series of recordings with descriptive booklets, accompanies the text.

The Universe of Music: A History forthcoming. This effort, jointly sponsored by UNESCO and the International Music Council, will be a twelve–volume exhaustive treatment of the world's music, past and present, of all sorts and types. It is an attempt to rectify the Western art music bias that is prevalent in most literature on music.

Surveys of Music History

Byrnside, Ron. *Music: Sound and Sense*, 2d ed. Dubuque, Iowa: William C. Brown, 1990. Especially valuable for its treatment of vernacular music.

Hickok, Robert. *Exploring Music*, 4th ed. Dubuque, Iowa: William C. Brown, 1989.

Kamien, Roger. *Music: An Appreciation*, 4th ed. New York: McGraw–Hill, 1988.

Kerman, Joseph, with Vivian Kerman. *Listen*, 3d ed. New York: Worth, 1980.

Lang, Paul Henry. *Music in Western Civilization*. New York: W. W. Norton, 1941. Especially valuable for background in political, economic, social, and cultural history.

Machlis, Joseph, with Kristine Forney. *The Enjoyment of Music*, 6th ed. New York: W. W. Norton, 1990.

Rosenstiel, Léonie, ed. *Schirmer History of Music*. New York: Schirmer, 1982.

Sadie, Stanley, ed., with Alison Latham. *Music Guide: An Introduction*. Englewood Cliffs, N.J.: Prentice–Hall, 1986.

Historical Periods and Styles

Antiquity

Sachs, Curt. *The Rise of Music in the Ancient World, East and West*. New York: W. W. Norton, 1943.

The Middle Ages

Bukofzer, Manfred. *Studies in Medieval and Renaissance Music*. New York: W. W. Norton, 1950.

Hoppin, Richard H. *Medieval Music*. New York: W. W. Norton, 1978.

Reese, Gustave. *Music in the Middle Ages*. New York: W. W. Norton, 1940.

Seay, Albert. *Music in the Medieval World*, 2d ed. Englewood Cliffs, N.J.: Prentice–Hall, 1975.

Yudkin, Jeremy. *Music in Medieval Europe*. Englewood Cliffs, N.J.: Prentice–Hall, 1989.

The Renaissance

Blume, Friedrich. *Renaissance and Baroque Music*. New York: W. W. Norton, 1967.

Brown, Howard M. *Music in the Renaissance*. Englewood Cliffs, N.J.: Prentice–Hall, 1976.

Reese, Gustave. *Music in the Renaissance*, 2d ed. New York: W. W. Norton, 1959.

The Baroque

Bukofzer, Manfred. *Music in the Baroque Era*. New York: W. W. Norton, 1947.

Palisca, Claude V. *Baroque Music*, 3d ed. Englewood Cliffs, N.J.: Prentice–Hall, 1988.

The Classical Period

Blume, Friedrich. *Classic and Romantic Music*. New York: W. W. Norton, 1970.

Pauly, Reinhard. *Music in the Classic Period*, 3d ed. Englewood Cliffs, N.J.: Prentice–Hall, 1988.

Ratner, Leonard. *Classic Music: Expression, Form, and Style*. New York: Macmillan, 1985.

Rosen, Charles. *The Classical Style: Haydn, Mozart, Beethoven*. New York: W. W. Norton, 1972.

The Romantic Period

Abraham, Gerald. *One Hundred Years of Music*, 4th ed. London: Duckworth, 1974.

Einstein, Alfred. *Music in the Romantic Era*. New York: W. W. Norton, 1947.

Longyear, Rey M. *Nineteenth–Century Romanticism in Music*, 3d ed. Englewood Cliffs, N.J.: Prentice–Hall, 1988.

Plantinga, Leon. *Romantic Music*. New York: W. W. Norton, 1984.

The Twentieth Century

Austin, William. *Music in the Twentieth Century from Debussy through Stravinsky*. New York: W. W. Norton, 1966.

Cope, David H. *New Directions in Music*, 4th ed. Dubuque, Iowa: W.C. Brown, 1984.

Griffiths, Paul. *Modern Music: The Avante–Garde Since 1945*. London: Dent, 1981.

Machlis, Joseph. *Introduction to Contemporary Music*, 2d ed. New York: W. W. Norton, 1979.

Nyman, Michael. *Experimental Music: Cage and Beyond* New York: Schirmer, 1981.

Salzman, Eric. *Twentieth–Century Music: An Introduction*, 3d ed. Englewood Cliffs, N.J.: Prentice–Hall, 1988.

Simms, Bryan. *Music of the Twentieth Century: Style and Structure*. New York: Schirmer, 1986.

Watkins, Glen. *Soundings: Music in the Twentieth Century*. New York: Schirmer, 1988.

Popular Music

Hamm, Charles. *Yesterdays: Popular Song in America*. New York: W. W. Norton, 1979.

Jazz

Kernfeld, Barry, ed. *The New Grove Dictionary of Jazz*, 2 vols., London: Macmillan, 1988.

Tirro, Frank. *Jazz: A History.* New York: W. W. Norton, 1977.

Rock

Charlton, Katherine. *Rock Music Styles: A History.* Dubuque, Iowa: William C. Brown, 1990.

Miller, Jim, ed. *The Rolling Stone Illustrated History of Rock and Roll*, rev. ed. New York: Rolling Stone, 1980.

Other Subjects

Musical Instruments

Sachs, Curt. *The History of Musical Instruments.* New York: W. W. Norton, 1940.

Sadie, Stanley, ed. *The New Grove Dictionary of Musical Instruments.* 3 vols. London: Macmillan, 1984.

Notation

Apel, Willi. *The Notation of Polyphonic Music*, 5th ed. Cambridge: Medieval Academy of America, 1961.

Parrish, Carl. *The Notation of Medieval Music.* New York: Pendragon, 1978.

Theoretical Writings

Strunk, Oliver. *Source Readings in Music History from Classical Antiquity through the Romantic Era.* New York: W. W. Norton, 1950. Translations of important writings of theorists.

Glossary

A Cappella.	Choral music without instrumental accompaniment.
Accent.	Dynamic emphasis placed on a tone or chord.
Accidental.	A sharp, flat, or natural sign that alters a diatonic pitch.
Accompaniment.	Subordinate harmonic or rhythmic material supporting a principal melody.
Air.	A vocal or instrumental melody.
Answer.	The countersubject in a fugue.
Anticipation.	An unaccented nonharmonic tone that resolves by repetition.
Antiphonal.	Containing alternating choirs.
Aria.	A solo song in an opera, oratorio, or cantata.
Arpeggio.	The notes of a chord played consecutively in a consistently ascending or descending direction.
Atonality.	Absence of key or central tonality.
Augmentation.	Doubling of the note values of a melody.
Augmented triad.	A three–note chord consisting of two major thirds.
Authentic cadence.	A cadence consisting of the progression dominant to tonic (V – I).
Auxiliary tone.	An unaccented nonharmonic tone approached stepwise from above or below a chordal tone to which it returns.
Backbeat.	A regular emphasis on the typically unstressed beats in a $\frac{4}{4}$ meter (i.e., beats two and four).
Band.	A large ensemble consisting mainly of wind instruments.
Bar, barline.	A vertical line drawn through one or more staves to indicate measure divisions. *Bar* also means measure (as in, a four–bar phrase).
Bar form.	A form in three sections, the first of which is repeated (*AAB*).
Bass.	A voice, instrument, or part in the lowest register.
Basso continuo.	The instrumental figured–bass part in an ensemble, played by one or more bass instruments and a keyboard instrument.

Beat.	The unit of time in metric music. In time signatures, the upper numeral indicates the number of beats per measure.
Bel canto.	Literally, beautiful singing, or singing in a highly lyrical mode. Generally associated with Italian opera in the early nineteenth century.
Binary.	A form in two sections (*AB*).
Bitonality.	Use of two different keys simultaneously.
Brass.	Wind instruments that produce tone by vibration of the lips.
Broken chord.	The tones of a chord played consecutively, usually according to some pattern.
Cadence.	The harmonic or melodic progression that concludes a phrase, section, or composition.
Canon.	Contrapuntal form in which the entire melodic line in one part is strictly imitated in one or more other parts at fixed intervals of pitch and time.
Cantabile.	In a singing style.
Cantus firmus.	A melody that serves as the structural basis for music in the Middle Ages and Renaissance.
Chamber music.	An ensemble consisting of only a few instruments, and usually only one instrument to a part.
Chanson.	French term for song.
Chant.	General term for liturgical song; Gregorian chant.
Chart.	The score of a jazz composition.
Choir.	Vocal ensemble, usually a small church chorus. Also applied to groups in an orchestra (e.g., brass choir, woodwind choir).
Choral.	Music for chorus or choir.
Chorale.	German hymn.
Chorale prelude.	Organ composition based on a chorale melody.
Chord.	A combination of three or more tones heard simultaneously.
Chordal style.	In vocal polyphony, a texture in which all the parts have the same rhythm and sing the same syllables simultaneously. Also called homophonic style.
Chorus.	A large vocal ensemble. In vernacular music, an extended refrain to a song; jazz further defines it as the main unit of improvisation.
Chromatic, chromaticism.	Extensive use of nondiatonic pitches in melody and harmony.
Chromatic scale.	Twelve consecutive half–steps.
Clef.	A symbol that establishes a particular pitch on the staff, from which the other pitches can be deduced.
Coda.	A closing section.

Codetta.	A short closing section.
Coloratura.	A vocal style involving light and fast running passages, arpeggios, and ornaments. Also, a high soprano voice capable of singing such music.
Common practice.	Refers to the musical language of the West between the sixteenth and twentieth centuries.
Conjunct.	Progressing stepwise in melody.
Consonance, consonant.	Harmonic intervals (thirds, fourths, fifths, sixths, and octaves) that produce a sense of repose; harmony that consists only or mainly of these intervals.
Consort.	A term of the sixteenth and seventeenth centuries meaning ensemble.
Contrafactum.	Replacement of the original text to a piece by a new, different one.
Counterpoint, contrapuntal.	Texture consisting of two or more independent lines.
Contrary motion.	Simultaneous melodic progression in opposite direction between two parts.
Crescendo.	Increasing the dynamic level; getting louder.
Da capo.	To return to the beginning of a composition. Abbreviation: *D.C.*
Decrescendo.	Decreasing the dynamic level; getting quieter.
Diatonic.	Melody or harmony confined to the pitches within a major or minor key.
Diminished triad.	A three–note chord consisting of two minor thirds.
Diminuendo.	Decreasing the dynamic level; getting quieter.
Diminution.	To decrease the note values of a melody. Also, a form of ornamentation.
Discant.	In fifteenth–century practice, akin to *fauxbourdon*. In modern practice, a melodic line sung contrapuntally against a familiar melody.
Disjunct.	Melodic progression dominated by wide skips.
Dissonance, dissonant.	Harmonic intervals (conventionally, seconds, sevenths, ninths, and augmented and diminished intervals) that produce the effect of action or tension; chords that contain one or more of these intervals.
Dominant.	The fifth tone of a diatonic scale, and the chord built on that tone.
Dotted rhythm.	Rhythmic patterns consisting of a dotted note followed by a note of the next smaller denomination (e.g., a dotted quarter followed by an eighth note).
Double bar.	Two vertical lines drawn through one or more staves to indicate a major sectional division or the conclusion of a composition.
Double fugue.	A fugue with two subjects and, correspondingly, two expositions.
Double stop.	The playing of two notes simultaneously on a bowed string instrument.
Duple meter.	Two or four beats to the measure.
Dynamics.	Levels of soft and loud.

Eighth note. One eighth the value of a whole note (♪).

Eleventh chord. A chord of six tones, five superimposed thirds.

Embellishment. Ornamentation such as trills, mordents, and turns.

Enharmonic. Two different notations of the same pitch (e.g., C♯ and D♭ are the same sound).

Ensemble. A performing group consisting of two or more players or singers.

Episode. A section in a piece of music in with no important thematic material.

Equal temperament. The standard method of tuning Western instruments since the early eighteenth century. The twelve semitones that form an octave are equally spaced.

Ethnomusicology. The systematic study of music in different cultures, especially non–Western or non–European music.

Exposition. The section in which thematic material is introduced.

Familiar style. Homophonic style.

Fauxbourdon. Parallel first–inversion chords in fifteenth–century music.

Fermata. A symbol (⌢) signifying a pause.

Figuration. Recurrent melodic pattern.

Figured bass. Use of numerals and other signs accompanying the notes of a bass part to indicate harmony to be filled in on a keyboard instrument; used in the Baroque.

Final. The concluding tone in a Gregorian chant; the tonic.

Finale. The last movement or concluding section of a large composition. In opera, the section from the last recitative.

Flat. A symbol placed in front of a note to indicate lowering that note by one half–step (♭).

Florid. Ornamented, embellished, decorated.

Form. The plan of organization of musical materials.

Forte. Loud. Abbreviation: *f.*

Fugal. In the style of a fugue; involving of contrapuntal imitation.

Fughetta. A short fugue or a fugal section in a composition.

Fugue. A contrapuntal form based on imitation of a subject and a contrasting answer.

Genre. A type of music, usually defined by form or medium.

Glissando. Producing all pitches between two or more notes, as by sliding the finger along the string of a violin or the keyboard of a piano.

Gregorian chant. Liturgical Catholic monophonic song. Also called *plainsong* or *plainchant*.

Half note. One–half the value of a whole note (\half).

Half–step. In the chromatic scale, the distance from one note to its immediate neighbor.

Harmony. The aspect of music involving simultaneous sounds, the combinations of tones, chord structure, chord progression, consonance, and dissonance.

Heterophony. Two or more versions of the same melody played or sung simultaneously.

Homophony, homophonic. A texture consisting of a single melodic line with subordinate accompaniment. Also, sometimes used to mean chordal style in polyphonic music.

Hymn. A religious song.

Idiom. Style appropriate to a specific medium, its capacities and limitations. Also used to mean style in general.

Imitation. The repetition of a theme or melody in different parts within a contrapuntal texture.

Improvisation. To create music extemporaneously, usually within the constraints of some structural framework.

Incipit. The first word or words of a text. Also, the first few identifying notes of a theme.

Instrumentation. The instruments indicated in an orchestral score.

Interval. The pitch distance between two tones, designated numerically as seconds, thirds, fourths, and so on.

Inversion. In melody, the interval–for–interval progression in the opposite direction. In harmony, the root of a chord in some part other than the bass—for example, first inversion (third of the chord in the bass) or second inversion (fifth of the chord in the bass).

Invertible counterpoint. Counterpoint so designed that either of two melodic lines may be the upper line.

Key. The tonal center of a composition or subdivision thereof, indicated by the letter name of its tonic.

Keyboard. The series of black and white keys of a piano, organ, harpsichord, or similar instrument.

Key signature. Sharps or flats at the beginning of each staff that indicate the key of the composition.

Leading tone. The seventh note of a diatonic scale and the chord built on that note.

Libretto. The text of an opera, oratorio, or cantata.

Lied. German word for song. Plural: *Lieder*.

Line. The melodic component in a composition; melodic line.

Liturgical. Proper for use in a church service.

Lyric. Songlike, as opposed to dramatic.

Major. A mode based on a diatonic scale with half–steps between the third and fourth degrees and the seventh and eighth degrees. A triad consisting of a major third between the two lower notes and minor third between the two upper notes.

Measure. A group of beats between bar lines; also, all the notes between two bar lines.

Mediant. The third note of a diatonic scale, and the chord built on that note.

Medium. The voices or instruments, or a combination thereof, required for the performance of a composition. Plural: *media.*

Melisma, melismatic. A melodic passage sung to one syllable of text; a melodic style of many notes to a syllable.

Melody, melodic. Consecutive tones; the linear or horizontal element of music.

Mensural, mensuration. This refers to premetric temporal concepts of the sixteenth century and earlier, in which fixed time–value relationships between notes determined rhythm.

Meter, metric. The measuring of time in music according to a specific number of beats and accents to the measure.

Minor. A mode based on a diatonic scale with a half–step between the second and third notes of the scale; the upper tetrachord of a minor mode is variable, resulting in natural, harmonic, and melodic forms of the mode. A triad consisting of a minor third between the two lower notes and major third between the two upper notes.

Modality, modal. Melody or harmony based on one of the church modes.

Mode. One of the eight church modes. Also refers to major or minor keys.

Modulation. Melodic or harmonic progressions that begin in one key and end in another.

Monody. Early seventeenth–century term for accompanied solo songs.

Monophony, monophonic. Texture consisting of a single melodic line without accompaniment.

Motive. A short melodic or rhythmic fragment long enough to be identifiable.

Movement. A complete and independent part of large works such as sonatas, symphonies, suites.

Musicology. The scholarly study of music, especially systematic research in music history.

Natural. A symbol that cancels a previously indicated sharp or flat (♮).

Neighbor tone. Same as auxiliary tone.

Neumatic. A melodic style in which several notes are sung to a single syllable. Also a type of notation that indicates general pitch direction.

Ninth chord. A chord of five tones, four superimposed thirds.

Nonchordal, nonharmonic.	A dissonant tone that does not function within the chord with which it sounds.
Notation.	A system of symbols for writing music, mainly indicating pitch and duration of tones.
Octave.	The pitch interval between a tone and the seventh tone above it in a diatonic scale, or between the letter name of a tone and its recurrence above or below. The vibration ratio of an octave is two to one: if the tone *A* has 440 vibrations per second, the octave above it has 880 and the octave below has 220.
Opera.	A drama with music.
Oratorio.	A nonliturgical, nontheatrical religious work.
Orchestra.	A large instrumental ensemble.
Orchestration.	The manner in which instruments are employed in an orchestral composition.
Ostinato.	A persistent rhythmic or melodic pattern.
Overture.	The instrumental introduction to an opera or oratorio.
Parallel keys.	Major and minor keys having the same letter name but different key signatures (e.g., G Major with one sharp and g minor with two flats).
Parallel motion, parallelism.	Two or more melodic lines that move simultaneously in the same direction and by the same intervals.
Part.	The single line in a polyphonic composition. One refers to the soprano part, the violin part, and so on.
Passing tone.	An unaccented nonharmonic tone that moves stepwise between two chordal tones up to a third apart.
Pedal point.	A sustained tone in the bass over which changing harmonies take place.
Pentatonic.	A mode based on a five–tone scale (e.g., the black keys of the piano).
Percussion.	Essentially, rhythmic instruments such as drums, cymbals, gongs, and triangle.
Phrase.	A musical unit, often four measures in length, which concludes with a cadence. It usually refers to the melody.
Piano.	A keyboard instrument. Also, the indication for a low dynamic level. Abbreviation: *p*.
Pickup beat.	One or several unaccented notes of a melody preceding the bar line at the beginning of a phrase. Also called anacrusis.
Pitch.	The vibration frequency of a tone.
Pizzicato.	Plucking the strings of a bowed string instrument.
Plagal cadence.	The cadence progression subdominant to tonic (IV – I).
Plagal mode.	In Gregorian chant, the modes that range approximately a fourth below and a fifth above the final.

Plainsong. Gregorian chant.

Point of imitation. In the Renaissance, a structural device in which each phrase or line of text received full treatment in imitation; these sections overlapped somewhat giving a characteristic sense of continuity to the music.

Polychoral. The use of two or more separate choirs.

Polyphony, polyphonic. A texture consisting of two or more lines. In practice, the terms are related to counterpoint and contrapuntal respectively.

Polyrhythm. The layering of metric rhythmic patterns.

Polytonality, polytonal. The simultaneous use of two or more keys.

Preparation. A chordal (consonant) tone that subsequently becomes a nonchordal (dissonant) tone, as in a suspension.

Program music. Instrumental music through which the composer intends to describe some action, scene, or story, and which carries a descriptive title.

Progression. A sequence of tones in melody, or chords in harmony that makes some musically grammatical sense.

Psalm. Musical setting of texts from the biblical book of Psalms.

Quarter note. One–fourth the value of a whole note (♩).

Range. The pitch distance between the highest and lowest note of a melody, voice, or instrument.

Realization, to realize. Filling in the harmony of a figured bass.

Recitative. A declamatory prose style of singing in operas, oratorios, and cantatas.

Refrain. Recurrent lines of text and music at the end of each stanza of a song.

Register. The general pitch level of a part, voice, or instrument (e.g., soprano implies a high register; bass, a low register).

Registration. The combinations of stops used in an organ composition.

Relative keys. Major and minor keys that have the same key signature (e.g., C major and A minor are relative keys).

Responsorial. In Gregorian chant, a section for solo voice followed by a section for chorus in unison.

Retrograde. Music read backward.

Rhythm. The time element in music that is determined by accent or duration of tones.

Riff. A short melodic background pattern, typically repeated throughout a jazz or rock composition.

Root. The tone on which a chord is built.

Round. A form of canon.

Scale. A system of adjacent notes.

Score. Two or more staves with notes vertically aligned in vocal or instrumental part music.

Semitone. A half–step in the diatonic or chromatic scale.

Sequence. A recurrent melodic pattern repeated at successively higher or lower intervals. In Gregorian chant, a form of trope.

Seventh chord. A chord of four tones, three superimposed thirds.

Sharp. A symbol placed in front of a note to indicate raising that note by one half step (♯).

Sixteenth note. One–sixteenth the value of a whole note (♪).

Song. An independent composition with text.

Sonority. Qualities of texture (e.g., thick or thin, heavy or light, etc.).

Staff, staves. The five horizontal parallel lines on or between which notes are written.

Strings. Instruments whose tone is produced by bowing or plucking taut strings (e.g., violins and guitars).

String quartet. A chamber ensemble consisting of two violins, viola, and cello. Also, compositions written for that medium.

Strophic. Song form in which all stanzas of the text are set to the same music.

Style. The characteristic quality of music determined by the integration of all elements (e.g., rhythm, melody, harmony, texture, and medium).

Subdominant. The fourth note of a diatonic scale and the chord built on that note.

Subject. The theme of a fugue.

Submediant. The sixth note of a diatonic scale and the chord built on that note.

Supertonic. The second note of a diatonic scale and the chord built on that note.

Suspension. A nonharmonic device in which a chordal (consonant) tone is held through a change of harmony to become a nonchordal (dissonant) tone that then resolves downward to another chordal (consonant) tone.

Syllabic. A style of text setting in which there is generally one syllable of text to one note of the melody.

Syncopation. A rhythmic device in which the normal accents of the measure are displaced by accenting weak beats, rests on strong beats, or tying notes over from a weak to a strong beat.

Tablature. A type of instrumental notation that indicates where to place the fingers.

Tempo. Generally, the relative speed of music; the rate of beats as indicated by such terms as *allegro*, *presto*, *adagio*, *lento*, and *andante*.

Tenor. The voice part that held the cantus firmus in music of the Middle Ages and Renaissance; also a high male voice type.

Ternary.	A form in three sections (*ABA*).
Tessitura.	Register.
Tetrachord.	A four–tone section of a scale.
Texture.	The disposition of the melodic element in music (see monophonic, heterophonic, polyphonic, and homophonic); also means sonority.
Theme.	The melodic idea on which a composition is based. A theme may also include rhythmic, harmonic, and other factors.
Thoroughbass.	See basso continuo, figured bass.
Tie.	A curved line connecting two consecutive notes on the same line or space of the staff; indicates the note to be held over rather than repeated.
Timbre.	Tone color or tone quality.
Time signature.	Numerals at the beginning of a composition, the upper figure of which indicates the number of beats in the measure, and the lower of which indicates the kind of note that gets one beat.
Tonality.	The sense of gravitation around a tonal center or key.
Tonic.	The first note of a diatonic scale, the note from which a key gets its name, and the chord built on that note.
Transcription.	The arrangement of a composition for a different medium.
Treble.	A relatively high–register part, indicated by the *G* clef, or treble clef.
Tremolo.	Rapid reiteration of a single note or rapid alternation between two notes.
Triad.	A three–note chord, consisting of two thirds.
Triple meter.	Three beats to the measure.
Tune.	A melody.
Tutti.	A passage played by the entire ensemble.
Unaccompanied.	A solo part, passage, or vocal ensemble without accompaniment.
Unison.	Two or more parts singing or playing the same melody.
Variation.	The modified repetition of a theme or melody; a form based on this technique.
Virtuosity.	Prominent display of technical facility in performance.
Vocal.	To be performed by the human voice or voices.
Voice.	The human organ of sound, classified in the West according to registers (e.g., soprano, alto, tenor, and bass). Also, a part in polyphonic music (e.g., a four–voice madrigal or a five–voice fugue).
Whole note.	The basic unit of note values (o).
Whole–step.	An interval consisting of two half steps.
Whole–tone mode.	A mode based on a scale of six notes, separated by whole–steps.

Wind instruments.	Instruments that produce tones by a vibrating column of air when blown; woodwinds and brass.
Woodwind instruments.	Wind instruments that generate tone by a vibrating reed (e.g., oboes, clarinets, saxophones, and bassoons) or by a whistle–type mechanism (flutes and recorders).

Index

I

J

S